LANDSCAPE
PHOTOGRAPHER OF THE YEAR

COLLECTION 03

Senior Art Editor: Nick Otway @ Alphaforme
Managing Editor: Paul Mitchell
Senior Editor: Donna Wood
Image retouching and colour repro: Sarah Montgomery
Production: Rachel Davis
Indexer: Hilary Bird

Produced by AA Publishing
© AA Media Limited 2009
Reprinted in February 2010

Published by AA Publishing (a trading name of AA Media Limited, whose registered
office is Fanum House, Basing View, Basingstoke RG21 4EA; registered number
06112600).

A04385

ISBN: 978-0-7495-6334-9

A CIP catalogue record for this book is available from the British Library.

The contents of this book are believed correct at the time of printing. Nevertheless,
the publishers cannot be held responsible for any errors or omissions or for
changes in the details given in this book or for the consequences of any reliance on
the information provided by the same. This does not affect your statutory rights.

Origination by Keene Group, Andover
Printed and bound by Butler Tanner & Dennis Ltd, Frome, London

theAA.com/shop

ALEX NAIL ···▸

Oak tree near Becky Falls, Dartmoor, Devon, England

Mist and sunshine always lead to sunrays and, if you manage to find the right spot, the light
effects can be quite spectacular. I spent a while just walking back and forth, enjoying seeing
the rays move around me, before finally arriving at this simple composition. I usually try to
capture the entire dynamic range of a scene when I can but there was no chance here, the
sky was just too bright, but all that I was really worried about was showing the sunrays at
their best.

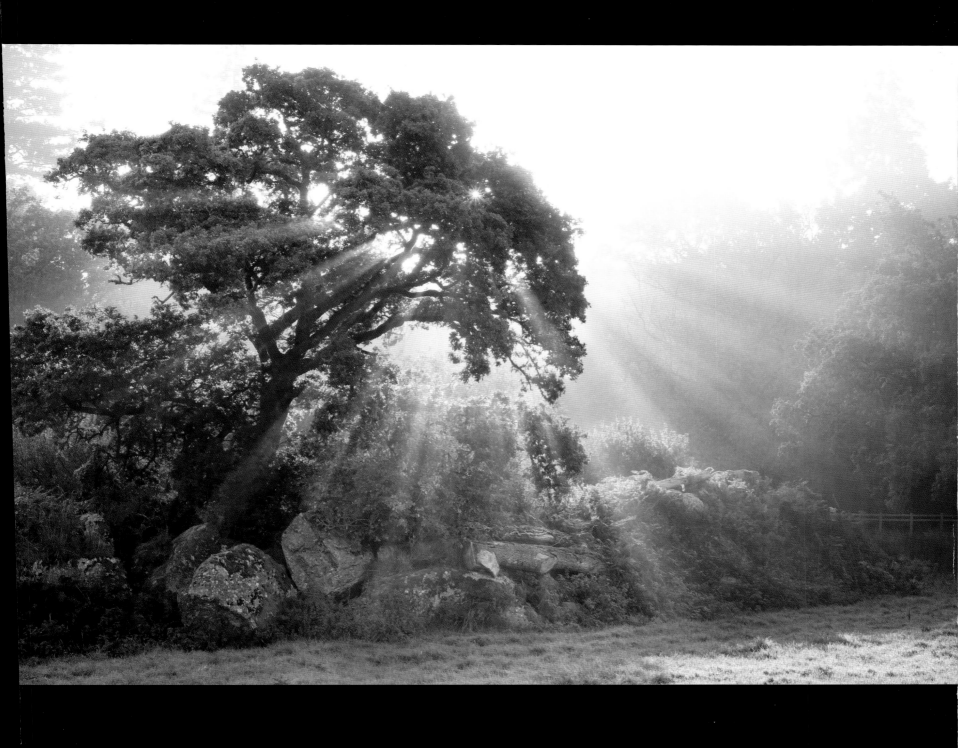

CONTENTS

STEEN DOESSING ···⟩

Distant Freighter, Portslade, East Sussex, England

This was a test shot with a new camera. Taken mid-morning, it was overcast with low-level cloud and occasional sun coming through. I didn't notice the freighter on the horizon until months later when I processed this.

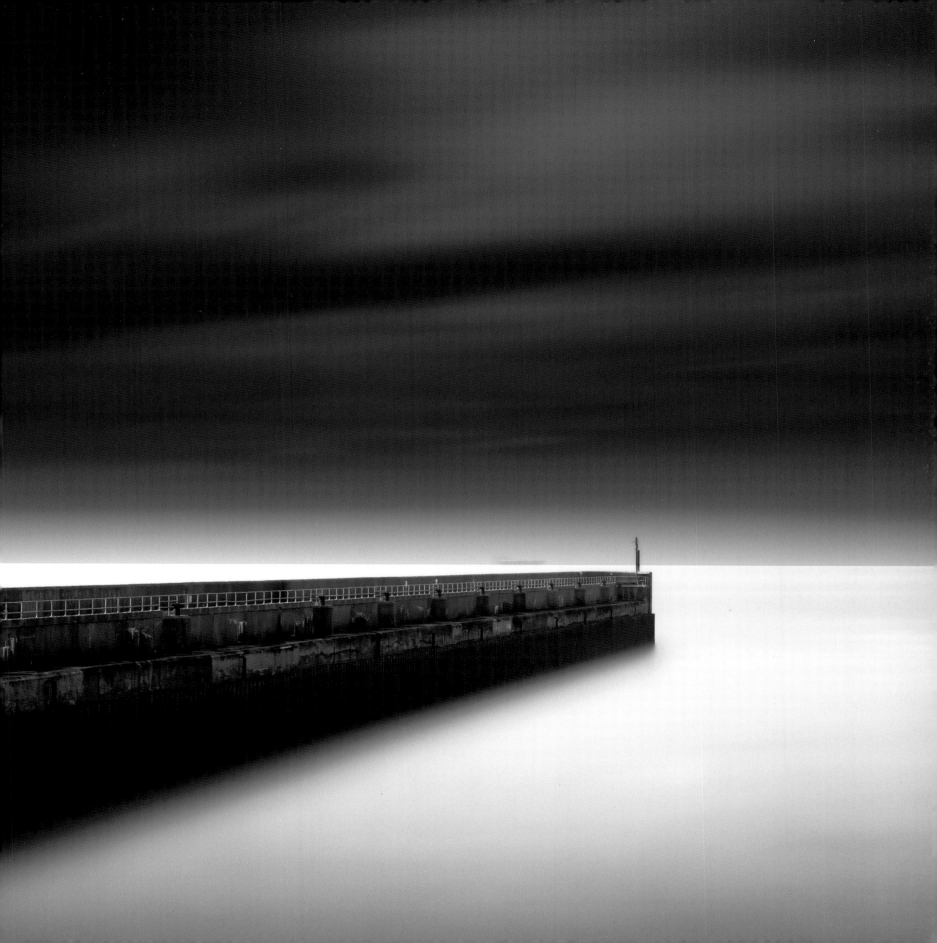

INTRODUCTION

THE COMPETITION

Take a view, the Landscape Photographer of the Year Award, is the idea of Charlie Waite, one of today's most respected landscape photographers. In this, its third year, the high standard of entries again proves that the Awards are the perfect platform to showcase the very best photography of the British landscape. This year's Awards would not have been possible without the invaluable help and support of Natural England and the English National Park Authorities.

Open to images of the United Kingdom, Isle of Man and the Channel Islands, Take a view is divided into two main sections, the Landscape Photographer of the Year Award and the Young Landscape Photographer of the Year Award. With a total prize fund worth £20,000 and an exhibition of winning and commended entries at London's National Theatre, Take a view has become a desirable annual competition for photographers of all ages.

All images within this book were judged by the panel as *Commended* or above, a high accolade given the total entry.

www.landscapephotographeroftheyear.co.uk
www.take-a-view.co.uk

THE CATEGORIES

Classic View

For images that capture the beauty and variety of the UK landscape. The rugged cliffs and endless beaches of the coastline, the majestic mountains of the highlands and the verdant splendour of the National Parks, recognisable and memorable – these are true classics.

Living the View

Featuring images of people interacting with the outdoors – working or playing in the UK landscape. From the energy of the northern fell race to the escapism of wild camping on rugged headlands or the bustle of our cities, these images illustrate the many ways in which we connect with our outdoor environment.

Your View

What does the UK landscape mean to you? Sometimes intensely personal and often very conceptual, the parameters of this category are far-reaching, with images showing a whole range of emotions and perspectives. Subjects vary from the frosty boughs of a tree in winter to the rushing crowds on London's Millennium Bridge.

Phone View

The key to this category is spontaneity. There may be no tripods or long lenses, but the great advantage of the camera phone is that it is always with you, so there are plenty of chances to capture the unexpected.

KEY SUPPORTERS

www.naturalengland.org.uk

www.nationalparks.gov.uk

WITH THANKS TO

AA Publishing
Epson UK
Light & Land
Bayeux
Amateur Photographer
Outdoor Photography
Calumet Photographic
Fujifilm
Campaign to Protect Rural England
Páramo Directional Clothing Systems
Cooltide Interactive

SPECIAL PRIZES

The English National Parks Award

For the best image of an English National Park entered into any category. The English National Park Authorities are currently as follows: Dartmoor, Exmoor, New Forest, Northumberland, Lake District, Peak District, North York Moors and the Yorkshire Dales, plus the Broads Authority, who have equivalent status.

Natural England's 'Landscape on your Doorstep' Award

For the photograph that best demonstrates how everyday landscapes matter. This award is open to all age groups and is for the image that captures an English landscape in close proximity to the entrant's home; 'low carbon' photography that best shows the accessibility of natural beauty.

FOREWORD

BY DR HELEN PHILLIPS,
CHIEF EXECUTIVE, NATURAL ENGLAND

LANDSCAPE PHOTOGRAPHER OF THE YEAR 2009

As we move inexorably towards a global society, with global problems to match, it is inevitable that our appreciation of the value of local identity, character and distinctiveness is rekindled. The beauty of the landscapes on these islands lies in their extraordinary diversity – the mountains and moors, sweeping rivers and glacial lakes, patchwork farmland and rugged coasts, sculpted city parks and neglected places too; land abandoned by people and reclaimed by nature.

This extraordinary range of places provides the antidote to the process of homogenisation that has standardised many of our high streets and housing developments over recent years. Each distinct place, however small, is special to someone.

Britain's landscapes have influenced the whole world – inspiring some of our greatest artists, composers, writers and poets such as Canaletto and Mendelssohn, as well as British icons including Constable, Britten, Hardy and Wordsworth. Across the globe you can see parks and gardens created and shaped from plans conceived and designed here.

The huge response to the third 'Take a view' competition underlines the enduring and widespread popularity of Britain's landscapes.

The famous landscape writer Professor W.G. Hoskins noted that: "The English landscape is the richest historical record we possess." These landscapes tell a vivid story of how, for centuries, nature and people have shaped each other's destiny. They are part of our cultural DNA and provide millions with spiritual fulfilment and places to relax and escape the rigours of the modern world, if only for a few precious moments.

The 'Take a view' competition has a vital role to play in the process of recording and remembering our history. In the age of high-quality, low-cost digital equipment, when printable photos can be taken on a £30 mobile phone, now everyone can add their memory, share their favourite place or cherished moment and add to our collective understanding of the changes taking place all around us.

This competition attracts submissions from every corner of the country – from hardened pros spending frosty hours on a desolate mountaintop waiting patiently for *that* moment, to the opportunistic snapper capturing that unexpected magical second

that transformed an otherwise mundane day. It reminds us that all landscapes matter. It reminds us too that Britain remains an extraordinarily beautiful place despite all the trauma inflicted on the natural world by a century of unfettered economic growth.

For Natural England to be co-sponsors, with the English National Park Authorities, of the Landscape Photographer of the Year 2009 is a great privilege, and an extremely timely one.

This year marks the 60th anniversary of the 1949 National Parks and Access to the Countryside Act, which led to the creation of our National Parks, National Nature Reserves and Areas of Outstanding Natural Beauty.

It is heartening to think that, in 1949, after the six dark and brutal years of the Second World War, when millions of lives had been lost and Europe's economy and infrastructure laid to ruins, the government of the day responded with this landmark Act – an ode to the beauty and wonder of the natural world packaged as legislation.

The landscape was relevant then to a nation traumatised by war. And it remains relevant now as we stand face to face with unprecedented economic and environmental challenges. The popularity of this photographic competition demonstrates the huge pleasure that people take from the natural world – exploring their local environment, recording it and sharing it with others.

Alongside safeguarding the places we have already – roughly a quarter of the country has legal protection – we need to invest in making sure that the natural world exists in everyday places, lights up everyday lives.

We need to recognise too that landscapes provide a huge range of services beyond beauty – they are our natural life-support system, filtering and storing water, holding fertile soils, locking in climate-changing carbon, soaking up flood water, and buffering coastal storms.

Our landscapes are ever changing – shaped by natural processes and human activity. But we are on the brink of change at an unprecedented scale and speed – land is in demand now more than ever and climate change threatens to redraw the map.

The power of the photograph is that it captures isolated moments in that process. It provides a unique point in time for both the photographer and the viewer to remember and enjoy.

This extraordinary collection of photographs reminds us of the natural riches that we still have. And provides a warning – let's look after them so others can enjoy taking their photographs of our landscapes in years to come.

THE ENGLISH NATIONAL PARK AUTHORITIES

PAUL HAMBLIN,
DIRECTOR, ENGLISH NATIONAL PARK
AUTHORITIES ASSOCIATION (ENPAA)

BRITAIN'S BREATHING SPACES

Landscape feeds us in so many ways. It can be the motivator to get us out and about to energise our bodies; it can open our minds, it can replenish our souls. Landscape touches us, strengthening our connection with the world around us. Such qualities were identified by those early champions of National Parks.

As we celebrate the 60th anniversary of the landmark National Parks and Access to the Countryside Act 1949, it is important to recognise the enduring and popular concept of our National Parks. They are certainly not alone in providing stunning landscapes but they do represent a concentration of landscape, wildlife and cultural heritage of huge significance. All great subject matter of course for the budding photographer!

The photographers featured in this book have demonstrated an outstanding ability to reflect on their surroundings and capture it through the lens. The images are an important antidote to our busy lives where the opportunities to sit back and simply 'be' can be rare. This is one reason why our National Parks have been branded 'Britain's Breathing Spaces'.

The English National Park Authorities are delighted to be sponsoring the Landscape Photographer of the Year competition alongside Natural England. We hope this book will help remind people that, in Britain, we are blessed with stunning landscapes of which we should be justly proud.

We should not forget though that behind each landscape lies a story. These are living landscapes, sculpted by human influence. They have changed too – sometimes dramatically, sometimes quite gradually through incremental and subtle variations. The task of National Park Authorities is to work with local communities, and with a wide range of interests and organisations, to manage that change in ways that protect landscape and keep our National Parks so special. And with ever increasing demands on our small island for development – and new pressures caused by climate change – the need for strong effective National Parks (and their cousins, Areas of Outstanding Natural Beauty) grows.

I hope you will join us in celebrating the vision of those who established our National Parks; in the creativity and skill displayed by the photographers shown here; and in the wonder of landscape and all it offers us. And then when you've done that, do a bit of exploring for yourself!

 Broads Authority
The Broads - a member of the
National Park family

The Broads is Britain's largest protected wetland and is one of Europe's most popular inland waterways. Its fens, wet woodlands, grazing marshes, 63 broads and six rivers provide unique habitats for a huge range of rare species. The broads or shallow lakes were formed in medieval times when peat was dug out to use as fuel for heating and cooking. Water levels rose and the peat diggings flooded, forming the broads. The Broads Authority was set up in 1989, with responsibility for conservation, planning, recreation and waterways.
www.broads-authority.gov.uk

 Dartmoor is the largest open space in southern England. It has wild open moorland, granite tors and wooded river valleys. Dartmoor's landscape is among the richest in western Europe in terms of its archaeological remains. Walking is perhaps the most popular way of enjoying Dartmoor National Park and the public can wander freely on foot or horseback over Dartmoor common land and other access land which amounts to around half of the National Park area.
www.dartmoor-npa.gov.uk

 Because of its accessibility and position at the heart of England, the Peak District is one of the most heavily visited National Parks in the world. In landscape terms there are two distinct Peak Districts: the White Peak – which takes its name from the underlying limestone rocks and the Dark Peak – named after the millstone grit rocks. The highest peak in the National Park is Kinder Scout, at 636m. It was the site of a mass trespass in 1932 – an event that helped spark the conservation movement that led to the creation of the National Parks.
www.peakdistrict.gov.uk

 Spectacular sea cliffs, a wealth of ancient woodland and secluded dales combine with the largest tract of heather moorland in England to give a welcoming landscape of wonderful variety. This is ideal walking and cycling country, with a good network of paths and tracks for all abilities, including the Cleveland Way National Trail. Ruined abbeys and moorland crosses abound, while castles and early industrial treasures dot the landscape. The friendly communities are distinctive too; fishing villages perched on the cliff sides and farming villages in the dales.
www.moors.uk.net

 The New Forest National Park is a unique landscape of ancient woodland, heather-covered heath, wide lawns, coastal saltmarsh and picturesque villages. It is one of the last places in the south-east of England to offer a sense of wildness and tranquillity. It is home to an extraordinary variety of plants and wildlife as well as the famous New Forest pony. The National Park was established in March 2005 and it was the first to be created in England for nearly 50 years.
www.newforestnpa.gov.uk

 YORKSHIRE DALES
National Park Authority

The Yorkshire Dales landscape has many moods; it can be wild and windswept or quietly tranquil. It includes some of the finest limestone scenery in the UK, from crags and pavements to an underground labyrinth of caves. Stone-built villages sit amongst traditional farming landscapes of field barns, drystone walls and flower-rich hay meadows. With 20 main dales, it straddles the central Pennines in North Yorkshire and Cumbria.
www.yorkshiredales.org.uk

 Northumberland National Park Authority

Officially the most tranquil place in the country, Northumberland National Park is 400 square miles of breathtaking vistas, crystal clear streams and rich wildlife havens – it also has some of the darkest night skies. Beginning at Hadrian's Wall World Heritage Site, it runs north through the picturesque valleys of the Rivers North Tyne, Rede and Coquet to the awe-inspiring Cheviot hills with their endless, traffic-free horizons. The remains of 10,000 years of human life and work can be seen and touched; from prehistoric rock art to early industry.
www.northumberlandnationalpark.org.uk

 EXMOOR NATIONAL PARK

There are few places that have such a variety of beautiful, unspoilt scenery packed into such a relatively small space as Exmoor National Park. The tallest sea cliffs in England give way to wide pebble beaches and small harbours. Heather and grass moorland contrast with deep wooded valleys. Villages and small towns cater for the vibrant local communities and visiting public alike. Exmoor is home to the finest red deer herd in the country and the Exmoor ponies, a recognised rare breed, live wild on the open moor.
www.exmoor-nationalpark.gov.uk

 Lake District National Park

With England's highest mountain, longest and deepest lakes, sweeping fells and rugged coastline, there is little wonder England's largest National Park attracts 12 million visitors a year. The Lake District is home to 42,000 people, as well as rare wildlife such as red squirrels and ospreys. There are more than 3,000 km of public rights of way for differing levels of ability and outstanding opportunities for anglers, climbers, canoeists, sailors, horse riders and cyclists.
www.lake-district.gov.uk

THE JUDGES

Damien Demolder

Amateur Photographer Magazine Editor

Damien Demolder is the editor of *Amateur Photographer* magazine, the world's oldest weekly magazine for photography enthusiasts, and a very keen photographer too. He started his photographic professional life at the age of 18, but since taking up the editorship of the magazine he has been able to return to his amateur status – shooting what he likes, for his own pleasure.

With interests in all areas of photography, Damien does not have a favourite subject, only subjects he is currently concentrating on. At the moment his efforts are going into landscapes and social documentary. When judging photography competitions Damien looks for signs of genuine talent or hard work. Originality is important, as is demonstrating a real understanding of the subject and an ability to capture it in a realistic manner. He says 'Drama is always eye-catching, but often it is the subtle, calm and intelligent images that are more pleasing and enduring.' Damien's work can be seen at damiendemolder.com

Charlie Waite

Landscape Photographer

Charlie Waite is firmly established as one of the world's most celebrated landscape photographers. He has published 28 books on photography and has held over 30 solo exhibitions across Europe, the USA, Japan and Australia, including three very successful exhibitions in the gallery at the OXO Tower in London, each visited by over twelve thousand visitors.

His company, Light & Land, runs photographic tours, courses and workshops worldwide that are dedicated to inspiring photographers and improving their photography. This is achieved with the help of a select team of specialist photographic leaders.

Charlie is the man behind the Landscape Photographer of the Year Award and this ties in perfectly with his desire to share his passion and appreciation of the beauty of our world.

Kos Evans

Marine & Sailing Photographer

Kos Evans is an award-winning marine sports photographer with a photographic career spanning more than 27 years. Born in England, Kos began taking photographs at the age of five with her father's Olympus Pen-FT. She shot her first powerboat at the age of 17, while still at school, when she was asked to cover a racing event on Lake Como in Italy. She hasn't had the silt, or the salt, out of her hair since!

She got her first big break in 1983 when Peter De Savary invited her to photograph his Victory America's Cup campaign. An acknowledged pioneer in her field, Kos is renowned for her extraordinary trademark masthead shots, taken some 200ft from the deck and often involving placing herself in real danger – dangling upside down from the masthead. Her aim is to capture the best, most challenging and most elusive photo, working against the elements to reflect her love – and awe – of the ocean in all its unfathomable majesty. Her work can be found at kospictures.com

Paul Hamblin

*Director
ENPAA*

Paul Hamblin is the Director of the English National Park Authorities Association (ENPAA). The Association provides a collective voice for the nine National Park Authorities within England on a range of policy issues. Paul joined the Association from its start in 2006 and has been inspired by the excellent work and the motivation of the people who work in National Parks. He has visited all of the National Parks in the UK and fully subscribes to them being truly 'Britain's Breathing Spaces'.

In a world where time can be a precious resource, the family of National Parks provide an opportunity for reflection, for creativity and enjoyment. Paul believes it is important that these landscapes are protected for the benefit of everyone, whether a professional photographer or an occasional walker. Paul is used to big cities, having grown up in London and studied in Manchester, but frequently visits the British countryside and feels a real strength is its diversity and distinctiveness.

Patrick Llewellyn

Assistant Picture Editor
The Sunday Times Magazine

Patrick Llewellyn has been at *The Sunday Times Magazine* since 2004. His love of photography began when, aged eight, he was given a Pentax Spotmatic camera, through which he viewed much of his early life. He learnt his trade freelancing as a picture researcher on leading newspaper titles; *The Independent*, *The Sun* and *The Times*, before taking on his current role.

Patrick works closely with the world's top photographic agencies, commissioning some of the finest reportage, art and portrait photographers working today. He feels most comfortable when dealing with images of the urban landscape, like that in which he grew up, but it is often imagery from nature that astounds him most.

John Langley

National Theatre Manager

John Langley is the Theatre Manager of the National Theatre, on London's South Bank. Alongside its three stages, summer outdoor events programme and early evening platform performances, the National has become renowned for its full and varied free exhibitions programme. Held regularly in two bespoke spaces, these exhibitions are an important, ongoing part of London's art and photographic scene. John is responsible for these shows and has organised over 300 exhibitions and played a significant role in presenting innovative and exciting photography to a wide and discerning audience.

When escaping from the urban bustle of the capital, John particularly loves the coastal scenery of the United Kingdom, with the North Norfolk Coast and Purbeck in Dorset being particular favourites.

David Watchus

Publisher, AA Media

David Watchus took over as Publisher at the AA at the beginning of 2006, having worked in a variety of roles within the business. His vision is to build on AA Media's strong base in travel, lifestyle and map and atlas publishing, areas in which the AA has many market-leading titles, while increasing the presence of AA Media in the wider illustrated reference market.

David's involvement in the Landscape Photographer of the Year competition is core to this vision and is also indicative of the quality of both production ideals and editorial integrity that is the cornerstone of the book-publishing ethos within AA Media.

Professor David Macdonald

Wildlife Conservation Research Unit

David Macdonald is the Director and founder of the Wildlife Conservation Research Unit (WildCRU) at Oxford University – one of the largest and most productive conservation research institutes in the world.

He has been an active wildlife photographer all his life and his photos are widely published – notably, the famous Smithsonian meerkat poster. David has won many prestigious awards, including the Dawkins Prize for Conservation and Animal Welfare. Among his award-winning TV documentaries are *The Night of the Fox* and *Meerkats United*.

His interests within Britain's natural world include being on the Boards of WWF-UK, Earthwatch-UK and the Wildfowl and Wetlands Trust. He is Chairman of the Darwin Advisory Committee for DEFRA, a Board Member for Natural England and is Chairman of Natural England's Science Advisory Committee. David is a Fellow of the Royal Society of Edinburgh.

PRE-JUDGING PANEL

The pre-judging panel has the difficult task of selecting the best images to go through to the final shortlist. Every image entered into the competition is meticulously analysed before the final list is put in front of the final judging team.

Julie Chamberlain, Photographer

Julie has had a passion for photography for as long as she can remember. She grew up in a small town on the edge of the New Forest National Park, which provided her with plenty of photographic opportunities from an early age. Her professional career has been primarily within the stock photographic industry and she started out in the agency Landscape Only, which, as its name suggests, specialised in landscape photography and represented some of the UK's best-known names. From picture editor to picture research, Julie has worked in a variety of creative roles and has also had a number of her own images published; a picture of moody Derwentwater that appeared on the cover of a best-selling novel being her favourite. Julie is based in Brighton but enjoys travelling around the whole of Britain, taking pictures on the way. She has recently taken up sailing and is co-owner of a small yacht based off the Sussex coast and this has enabled her to get a whole new perspective on the beautiful southern coastline.

Trevor Parr, Parr-Joyce Partnership

Trevor's love of photography started at art college. He became an assistant to a number of fashion photographers before setting up on his own in a Covent Garden studio. He moved to the Stock/Agency business, seeking new photography and acting as art director on a number of shoots. In the late 1980s, he started the Parr-Joyce Partnership with Christopher Joyce, marketing conceptual, landscape and fine art photography to poster, card and calendar companies. Trevor also owned a specialist landscape library that was later sold to a larger agency. He now concentrates on running Parr-Joyce from his base in the south of England.

Martin Halfhide & Robin Bernard, Bayeux

Robin and Martin are co-owners and directors of Bayeux, a professional imaging company that opened in 2001 and is now the largest in London's West End. With an extensive background in the pro-lab industry, both have experience in many technical areas. They were at London-based Ceta in the 1980s and then went on to be responsible for photographer liaison at Tapestry during the 1990s. Although very much attached to a London lifestyle, Robin escapes to the country at regular intervals, particularly the English Lakes. He likes both powerful, dramatic landscape images and minimal understated images – but is less enthusiastic about those in between. He dislikes 'copy-cat' images that are imitations of original styles. Martin favours the wilds of Scotland and visits every year.

and **Charlie Waite**

AWARDS DIRECTOR: Diana Leppard

Charlie Waite wishes to express his immense gratitude once again to Diana Leppard, the Awards Director, for all her noble work on Take a view 2009.

GRAHAM McKENZIE-SMITH ···⟩

The Roaches, Staffordshire, England

Being more used to the harder light of my homeland Scotland, I was taken by the softer light during a brief visit to the Peak District. The Roaches are a unique geological feature, popular with climbers, and I was rewarded with one on top of the rock on this beautiful summer's evening.

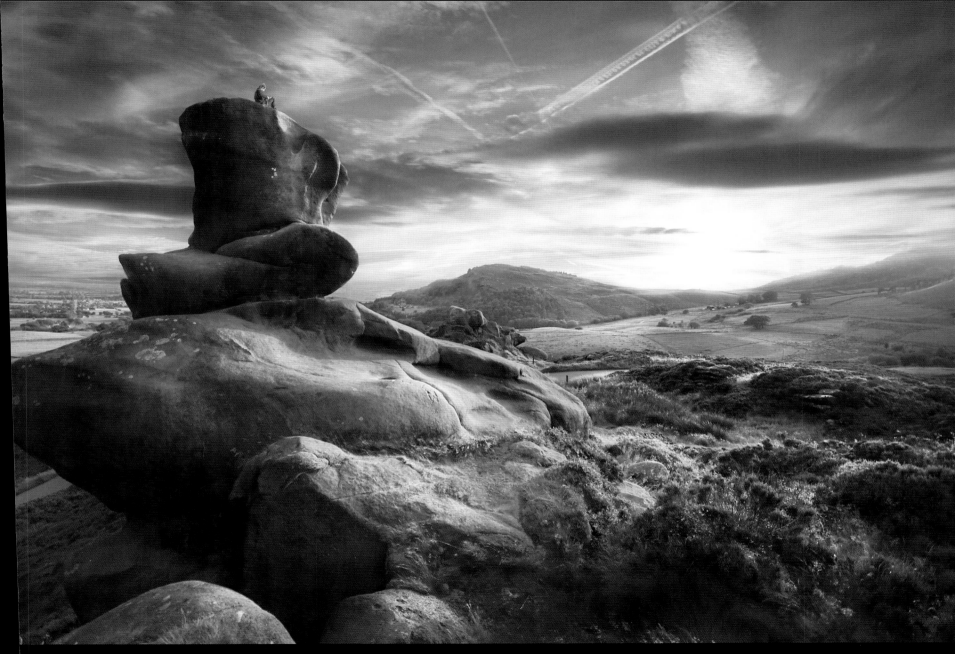

LANDSCAPE
PHOTOGRAPHER OF THE YEAR

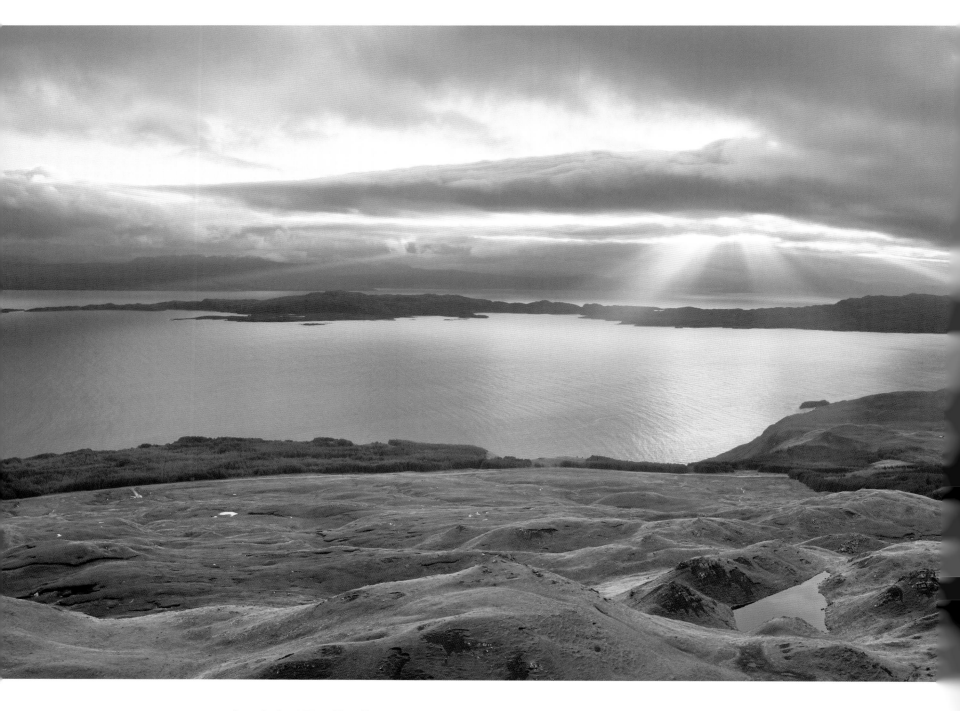

LANDSCAPE PHOTOGRAPHER OF THE YEAR 2009

OVERALL WINNER

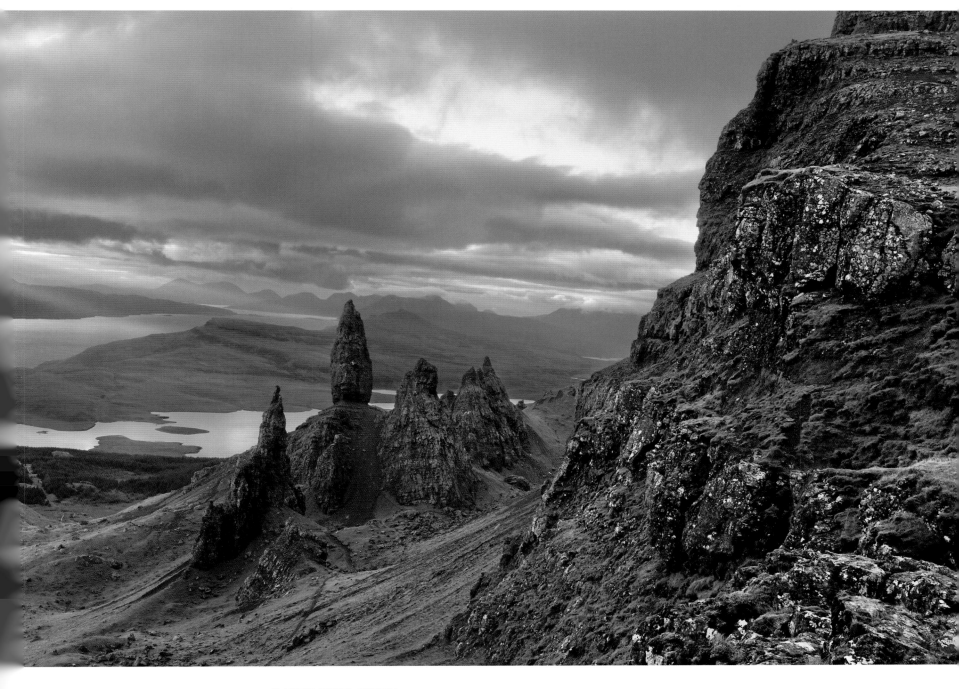

⁜ EMMANUEL COUPE

Sunrise over the Old Man of Storr, Isle of Skye, Scotland

I reached the Old Man while it was still dark, hoping that there might be some interesting light later on, but I surely did not expect the light show that ensued. Shortly after sunrise, and while the sun was still at a low angle, rays started to pierce through the clouds, spreading all across the Sound of Raasay, completing this classical Skye view in the most dramatic way.

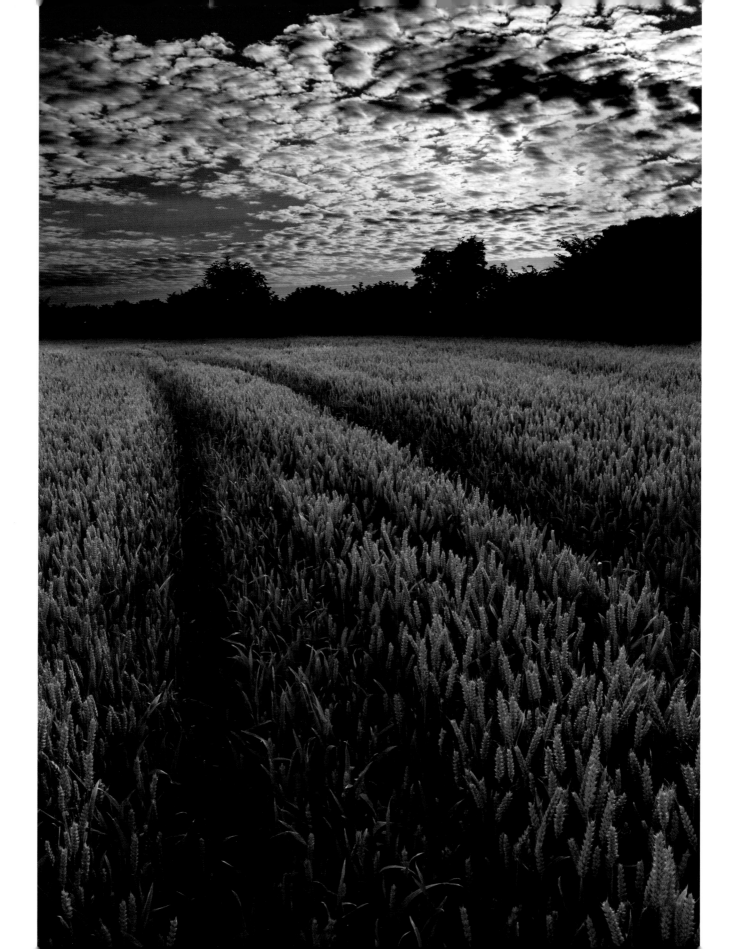

YOUNG LANDSCAPE PHOTOGRAPHER OF THE YEAR 2009

OVERALL WINNER

JON McGOVERN

Wheat field at dawn, Derby, England

I woke up and saw this amazing sky from the window, so I went to a nearby wheat field to create this photo. I've always loved the sweet lighting at dawn, so the mackerel sky was an added bonus.

CLASSIC VIEW
adult class

CLASSIC VIEW ADULT CLASS WINNER

JOHN PARMINTER ···⟩

Divided Glens, Buachaille Etive, Rannoch Moor, Scotland

You can't help but be impressed by the bulk of Buachaille Etive Mor as you travel north across Rannoch Moor towards Glen Coe. It stands guard at the entrance to Glens Etive and Coe and I remember, as a 17-year-old on my first Scottish camping trip, how taken aback I was at my first sight of it. I've passed it many times now, en route to other destinations, and always get a feeling of grandeur from it.

Judge's choice Charlie Waite

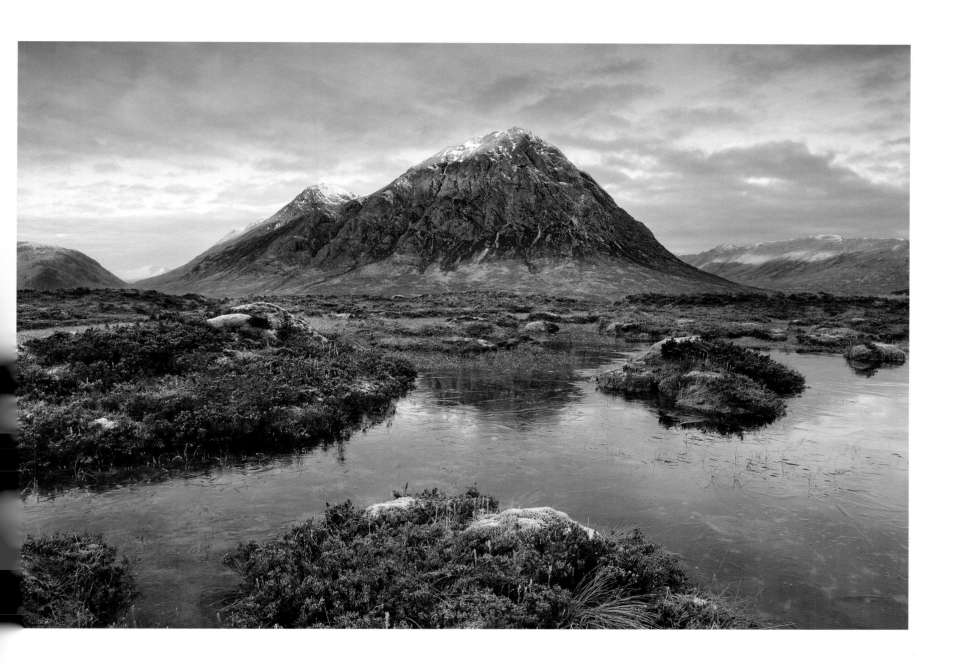

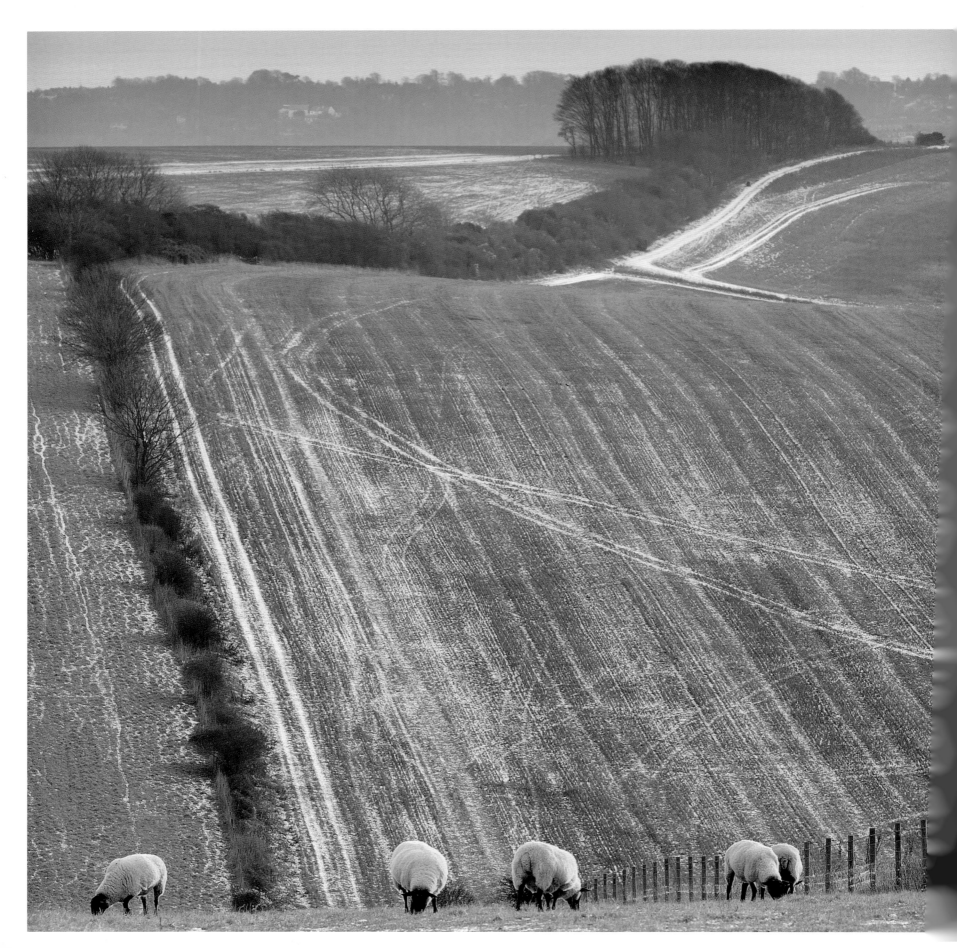

CLASSIC VIEW ADULT CLASS RUNNER-UP

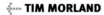 **TIM MORLAND**

The South Downs near Clayton, West Sussex, England

This was taken looking south from a spot near the Jack and Jill windmills. It was the end of a cold January afternoon and there was a window of only a few minutes before the light disappeared.

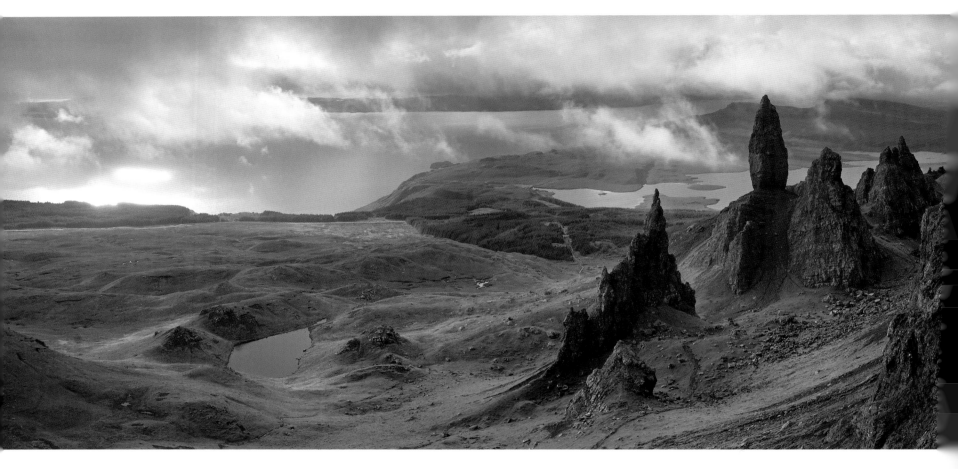

ALEX NAIL HIGHLY COMMENDED

JACKIE WU ···› HIGHLY COMMENDED

Broken Skye, the Old Man of Storr, Scotland

I try to avoid iconic locations when possible; I don't like the idea of replicating the work of others in any way at all if I can avoid it. The Storr was just an irresistible subject, jagged pinnacles of rock set against one of the most inspiring views in the world; you don't need to be a photographer to be amazed. I headed up for sunrise only to be shrouded in cloud for a couple of hours. As the sky broke up a dramatic scene was revealed, a perfect opportunity to capture something a little different from the other shots I had seen.

Billinghurst, West Sussex, England

Taken atop a bridge during sunset at Billingshurst station, West Sussex. I waited until a train approached before pressing the shutter.

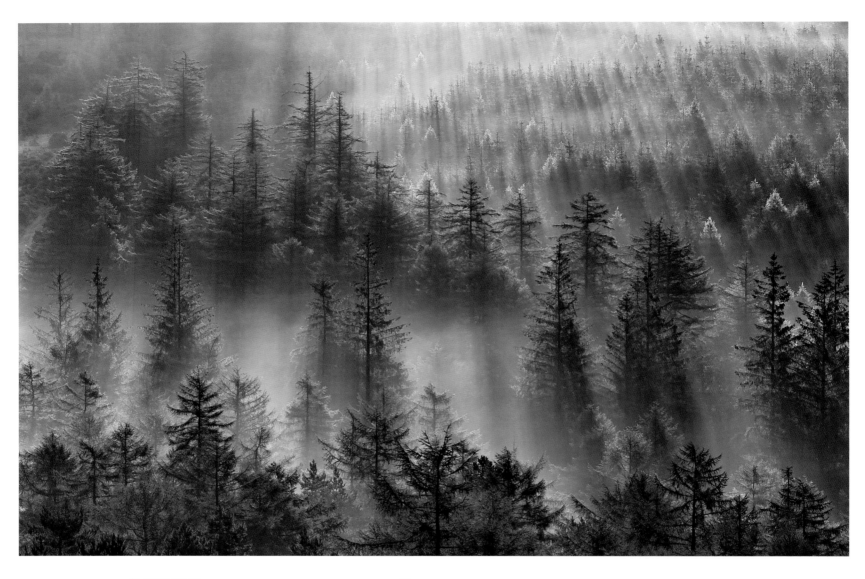

🌲 ALEX NAIL HIGHLY COMMENDED

Burrator Plantation in summer, Dartmoor, Devon, England

I dragged myself out of the tent at 5am after an overnight camp at Burrator Reservoir.
As the sun rose and the light became stronger I was ready to pack up, having already
captured the shot I came for, but I sat around for a while, eating breakfast and taking in
the view. I was glad I did; the sun started to light up the mist between the trees behind me
creating a wonderful scene. I framed the image to suggest an alpine forest, rather than a
small plantation.

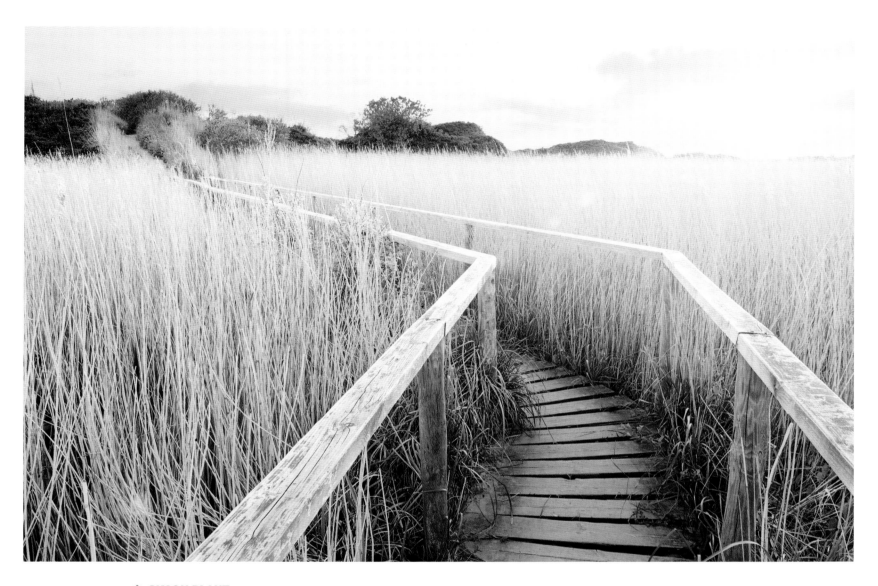

SIMON PLANT

The Walkway, Burnham-on-Sea, Somerset, England

This image was taken near my home town of Burnham-on-Sea. The walkway is part of a public path that is close to a golf course fairway. It goes over a reed bed and a sand dune before finally reaching the beach, overlooking the Bristol Channel. It's a great photographic location and this has become one of my best-selling fine art prints. Ironically, compared to some of my work, this image has had very little post-production work carried out upon it, apart from minor adjustments to colour and exposure.

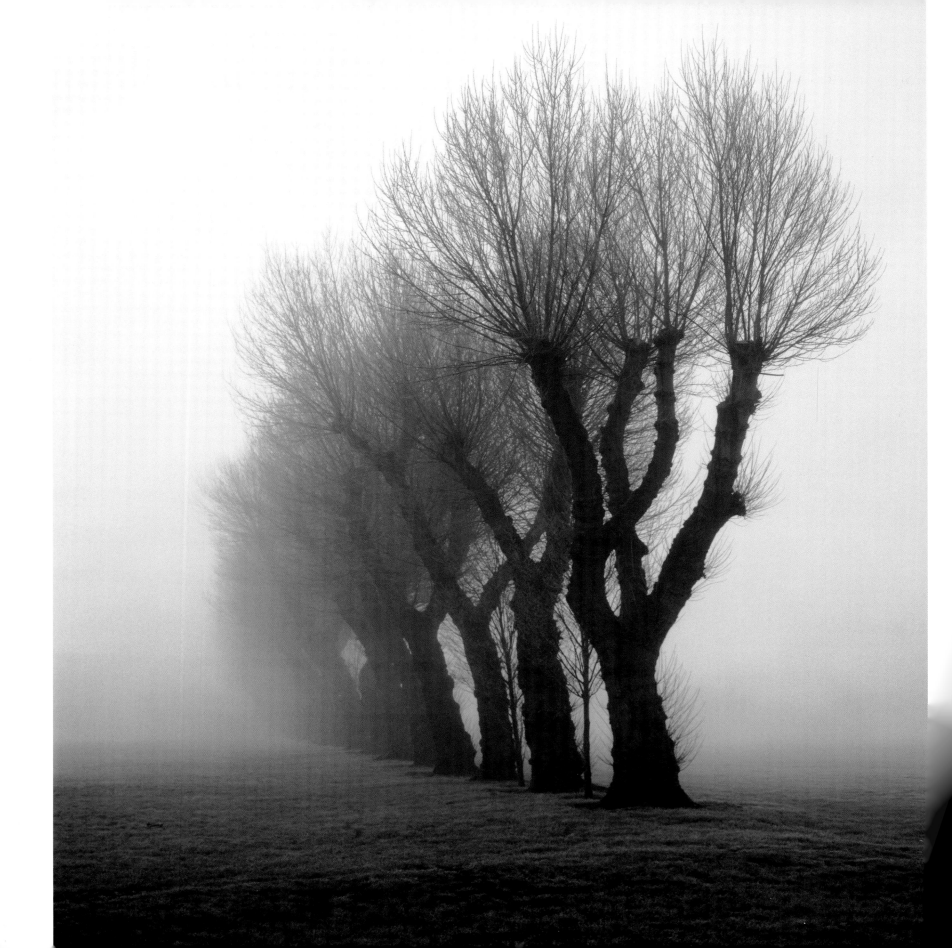

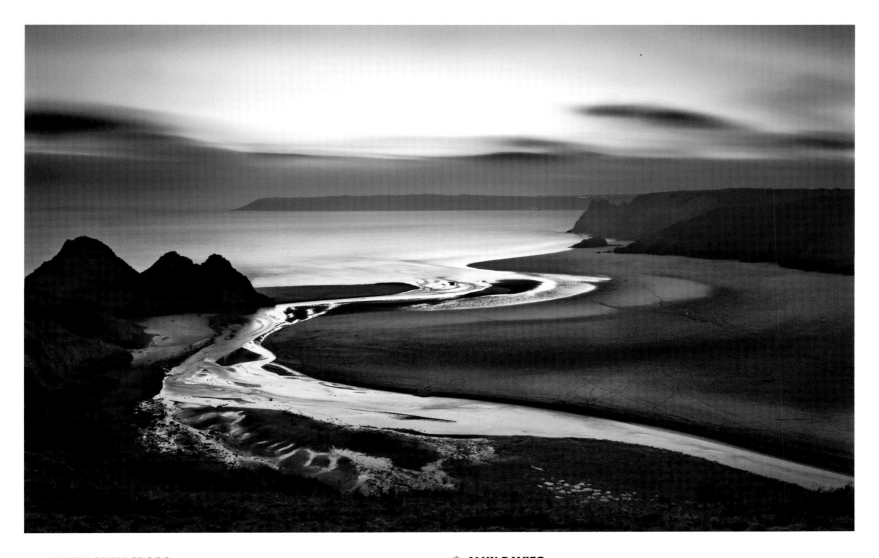

MARTIN SHALLCROSS

Park, near Manchester, England

Taken on a crisp, Sunday morning at my local park, several months after initially noticing the striking composition of the uniform trees.

ALUN DAVIES

Three Cliffs Bay, Gower, Wales

On a bitterly cold afternoon in December, I walked along the cliff-top path from Southgate on the Gower peninsular towards Three Cliffs Bay. I had pre-visualised this shot during a previous visit and so with full outdoor and photo kit and all the tide tables, sunset times, phases of the moon and weather forecasts the internet could provide, I travelled the few miles to the bay. I spent some time there exploring and explaining to curious youngsters that 'Yes' all the kit was necessary. I then made the arduous climb back up the dunes to regain the cliff top just as darkness descended. I composed the shot with black and white in mind aiming to convey shape, form and mood. Moonlight bathed the bay and highlighted Pennard Pill as it meandered to the sea guarded by the three iconic limestone cliffs that give this stunning location its name.

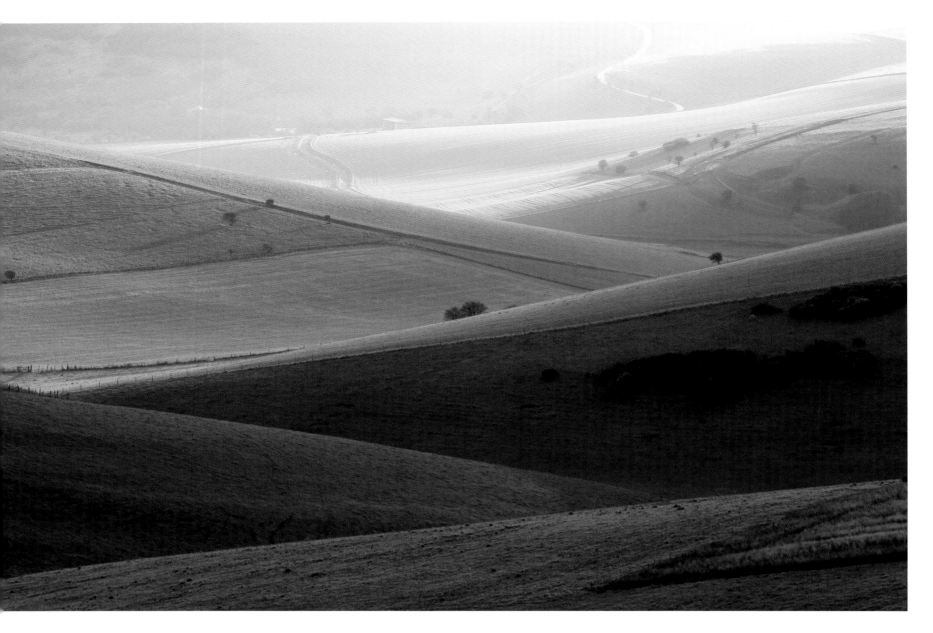

✝ SŁAWEK STASZCZUK

South Downs, East Sussex, England

I moved to Brighton a few years ago from Poland and the difference in the landscape
character of Sussex, as compared to what I was used to, spurred me on photographically.
I visit the same places dozens of times as the colours and textures of the land are always
changing. This picture was taken on Christmas Day, on a visit to the Downs near Falmer.

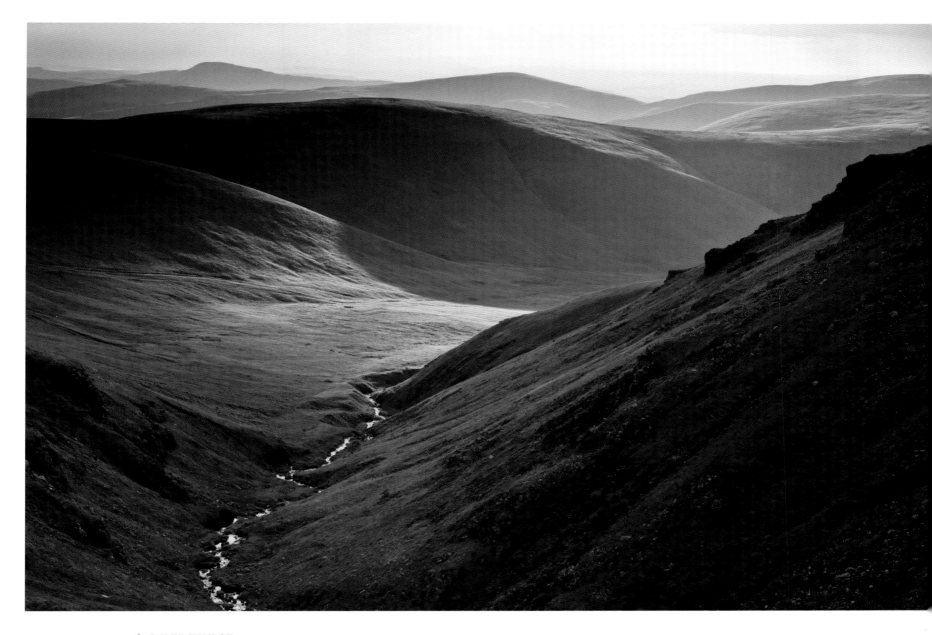

✝ DAVID TAYLOR

College Valley in the Cheviot Hills, Northumberland, England

I seem to get rained on a lot when I'm out and about creating photographs and was thoroughly wet after an afternoon exploring Henhole Crags at the top of the College Valley in the Cheviot Hills. With boots squelching, I was on my way back to the car when the weather broke and the valley below was lit theatrically, just for me! I managed to set the camera up in record time to capture the sight before me. And then, grinning madly, I continued on my way, still wet but now glowing.

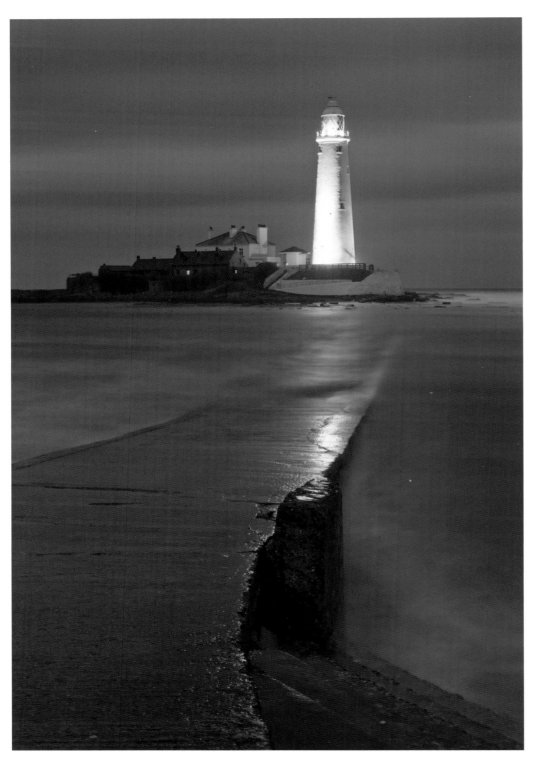

DAVID TAYLOR

St Mary's Lighthouse, Whitley Bay, Tyne & Wear, England

On a whim, I decided to drive to St Mary's Lighthouse to photograph it floodlit at dusk. What I hadn't anticipated was the gale-force wind blowing in from the North Sea! Within minutes I was drenched and the camera was in danger of toppling over, even though I was as low to the ground as the tripod would allow. It was worth the cold and wet to capture the drama of the location, though. And I suspect I was less cold and wet than the fisherman I saw out on the island.

IAN CAMERON ···⟩

Crimson Chill, Loch Achanalt, Strathbran, Scotland

With temperatures dipping to minus 23 degrees Celsius overnight, an intense hoar frost had coated every branch, twig and stem of grass. I positioned myself near the outflow of a river that hadn't quite frozen solid. Normally a difficult walk, the boggy ground had, on this occasion, turned to concrete. I settled down and watched, mesmerised, as the first fingers of dawn uncurled and painted the sky with a rosy glow of astonishing luminosity. The juxtaposition of hot and cool colours was in perfect harmony.

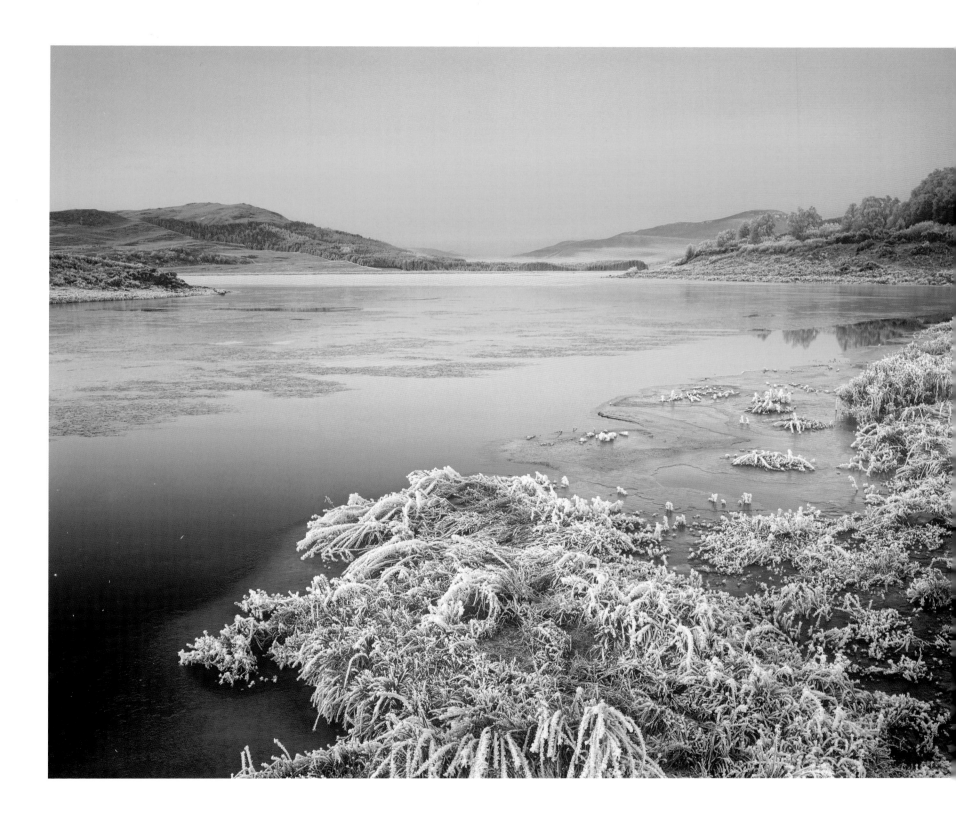

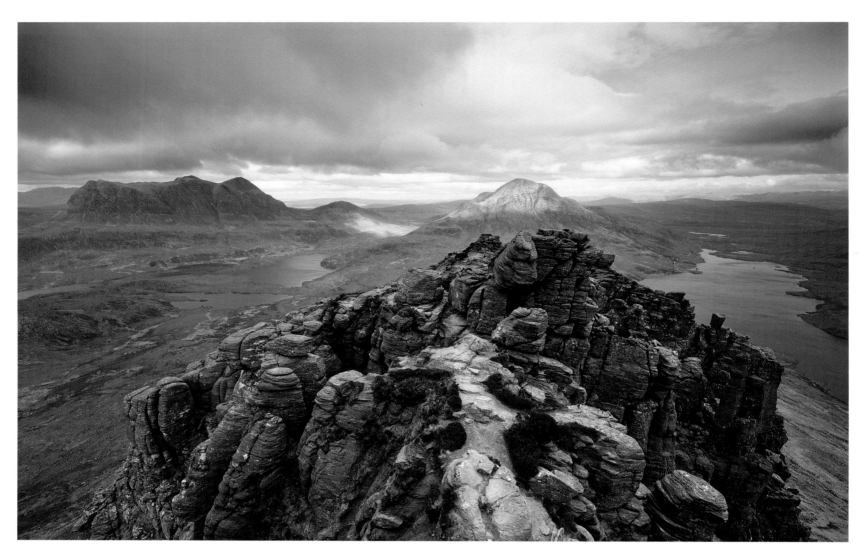

JOHN PARMINTER

Walk on air, Stac Pollaidh, Wester Ross, Scotland

A diminutive peak, but one of the best! I had been walking and photographing most of the day in the An Teallach area and was feeling a bit tired but made the effort to travel to and climb Stac Pollaidh for sunset. I'm glad I did as the views from the summit ridge blew me away. It may not rank as one of the highest of Scottish mountains but its easy access, pleasant climb and stunning scenery make it an absolute gem. This is the view from the summit ridge across to Cul Mor and Cul Beag; a little precarious as there was a buffeting wind to contend with.

CHRIS McILREAVY ⋯⋙

From the summit ridge of Blencathra at sunset, Cumbria, England

It is 3.20pm on Christmas Day. I am gazing south towards Great Dodd and Helvellyn from the summit ridge of Blencathra in the Lake District National Park. Light from the setting sun is exploding across the valley below and bathing the hills beyond in a gold and orange glow. Just a hint of Thirlmere can be seen beyond St John's in the Vale. As I press the shutter, I am aware that across the country at this moment millions of people are sitting on their sofas watching TV. I could have stayed at home too but here I am in the Lake District with a camera and looking at this view. Where would I rather be?

The English National Parks Award – Overall winner
Lake District National Park Authority – Best image

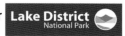

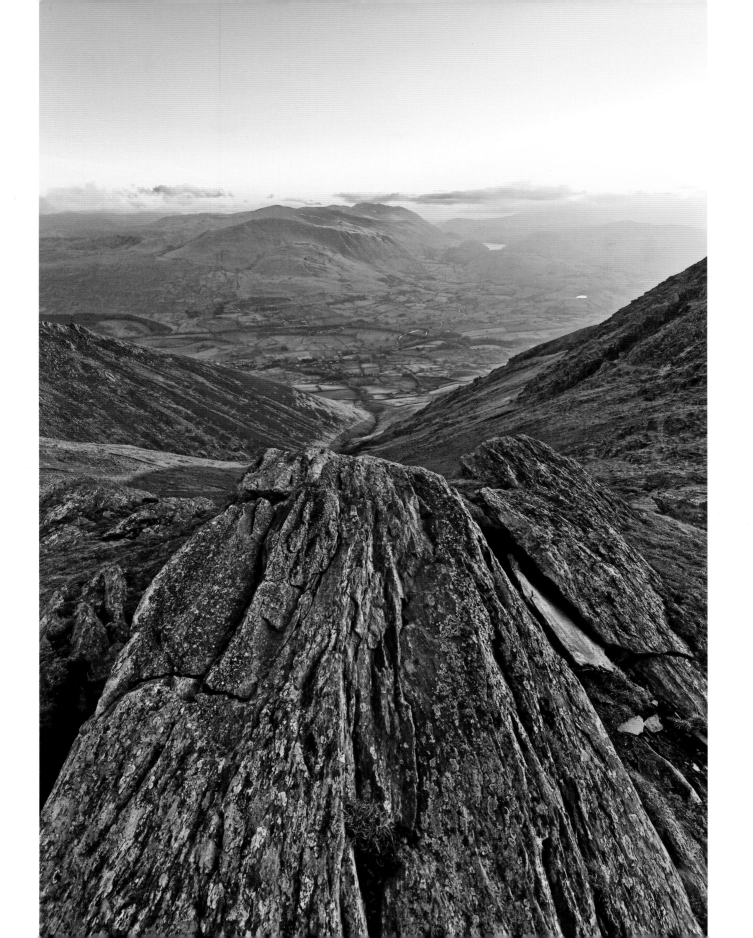

ANDREW WHITAKER

Newcastle Quayside, Tyne & Wear, England

I'd been going to photograph the Quayside quite regularly but was very conscious that most shots I was taking couldn't convey the drama of the place and indeed what the human eye actually sees when down there. I had exactly the kind of shot I wanted to take in mind, and knew that in order to do it I had to be there ready at least half an hour before sunrise when the water would be at its stillest and the lights from the buildings on. I wanted to photograph from this viewpoint mainly because the three bridges that feature are the oldest but also because I was very keen to try something new. It is a much-photographed area but experimenting with new perspectives and ways of doing things is what makes photography, and in particular digital, all the more exciting.

KEVIN SKINNER ····◆

White horses at Ness, Rubha Robhanais, Isle of Lewis, Scotland

Sometimes you can remember vividly the conditions when you took an image and why you were inspired to click the shutter. This is one of the most vivid for me where I can still taste the spray and smell that salt air. These waves were relentlessly rolling in and some were lapping the tops of the cliffs that are 20 to 30 metres high! It was one of those moments that leaves a permanent imprint in your mind. I used black and white to emphasise the spray, tones and, indeed, the exquisite light that can sometimes happen when the sun peaks through the clouds unexpectedly.

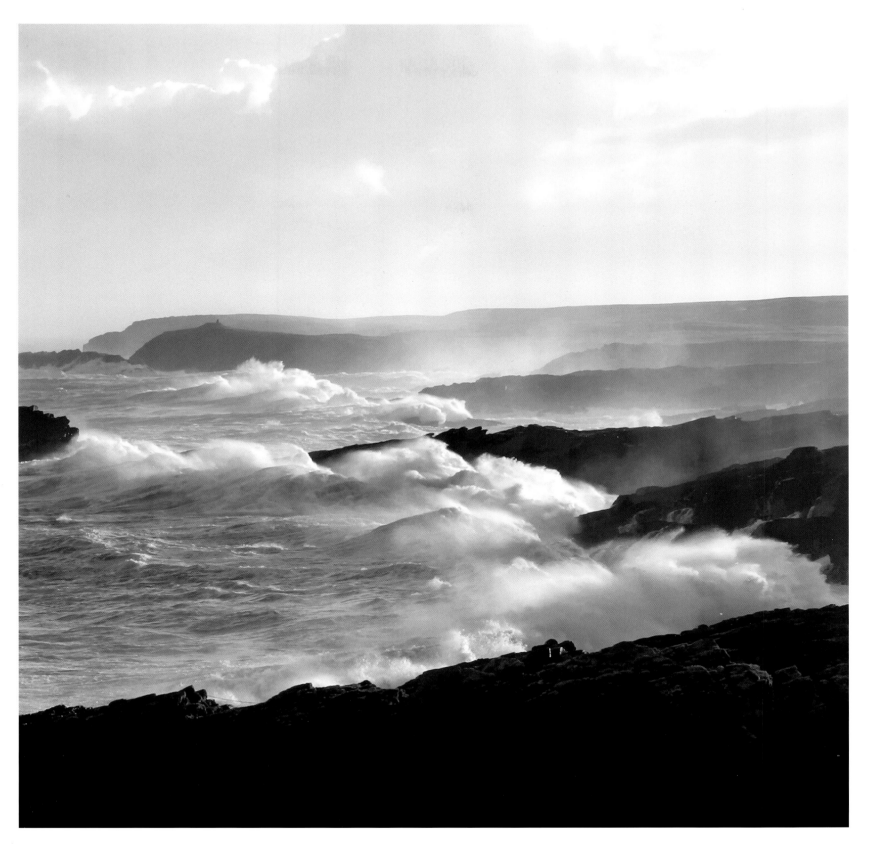

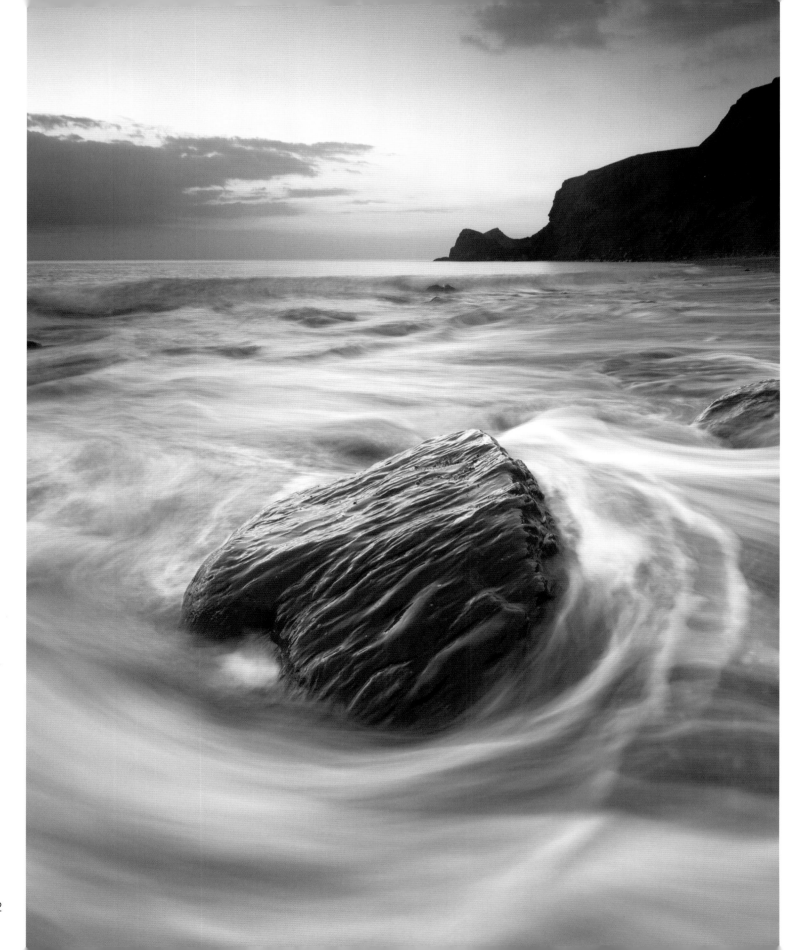

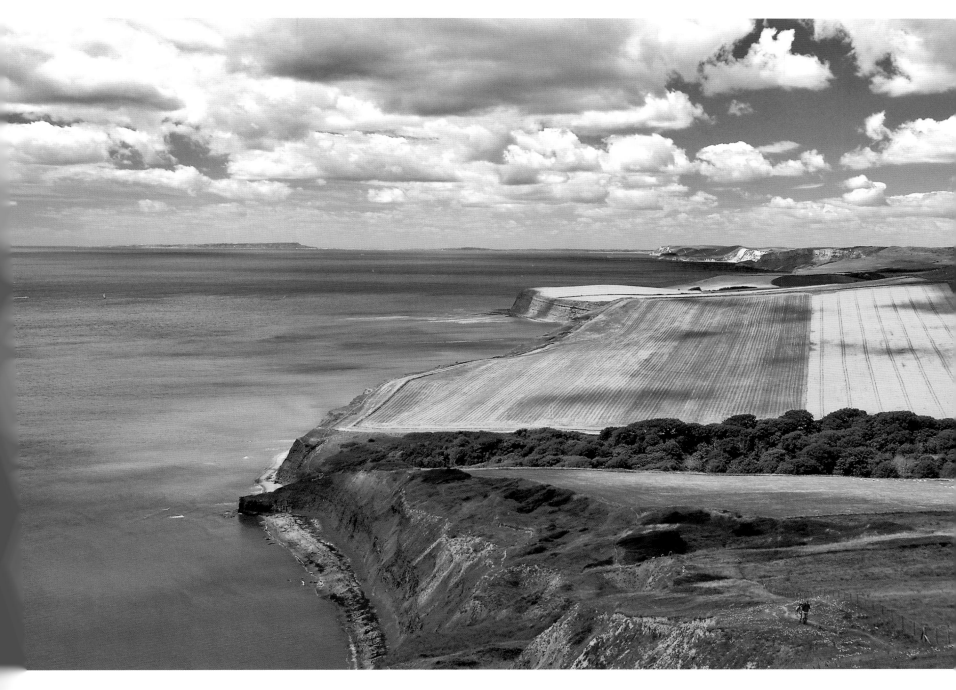

⟵··· JAMES PARREN

On the turning tide, Strangles Beach, North Cornwall, England

This is one of my favourite beaches in Cornwall; swept by the Atlantic and reached by a steep and winding descent, ending with a rope, to the black and white pebbled beach. This slate rock, reflecting the post-sunset light, was caught in the swirling, retreating tide.

⸸ PIOTR PIASECKI

From Houns-tout Cliff, Dorset, England

This image was captured whilst I was hiking along the Dorset coastline. The sun had broken through the cloud cover to create spectacular shadow play across both golden farmland and emerald sea. I had a gorgeous vista from the summit of Houns-tout Cliff. For me, this image is proof that Mother Nature creates the most unforgettable theatre.

43

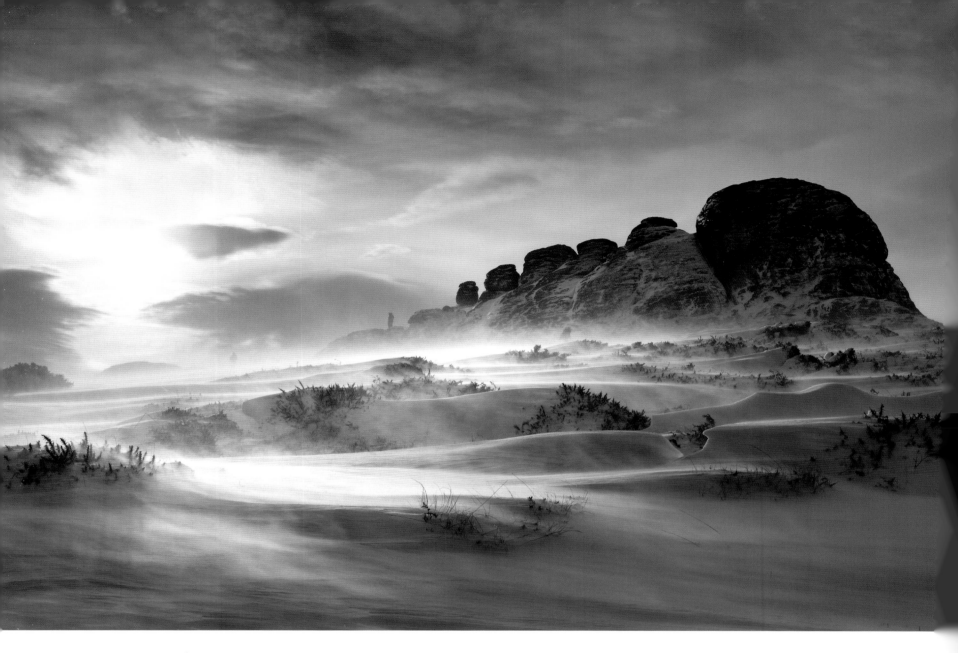

🕈 DAVID CLAPP

Space Walk, Haytor, Devon, England

After 20 years of wishing, Devon was finally blanketed with plentiful snow this year. With a location wish list as long as my arm, the problem was access. Moorland roads were mostly impassable, so my adventure began on foot at Haytor, undeniably Dartmoor's most iconic outcrop. With 40-mile-an-hour winds blowing spindrift across the alpine summit, two young lads towing a homemade sledge made their way past me and into the frame. In my overactive mind, these were spacemen, scouring the landscape of a frozen moon, alerted by a distress beacon, whilst just to their left all manner of sledging fun was underway. Snowboarders revelled in the powder and even a kayaker paddled his way through the laughter. It was the true sense of restored community that was so wonderful to feel again. I'll keep wishing for snow like this every year, don't you worry.

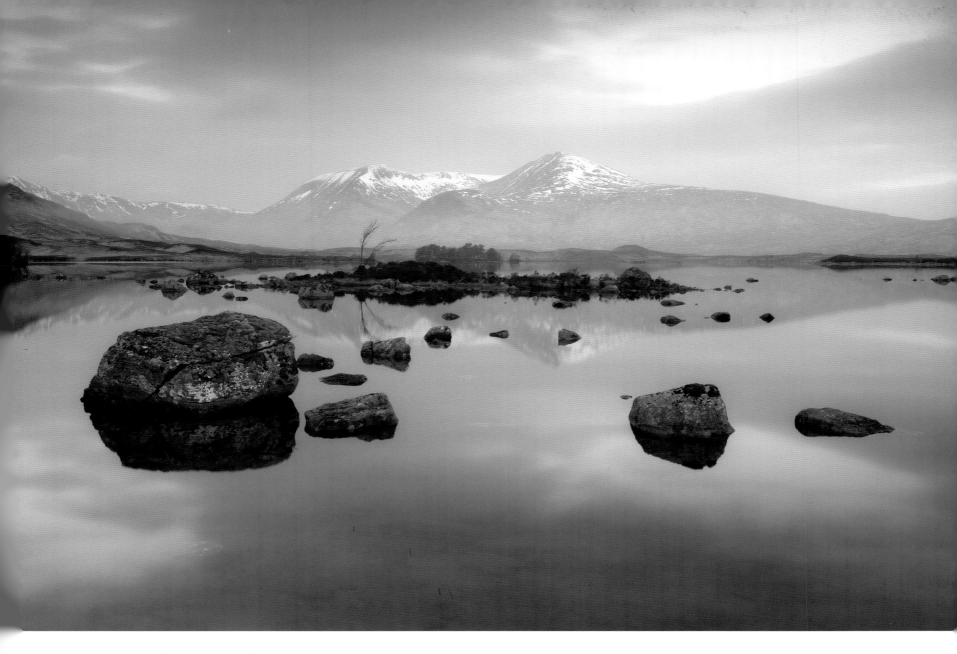

⚜ EMMANUEL COUPE

Dawn at Rannoch Moor, Scotland

The Scottish Highlands are a place of dramatic light shifts. This morning did not look promising but the light turned out to be amazing nonetheless. As the day started breaking, the sky filled with pastel colours as a soft mist began to rise across the surface of the water, gently masking the distant mountains and creating an ethereal feeling in this classic scenery.

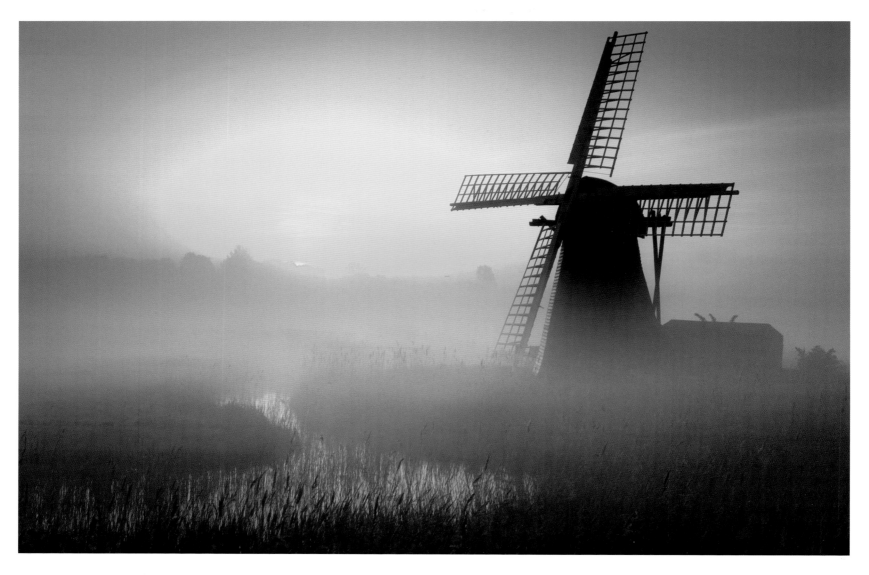

☂ KEITH NAYLOR

ADRIAN HALL ⋯⟩

Herringfleet Mist, Suffolk, England

This image was planned but the mist was a real bonus. I left Sheffield before 2am in order to be on location before dawn. As I drove across the Broads through a 10ft layer of mist I knew there was going to be a spectacular sunrise. I arrived with 20 minutes to spare and ran to the mill with full kit: two cameras, tripod and several lenses. Who says landscape photography is not energetic? I took several hundred photos during the next hour, but this one with the sun just breaking the tree line was the pick of the set.

Broads Authority – Best image

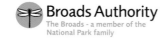
Broads Authority
The Broads - a member of the
National Park family

The Millennium Bridge at dusk, London, England

When I was on my way to this shoot, everyone thought I was mad heading out on a cloudy dull afternoon to lie down on the muddy south bank of the Thames. However, when these beautiful colours started to appear before me I knew it was all worthwhile.

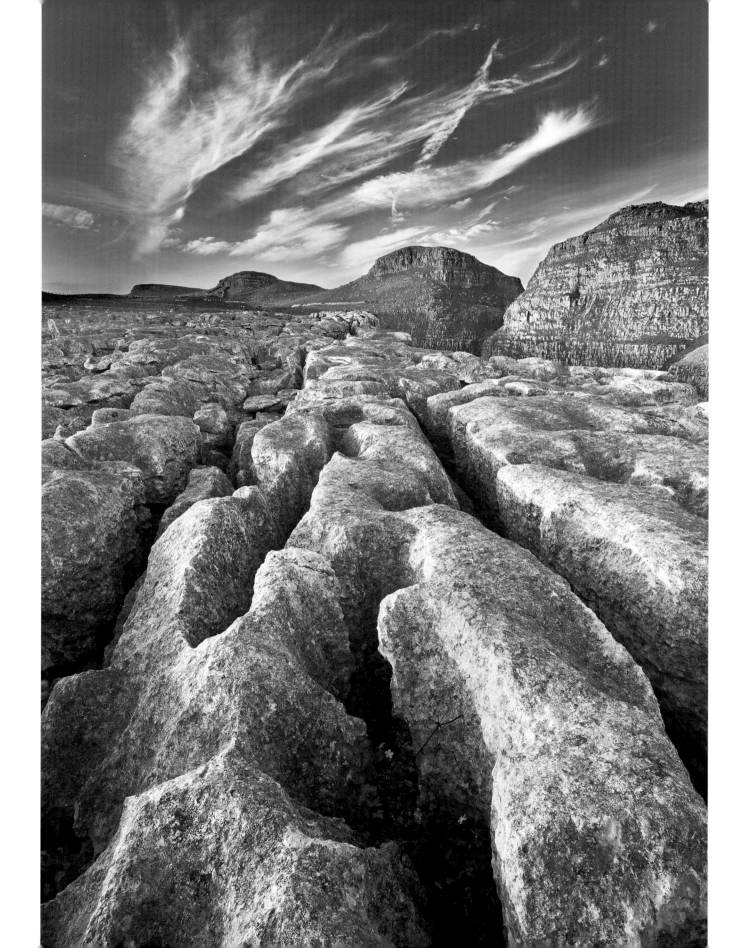

···□ DAVID SPEIGHT

Watlowes Dry Valley, Malham, Yorkshire Dales, England

I had arrived at Malham in the late afternoon with this kind of shot in mind. I planned to have a wander around trying a few different compositions and then hopefully settle on one and wait for the sun to drop. However, having taken a few test shots, I noticed that the jet contrails overhead and the small trace of cloud were rapidly burning off. By sundown, the light had faded and the sky was quite uninteresting so I headed off home disappointed. It was only a few months later when I revisited the shots that I wondered why I had never processed this shot, which was one of the 'test' shots I had taken.

**Yorkshire Dales National Park Authority –
Best image**

YORKSHIRE DALES
National Park Authority

··⊤ ANDREW ROBERTS

Distant Mist, Nash Point, Glamorgan, Wales

This was taken at Nash Point on the Glamorgan Heritage Coast. It's a great location as it is usually quiet, so there are hardly any footprints there, unlike Southerndown, which is a couple of miles away. There was a lot of sea spray from the wind this day and, coupled with the intense sunset, it added to the mood of the place. In the distance is a friend of mine, standing on a rock, and this gives some idea of the scale of the beach.

MARK BAUER

Summer mist, Rockford Common, New Forest, Hampshire, England

Rockford Common is one of my favourite places in the New Forest – I love the view over the valley towards Mockbeggar and, in late summer, when the heather flowers, it can be a real carnival of colour. On this particular morning, I was lucky enough to be there as a mist was lifting from the valley, creating a wonderful layering effect in the background. I used the bridle path to lead into the scene, and set the hyperfocal distance to maximise depth of field.

New Forest National Park Authority – Best image

NEW FOREST
NATIONAL PARK

KRIS DUTSON ···⟩

Pulpit Rock, Isle of Portland, Dorset, England

I have often photographed Pulpit Rock but have never done so late in the year, when the sun sets out to sea. The sunset was better than expected, with the lines of cloud appearing to emanate from the top of the rock and the sun breaking through low in the sky to the right, bringing out some great modelling of the rock surface. I chose quite a slow shutter speed to show the movement in the wave as it broke over the rock ledge at my feet. Although the colour was superb, I decided there and then this was to be a mono photograph to emphasise all the lovely textures and the shape and form revealed by the low-angle light.

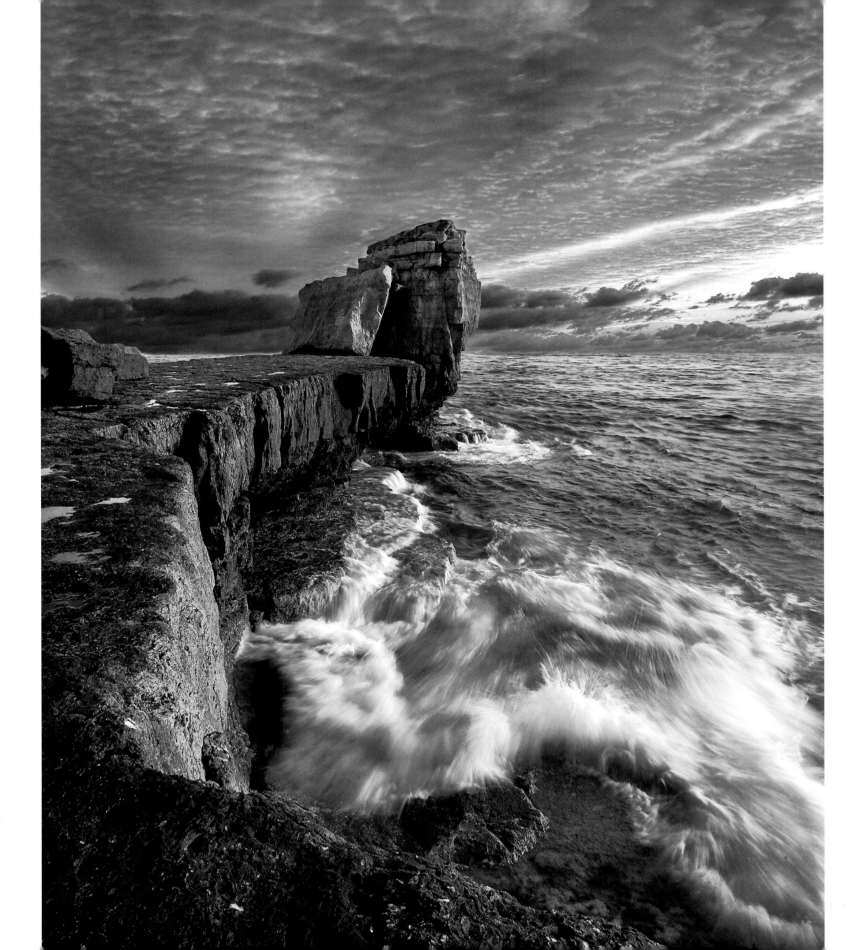

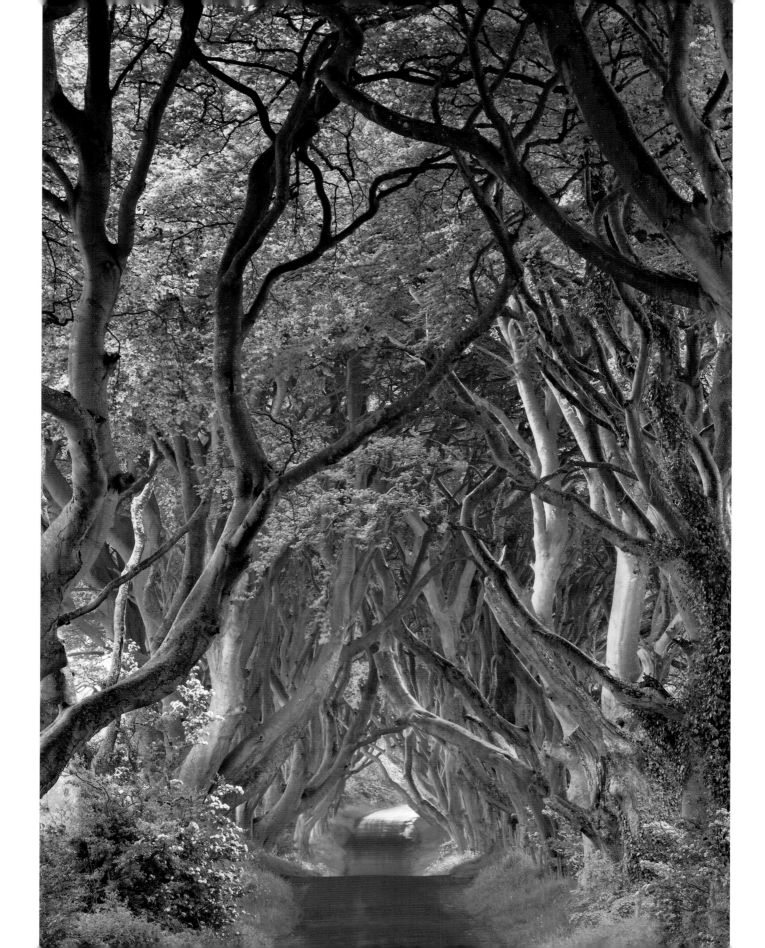

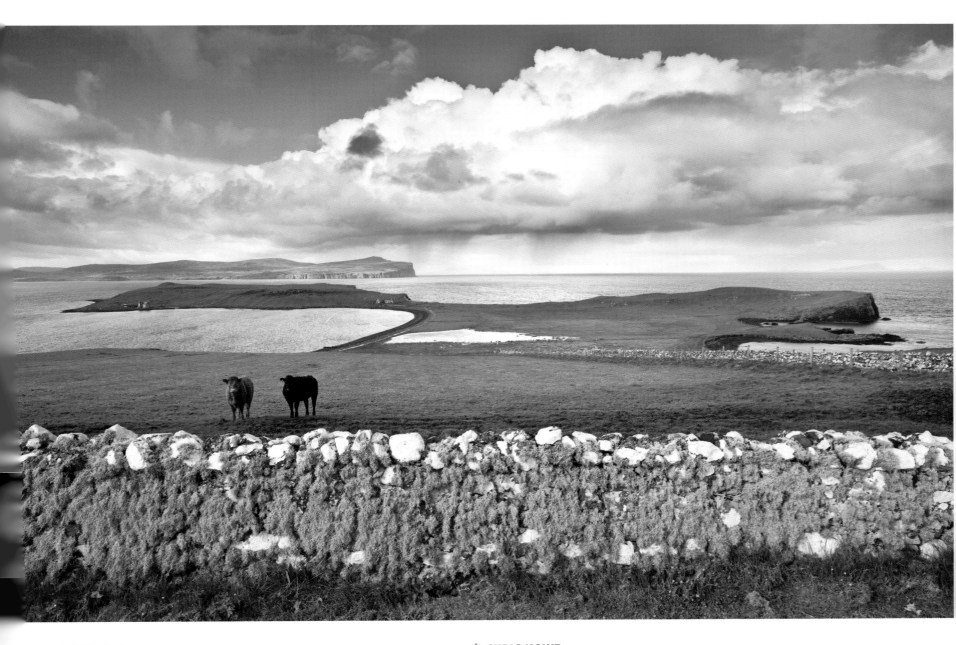

◀··· PETER COX

The Dark Hedges, Co. Antrim, Northern Ireland

This imposing view is located near the town of Armoy in County Antrim. Known as 'The Dark Hedges', these beech trees were planted in 1750 and have grown into this beautiful, surreal tunnel. Over time, various trees in the row have died and fallen, and recently several were removed as they were in danger of collapse. A local trust has been set up to replant the missing trees, so that this remarkable place will continue to exist in its current form. Shot with a long lens, the natural perspective compression serves to amplify the dark and brooding nature of the tunnel.

✝ CHRIS HOWE

Spring showers, Waternish, Skye, Scotland

A morning of showers, sun, rainbows, clouds and islands floating in the sea and sky. A spare day wandering to a later meeting brings rewards. I am alone at this graveyard on a western wing of Skye. A heavy passing shower means retreat for a while, but on my return two inquisitive cows join me beyond the ancient lichen-covered wall. Do I need the wall? Will it dominate the frame? But wait – it is part of this sense of place that made me stand here – right here. More shower clouds advance. I watch the pattern of sun and shadow move across the land, and choose my own decisive moment.

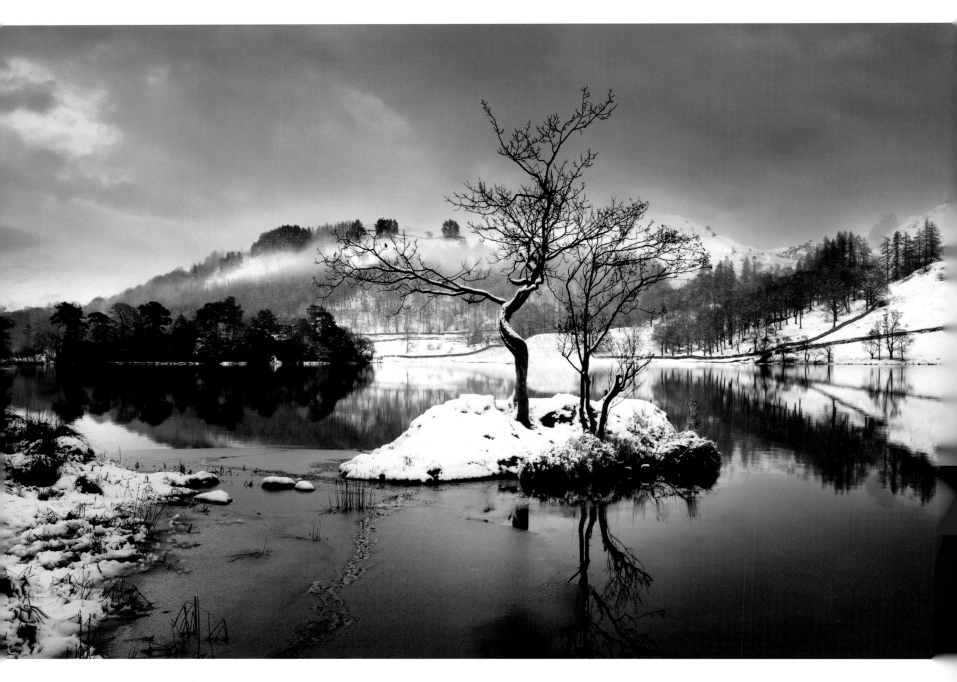

✝ PAUL KNIGHT

Rydal Water, The Lake District, Cumbria, England

The heavy snowfall seemed to muffle any sound. It was nearly dusk in midwinter; so peaceful, magical and surreal.

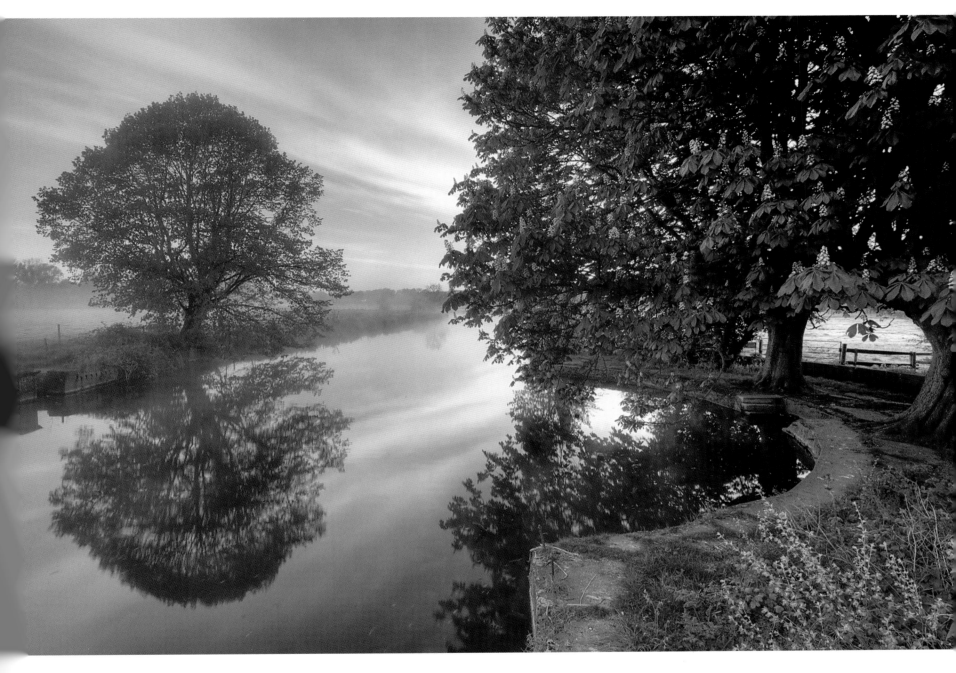

ANTONY BURCH

The Old Bathing Place, near Sudbury, Suffolk, England

The Old Bathing Place is the remains of a Victorian swimming pool situated on the River Stour in Sudbury. It was originally opened in 1894 and the surrounding horse chestnut trees were planted at the same time.

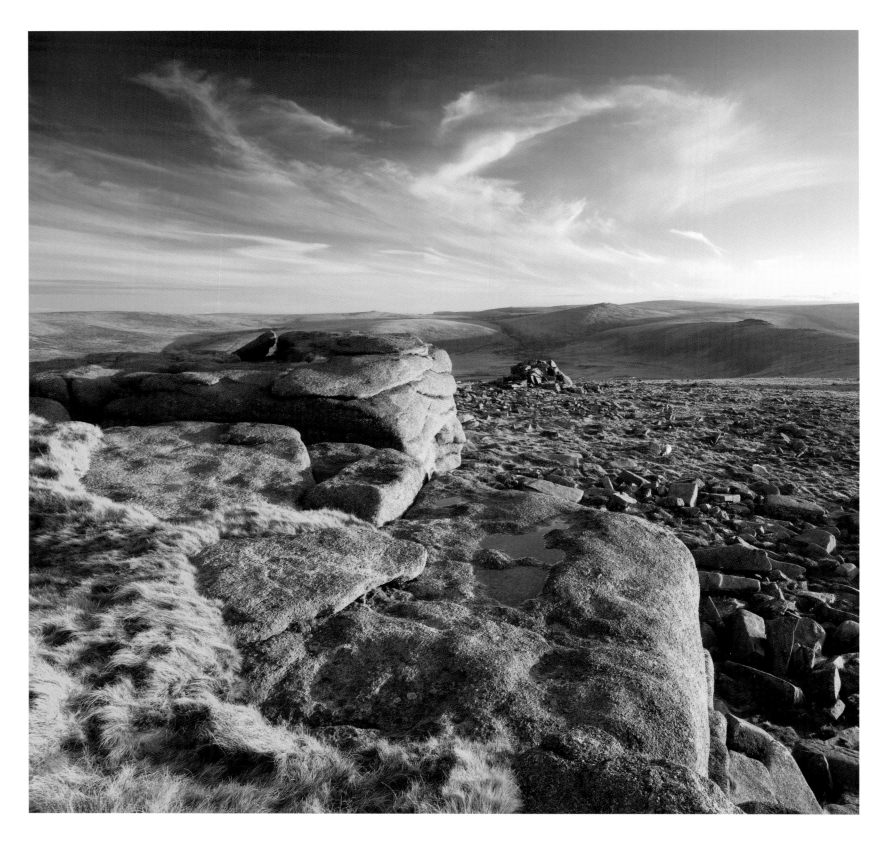

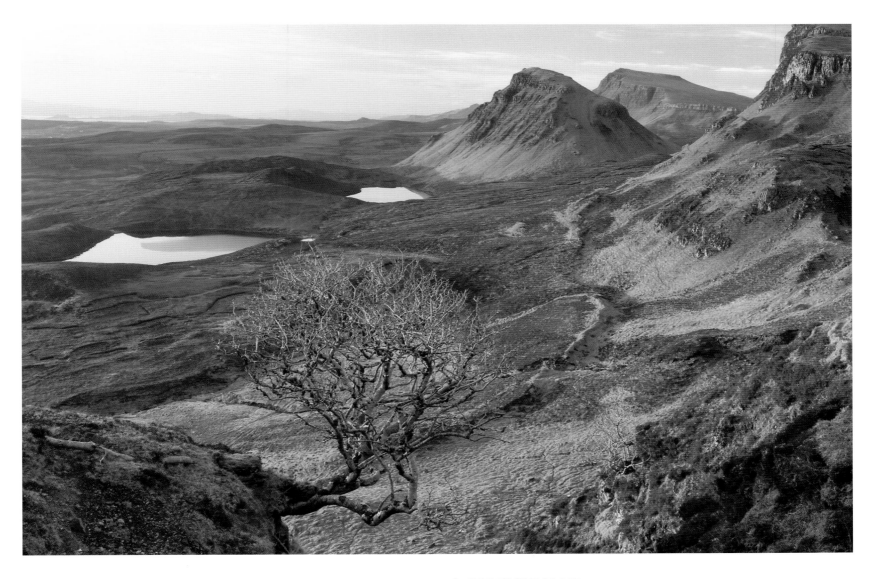

ADAM BURTON

The Golden Hour, Belstone Tor, Dartmoor, Devon, England

I have headed to this location on Belstone Common many times over the past year, hoping for some magical light to illuminate the scene. After many trips involving dense fog, snow, rain and heavy wind I was thrilled to stand on this tor on this particular winter evening, as the low lighting bathed the granite outcrop and moorland landscape in golden tones. For me, this location and image perfectly capture the special feeling of Dartmoor; a wild and exposed moorland that in brief moments of magic can be transformed to such a beautiful and appealing landscape.

Dartmoor National Park Authority – Best image

ADRIAN METZELAAR

Trotternish from the Quiraing, Skye, Scotland

This was my first trip to Scotland and, therefore, the Isle of Skye. I was there on a weekend photography course and the weather was truly amazing and unusual – beautiful sun every day and gorgeous sunrises and sunsets. When I got to this viewpoint, the sun rose slowly, casting a beautiful, warm light on the wonderfully primeval landscape of the Quiraing. The tree provided the perfect foreground and anchor point to this already wonderful vista.

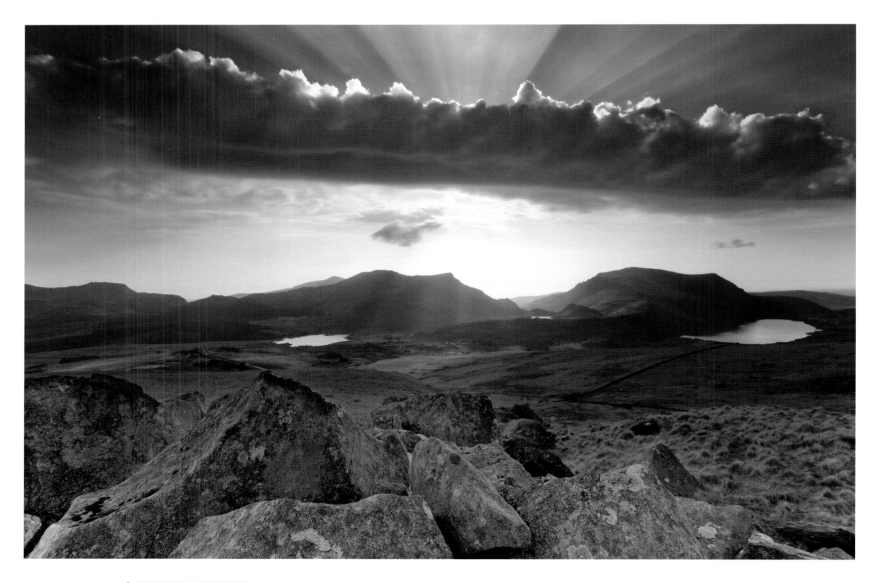

ROBERT GARRIGUS

Sunbeams in Snowdonia, Wales

Crepuscular rays over Snowdonia as seen from the Snowdon Ranger path near Rhyd Ddu.
I was moving to a location for later light and saw this amazing scene unfold.

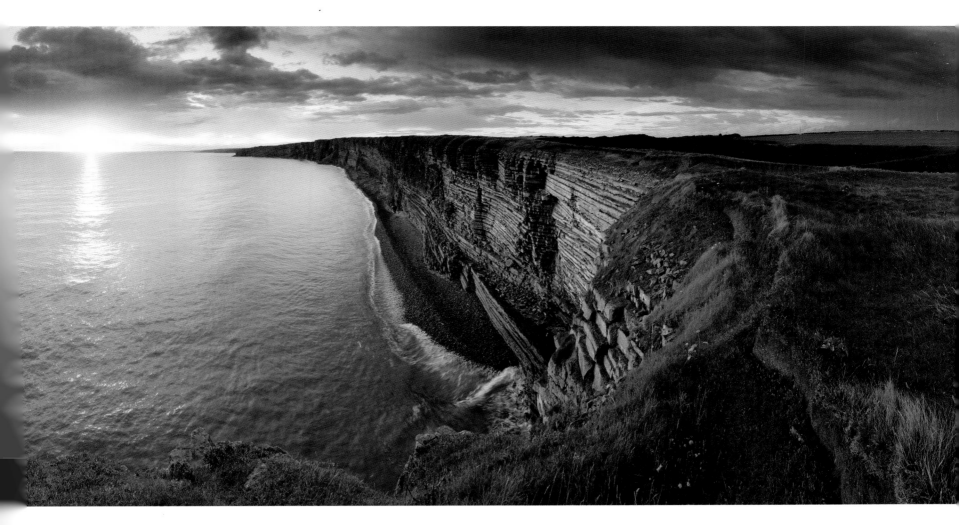

CRAIG JOINER

Sunset at Nash Point, Glamorgan, Wales

On this particular day I had set out to photograph the two lighthouses on the cliff top but a violent storm soon put an end to that. After watching a terrific display over the Bristol Channel and distant hills of Exmoor and getting a good drenching in the process, I turned towards the car park. Walking back to the car I noticed the cloud breaking up in the west. If I was lucky I might get a glimpse of the sun before it set. I set up my camera at the top of the cliff and arranged my composition so that the magnificent cliffs of this coastline lead the eye towards the horizon and setting sun. When the sun finally broke through the cloud it was still a little diffused by the cloud, but it was just enough to add some colour to the cliff face.

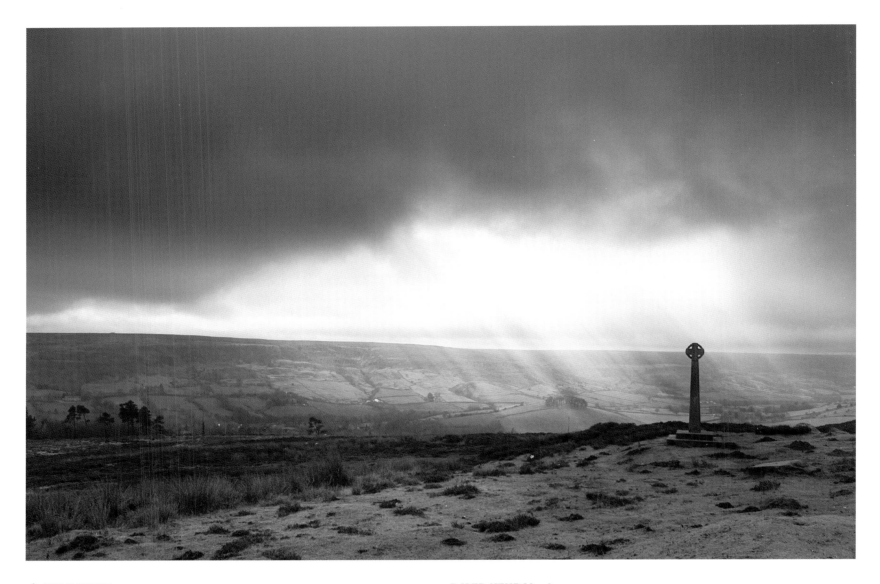

🐾 JIM BARTER

Rosedale Light, North Yorkshire Moors, England

This image was taken near Rosedale Abbey in the North York Moors on our return from a holiday in Staithes on the coast. The weather was awful; fast approaching storms and grey dreary light. We wanted to get home early, but a break in the clouds gave us this wonderful view just as we crested a rise. We stopped to admire the scenery and the heavens opened, but not with rain, a blissful light cascaded down – it was as if God was smiling on us.

**North York Moors National Park
Authority – Best image**

DAVID KENDAL ⋯⟩

Golden Light at Seilebost, Isle of Harris, Scotland

The dunes near Seilebost offer fantastic views over the Sound of Taransay to the hills of North Harris. This particular evening was quite breezy, and a lack of clouds in the sky meant that there was not going to be a great deal of interest above the hills in the distance. The sun was low in the sky at this point and the dune grasses in the foreground had really come to life. I decided to capture the motion of the grasses by lengthening my exposure time with the use of a neutral density filter. As they danced in the golden light this created an interesting soft effect in the foreground.

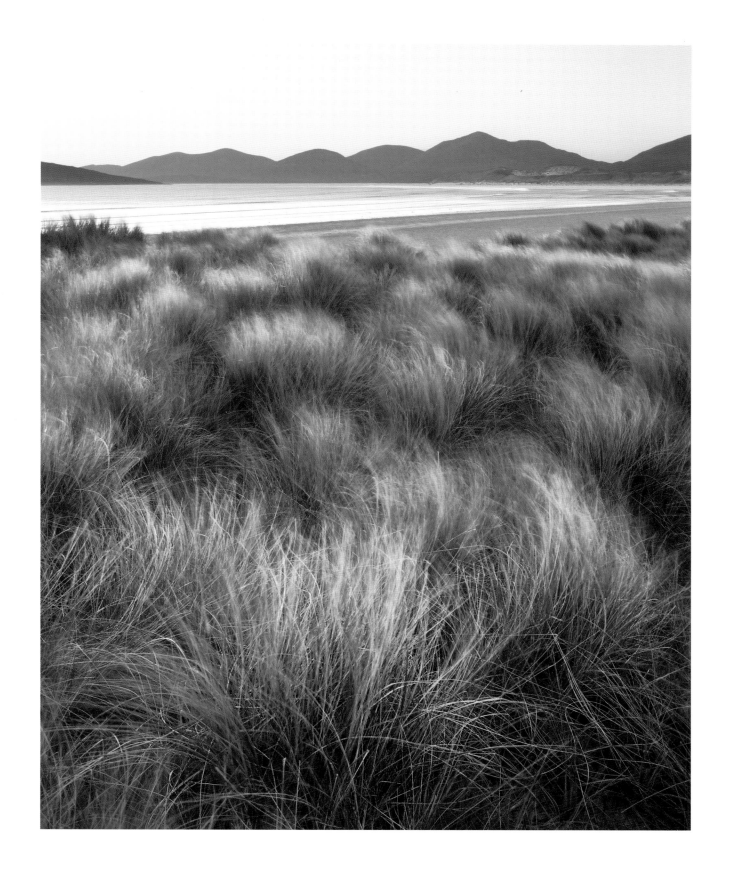

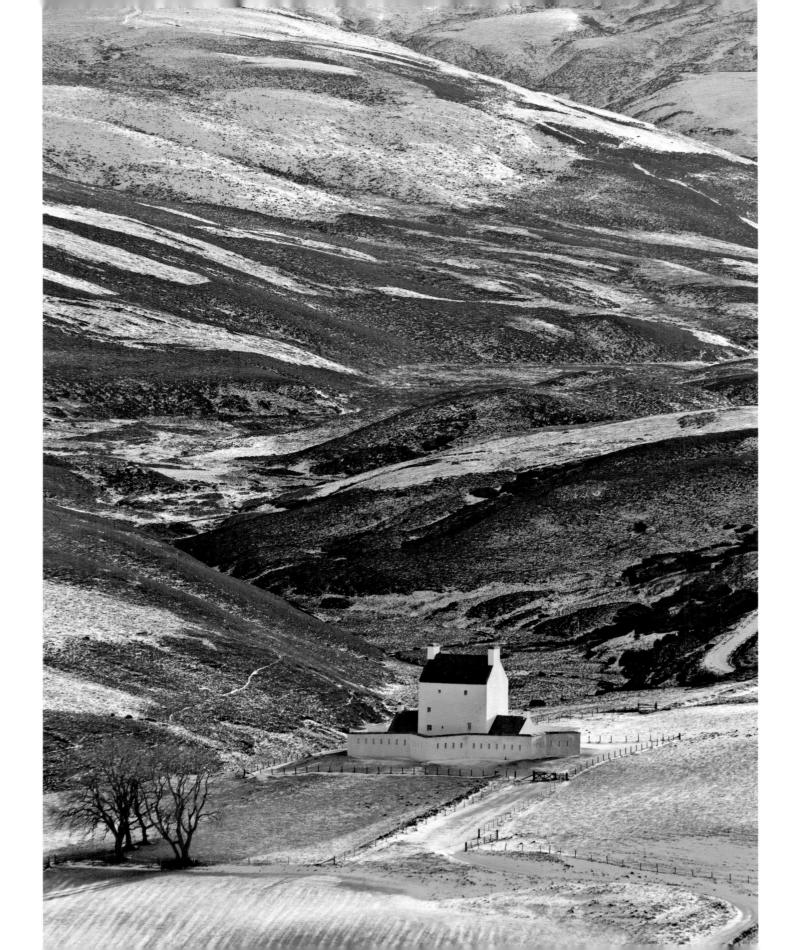

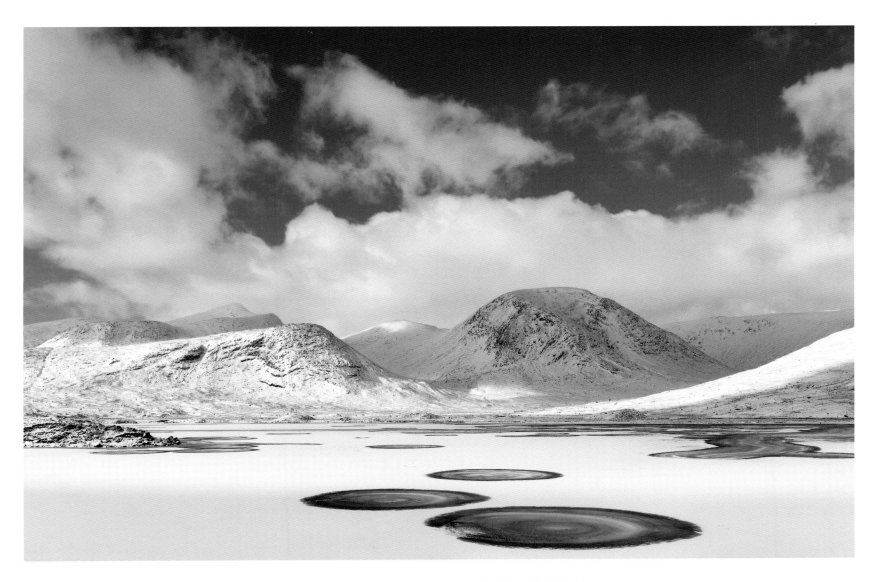

STEWART MITCHELL

Corgarff Castle, Strathdon, Scotland

Corgarff Castle enjoys an isolated location at Cockbridge in Upper Donside. This image was taken in late January and the low winter sun adds a touch of warmth to the cold conditions and somewhat barren surroundings. The castle sits just off the A939 Cockbridge to Tomintoul road, which is notorious as it is inevitably the first road in the UK to be blocked by snow every year!

Judge's choice David Macdonald

ANTHONY BRAWLEY

Loch Dochard & Meall nan Eun, Glen Kinglass, Scotland

It was a beautiful, but bitterly cold, February morning. I had parked the car near Victoria Bridge and walked along the north side of the river towards Loch Dochard. It's around four miles in each direction, but due to the heavy snow and the conditions underfoot, it felt like double that. By the time I reached the Loch I could no longer feel my hands or toes, as they were totally numb with the cold. I stopped in an old hut and had a bite to eat whilst waiting for some light. I was amazed by the scene that awaited me; a completely frozen loch with what looked like huge circles of ice cut out. Almost a lunar-landscape. For me the hike and the cold were worth it for this image.

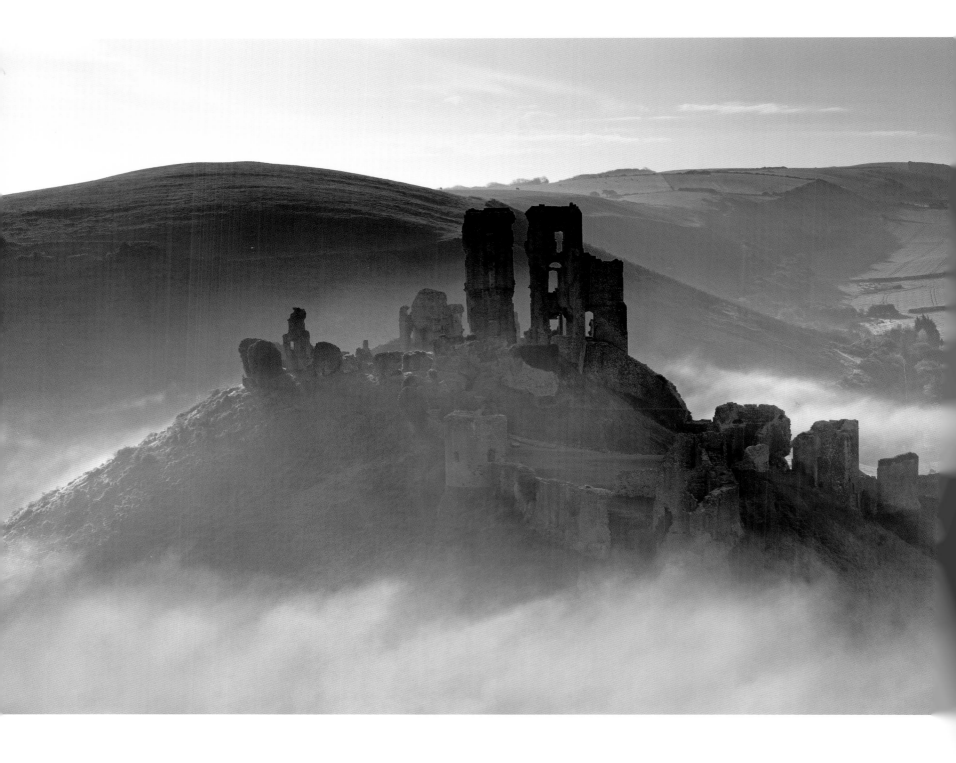

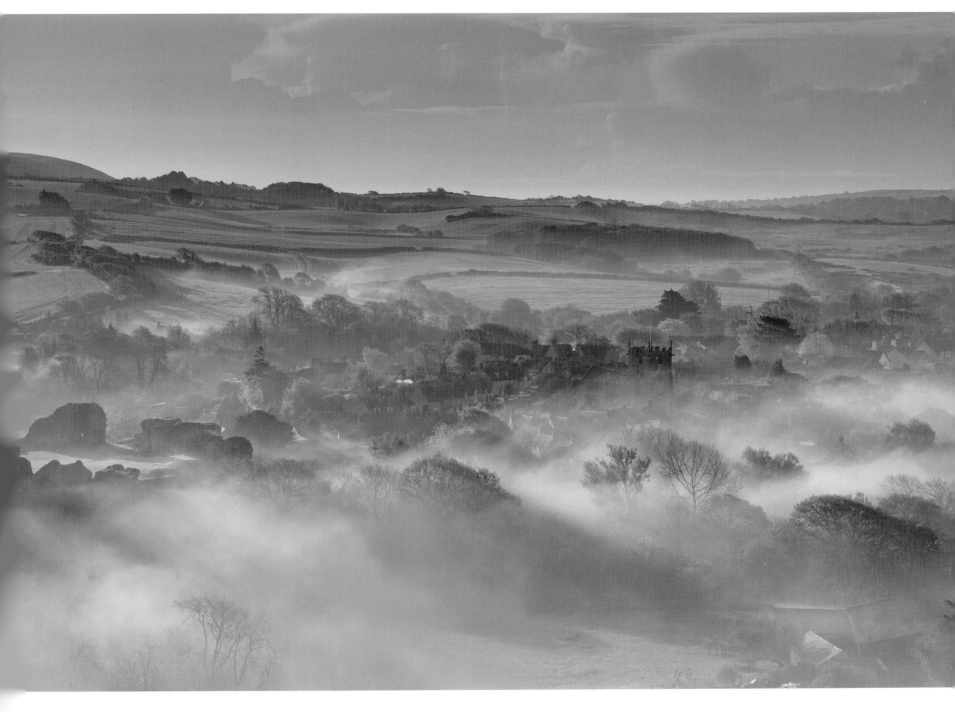

✝ **BART HEIRWEG**

Corfe Castle on a misty spring morning, Dorset, England

This is a sight I will never forget. The rain from the day before had created a blanket of mist around the Castle and its surrounding valley and, combined with the light of the setting sun, this landscape provided me with some very atmospheric images. I took a panoramic shot of this scene, as I wanted to capture both the perfect weather conditions and the medieval look of the ruins, in order to convey to the viewer the same mind-blowing effect that I experienced.

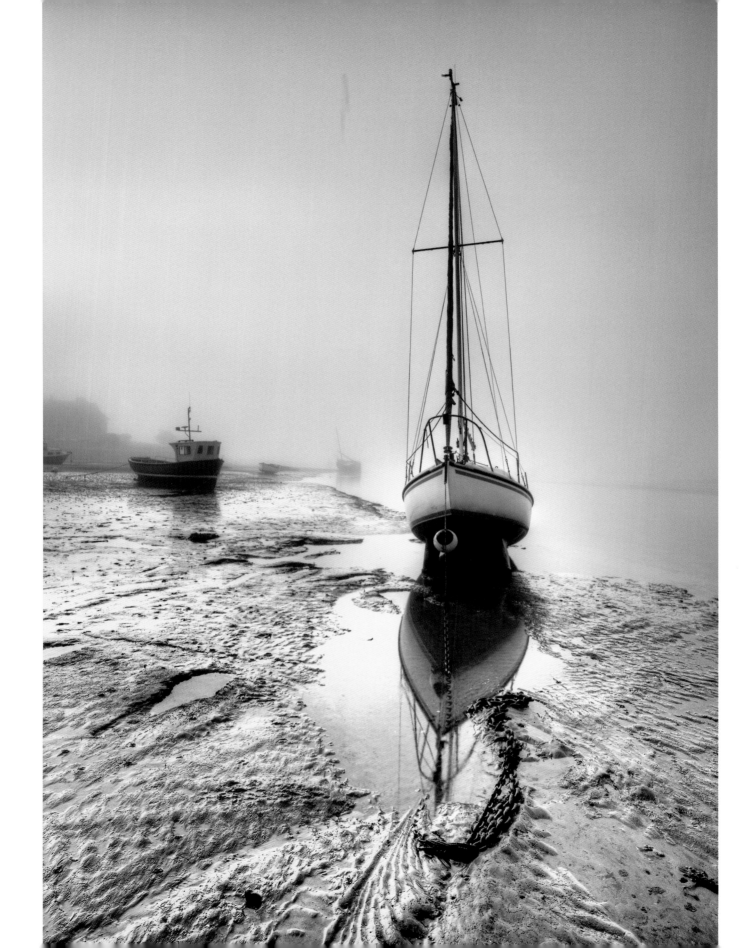

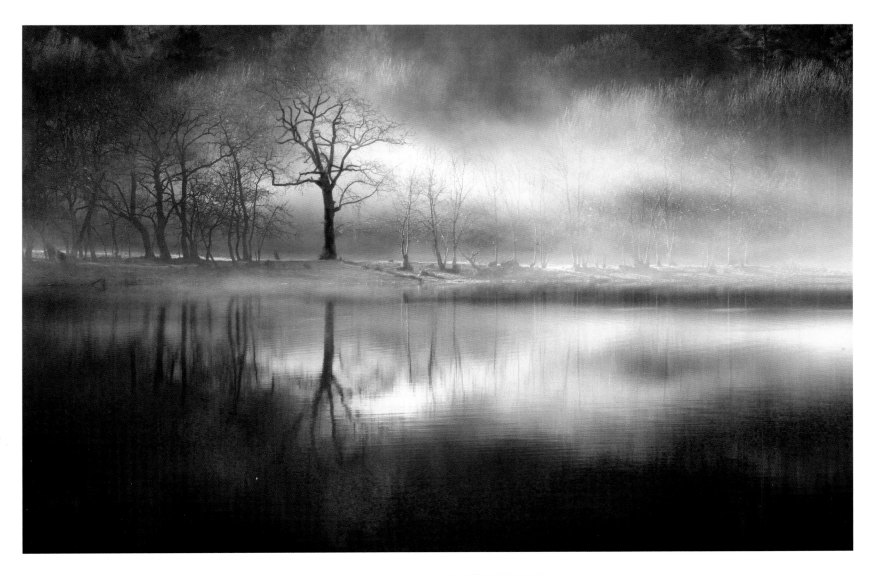

GEOFF PERRY

Misty dawn, Alnmouth Estuary, Northumberland, England

A serene moment as the North Sea tide and east coast fret recede along Alnmouth Estuary on an early morning in April. The sailboat, stranded on exposed mud flats, displays its reflected hull in the foreground pool. In front of the pool, a series of intricate patterns lead the eye into the image.

MIKE HUGHES

Smoke on the water, Loch Ossian, Scotland

This picture was taken on a February afternoon on the way home from a walk in the Scottish Highlands. When I saw the view, I asked the driver to stop and go back. I then realised that it wasn't mist, but smoke from a farmer's bonfire, but the backlight cast really nice reflections on the water.

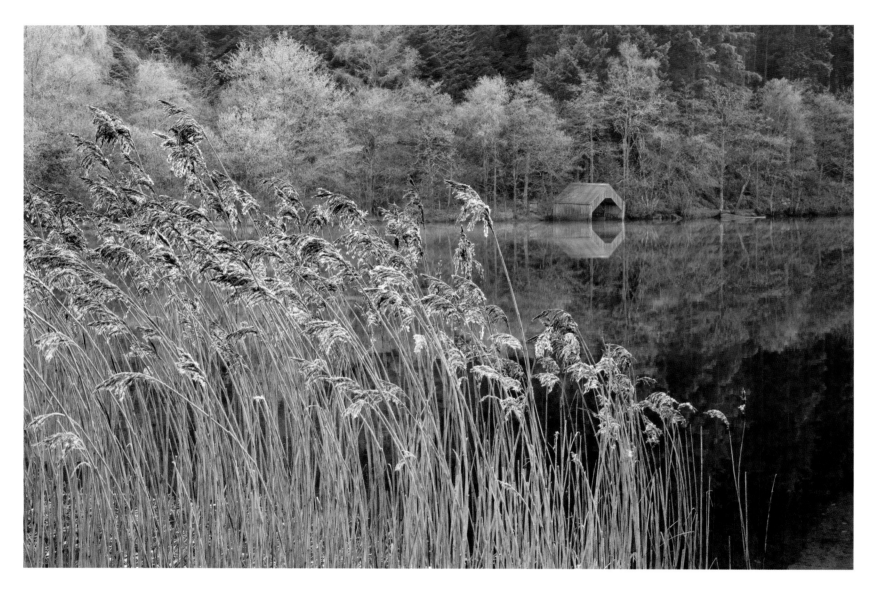

ALAN CAMERON

Reeds by Loch Ard, Scotland

I am blessed with luck in staying in one of the most photogenic countries in the world; Scotland, my land, spirit and love. This image was captured on a cold frosty late December afternoon, at Loch Ard. Initially it did not look promising for photo opportunities, but my eye was drawn to the warm tones of the foreground reeds contrasting with the cold tones of the background. Just then a breeze bowed the reeds back, as if pulling back a curtain to the old boathouse and frosted trees. Once again nature and light rewarded me for my perseverance, reminding me that it is in exceptional circumstances that the best images are found.

DAVID STANTON ⋯⟩

Abhainn Shira, Glen Kinglass, Scotland

The river, Abhainn Shira, runs eastward from Loch Dochard in Glen Kinglass until it joins Loch Tulla and is one of my favourite areas in autumn and winter. Last winter was a cold one in Scotland, which for me is ideal. This was one of those days that had everything – frost, snow-capped mountains and good light. I had to use exposure blending to eek out every detail from the brightest areas of the mountains to the weeds under the surface of the river.

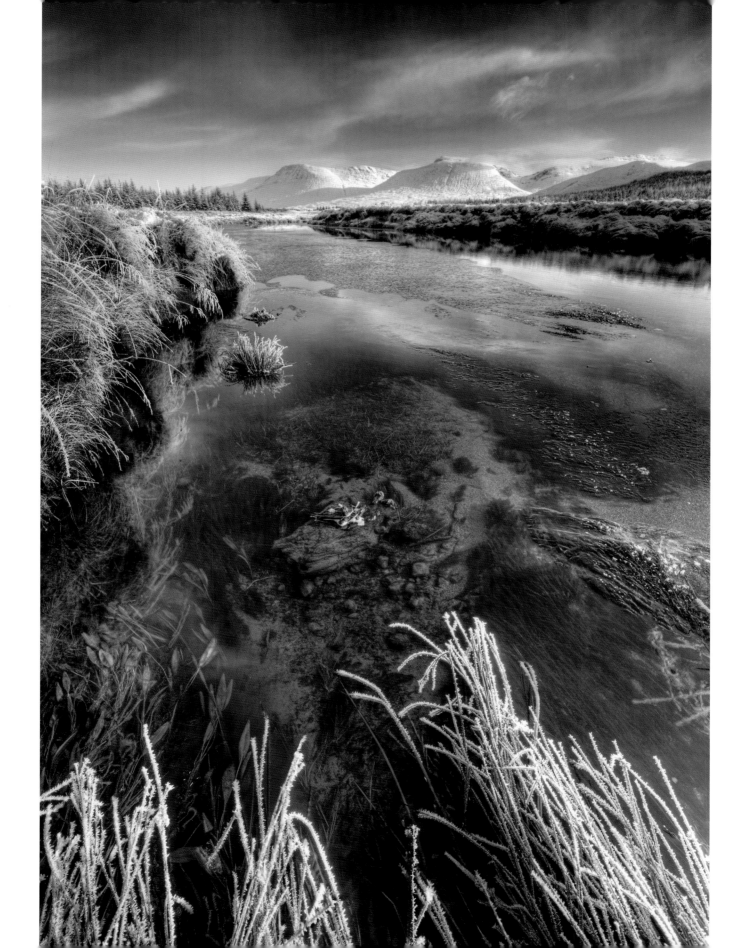

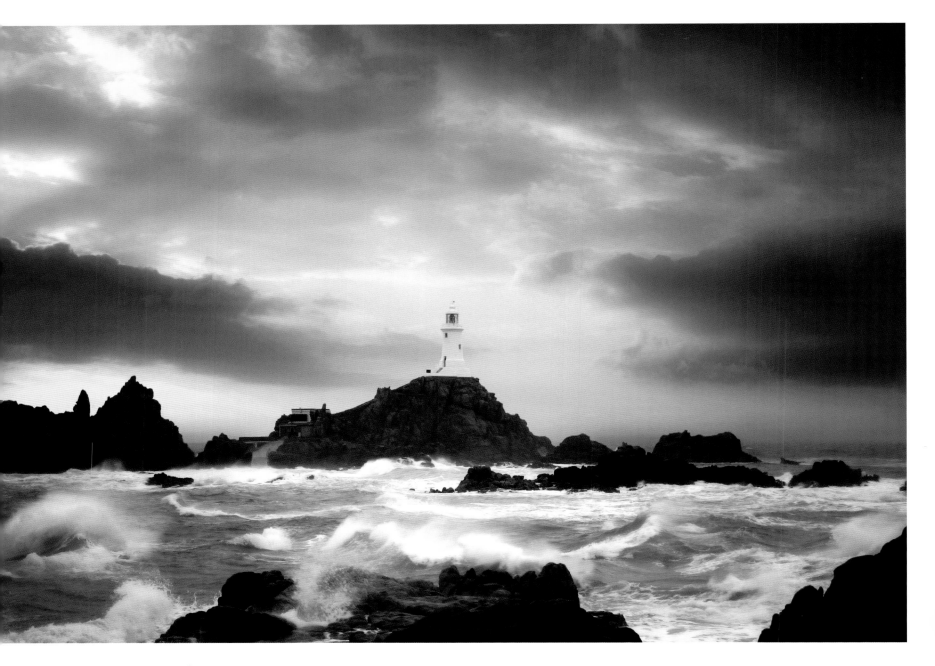

NICKY STEWART

La Corbière, St Brelade, Jersey

This shot was taken on a very cold winter's day with lots of sea spray in the air.
The wonderful light and energy of the sea was worth battling the elements for.

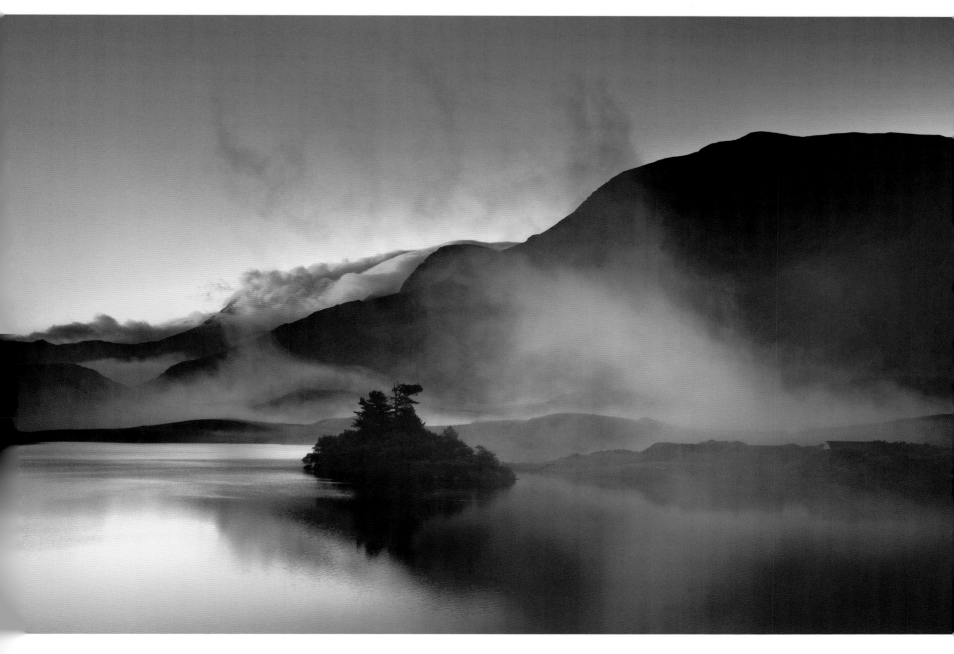

🍃 CLAIRE CARTER

Llynnau Cregennen, looking to Cadair Idris, Snowdonia, Wales

Watching recent footage of the first moon landing made me think of the morning this picture was taken. Not because this landscape has any lunar qualities but because of the sense of awe and privilege I got when witnessing a spectacular dawn in a beautiful place with the only proof it happened being a photograph.

SŁAWEK STASZCZUK ⋯⋯⁝

South Downs, East Sussex, England

Although I have looked many times, I have found very little interesting photography from the Sussex countryside, at least online. My guess is that many photographers are drawn to the immediately dramatic and wild areas of Britain. The Sussex landscape can be a harder subject to show in an interesting and appealing fashion. Thus, in a way, my goal is to make the viewer see the area as they never have before, by striving to show its inherent but often not-so-obvious beauty. This image was taken on Christmas Day near Falmer.

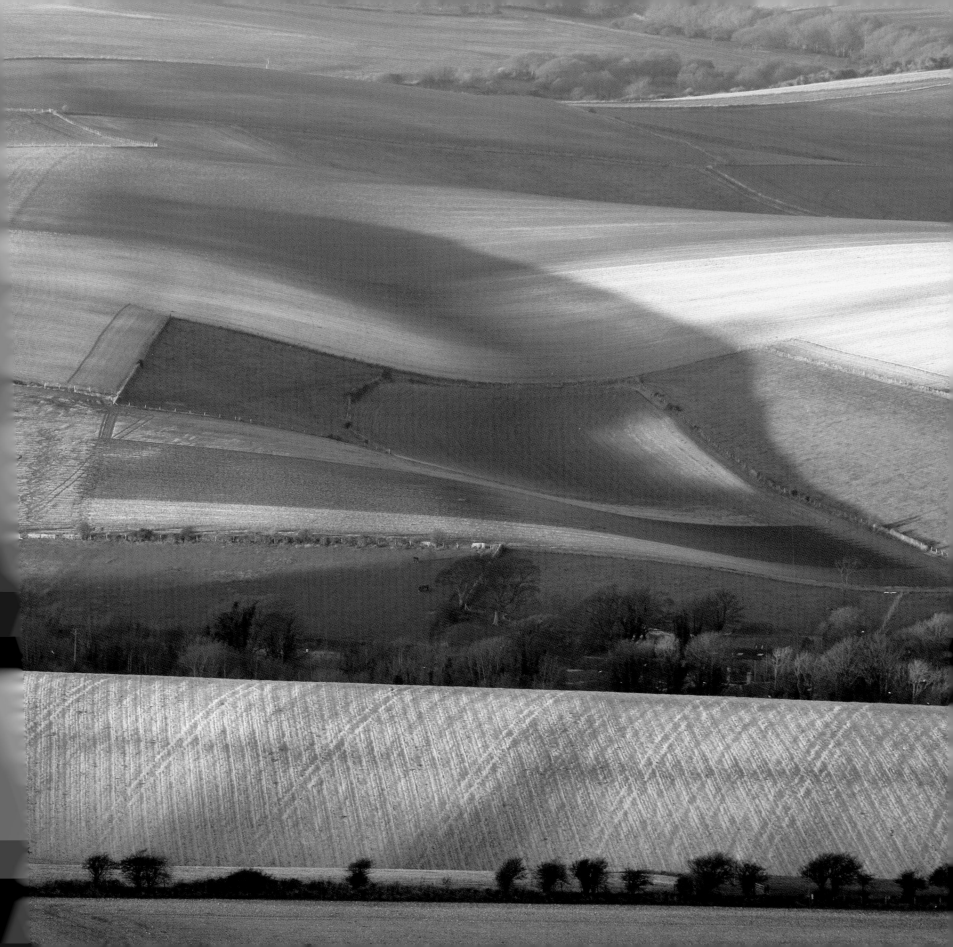

DAVID SPEIGHT

The Pennine Way and Pen-y-ghent, North Yorkshire, England

Typical Dales weather as fierce-looking storm clouds frame the instantly recognisable peak of Pen-y-ghent. This was one of those days when you really didn't know whether it was going to chuck it down, brighten up or even snow. As the sun went down, it lit the hill and path with favourable light, giving a window of about ten minutes to get the shot.

SŁAWEK STASZCZUK ⋯⋗

The Seven Sisters, East Sussex, England

This image was taken on a mid-Autumn morning during an ebb tide in November, shortly before noon. It is one of many images I have taken in Sussex – an area I am exploring and photographing in the hope that others will see or rediscover its inherent beauty.

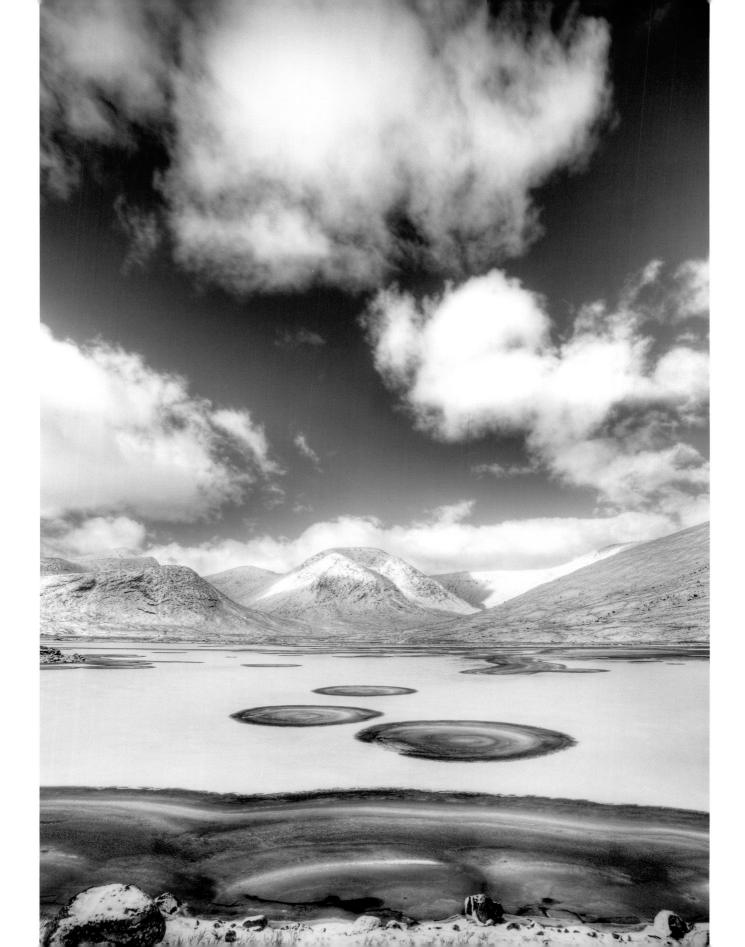

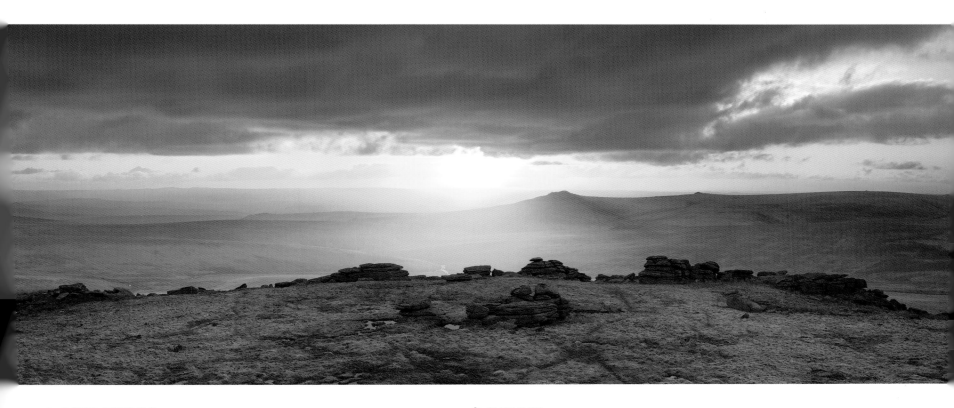

DAVID STANTON

Ice circles, Loch Dochard, Glen Kinglass, Scotland

A long, freezing cold four-mile walk, laden with camera gear, was rewarded with this quite bizarre scene. Loch Dochard in Glen Kinglass had frozen over and been covered by snow and strange black circles had formed where the snow had been lifted off the surface of the ice by forces unknown, most likely the wind.

ALEX NAIL

Fur Tor sunset in spring, Dartmoor, Devon, England

Fur Tor lies in the heart of the northern moor and is one of Dartmoor's most remote tors. In all my time spent on Dartmoor over the last few years, I have never experienced such a sense of timelessness as on that evening. The forecast of cloud over Dartmoor and clear skies to the west looked promising so I set out to capture this composition that I had originally photographed a week before. As I arrived the sun started to dip beneath the cloud cover. I had just enough time to capture this image, the valley below bathed in sunlight and the outcrops almost silhouetted in the shadow of the cloud.

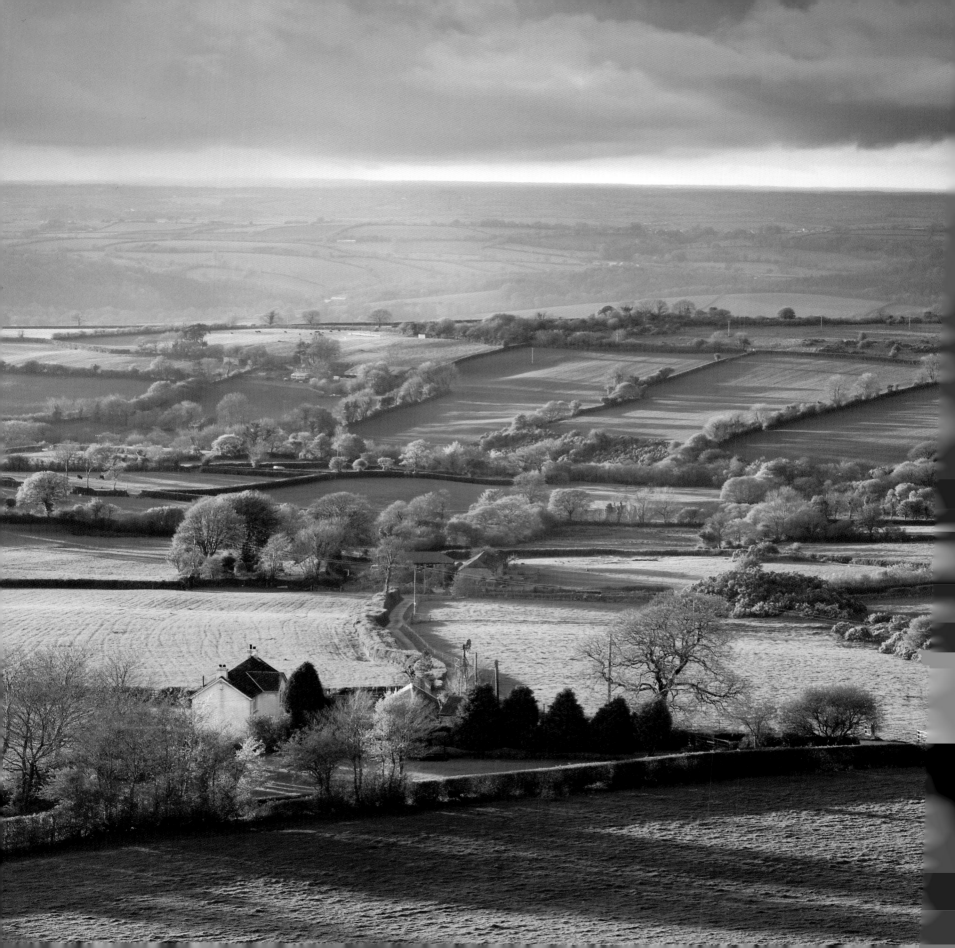

◄··· **ADAM BURTON**

Visions of Light, Brentor, Dartmoor, Devon, England

Brentor is a beautiful location to visit and to photograph at any time but this occasion was very special. On a stormy, spring evening, I was driving back from Tavistock in driving rain. Suddenly, the rain stopped and was replaced by a rich and magical light. I quickly changed plans and headed for nearby Brentor, a granite outcrop providing an elevated viewpoint over the surrounding countryside. After rushing to the top of the tor, I composed my shot to capture the sweeping rural landscape bathed in this wonderful and rare light.

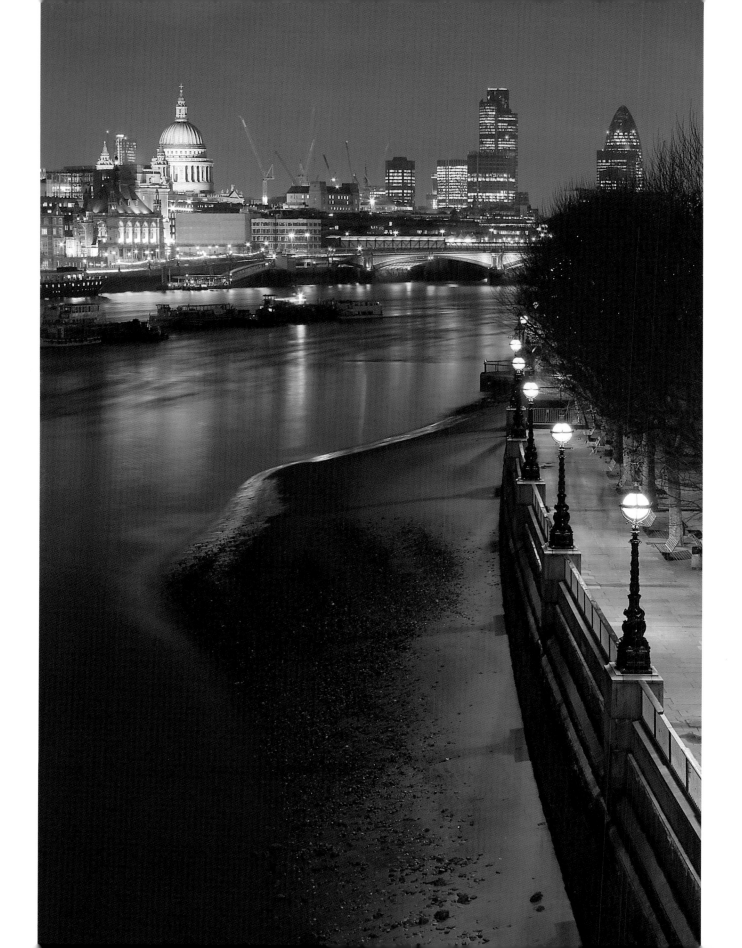

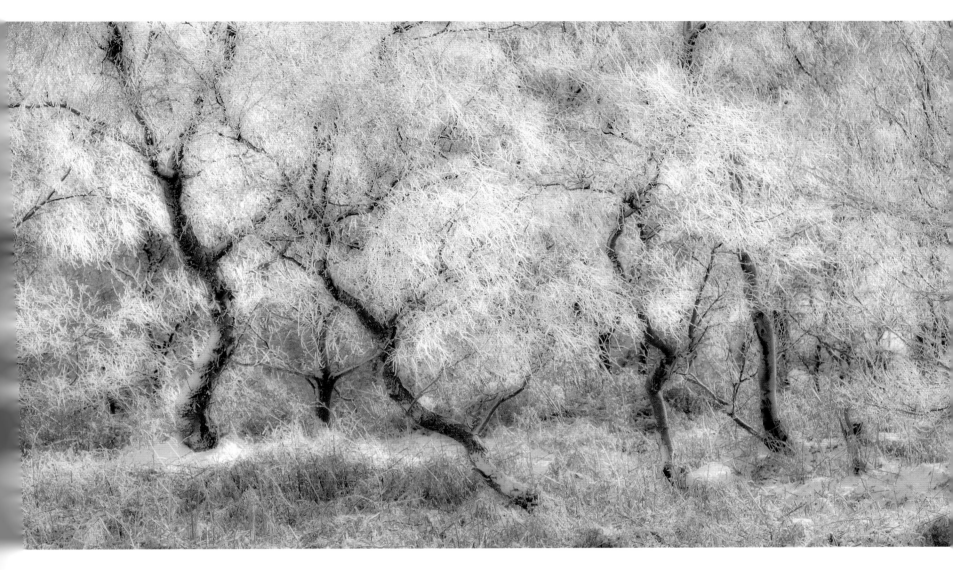

VÁCLAV KRPELIK

Night view, Waterloo Bridge, London, England

I was walking along the River Thames in Waterloo breathing in the mystical atmosphere of the coming night and wondering how to get that atmosphere into my images. When I reached Waterloo Bridge, I saw that the level of water in the river was quite low, and therefore had the idea of using the bank as a foreground and let the river and the row of streetlamps lead the viewer's eye to The Gherkin, St Paul's Cathedral, and the other famous buildings which were to form the background of the scene. To emphasise the warmth of the atmosphere, I adjusted the white balance on the camera to create the desired colour tone and took this picture.

CHRIS LEWIS

Silver trees, the Wrekin, Shropshire, England

These old silver birch trees stand near the summit of the Wrekin hill in Shropshire. At a height of around 1,300ft, on a bitterly cold January morning, I knew that conditions would be just perfect for some stunning landscape photographs. An overnight hoar frost had partially melted and then re-frozen in a cold wind leaving the branches coated in ice, which when backlit by the early morning sun gave the scene a magical appearance.

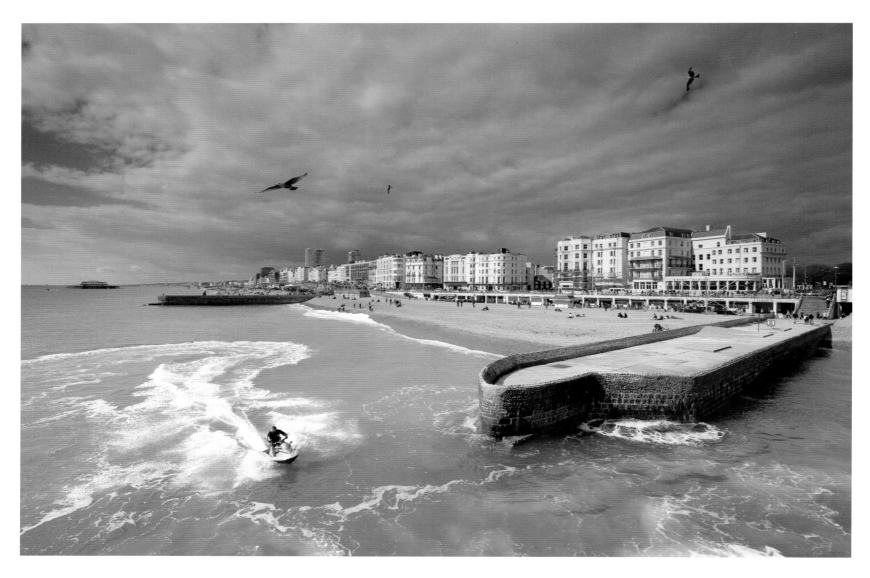

SŁAWEK STASZCZUK

Brighton in early spring, East Sussex, England

I call this picture 'Simply Brighton'. Although from Poland, I have lived in Brighton for over two years and taken many pictures of the town and surrounding landscape. I visit the same places dozens of times, examining the features of the terrain, looking for the best light, angles and vantage points. So most of my photographs are studied, thought out in advance. In this image, I like the way the wake of the jet-ski mirrors the shape of the jetty.

ROSS HODDINOTT ⋯⟩

Groyne at Swanage Bay, Dorset, England

I was staying in Swanage for a week during April, and had previously identified this viewpoint as a possible shot. This particular morning, the conditions were perfect – overcast, but with a stormy, menacing sky. I composed the image carefully, to ensure symmetry, and attached a 10stop neutral density filter in order to generate a lengthy three-minute shutter speed. The long exposure blurred the rising tide and movement of the storm cloud, producing an ethereal and moody result.

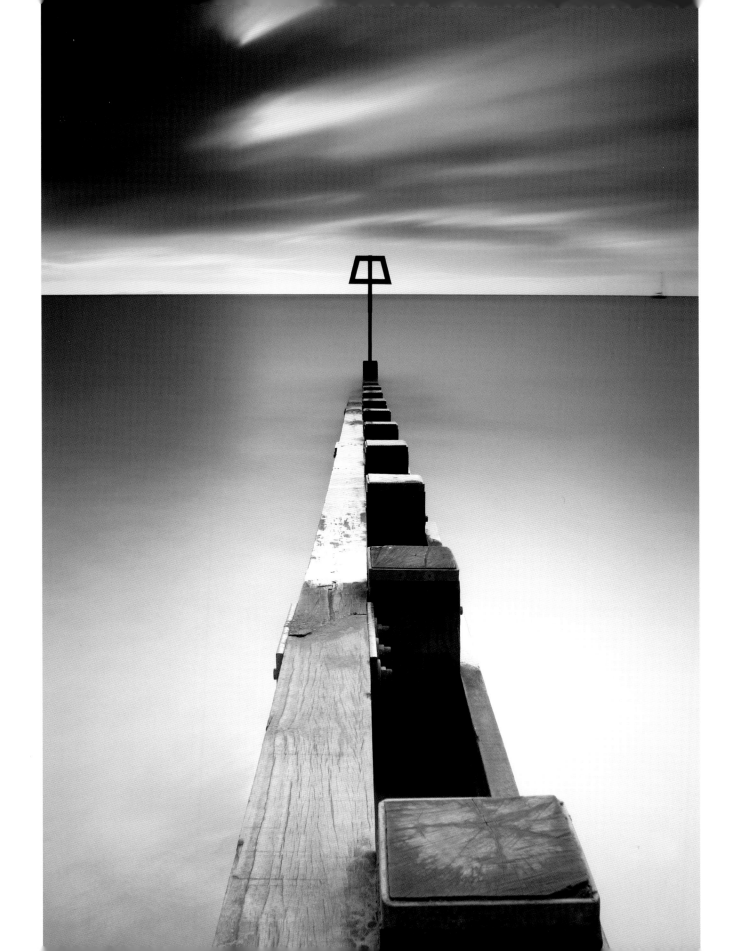

CLASSIC VIEW
youth class

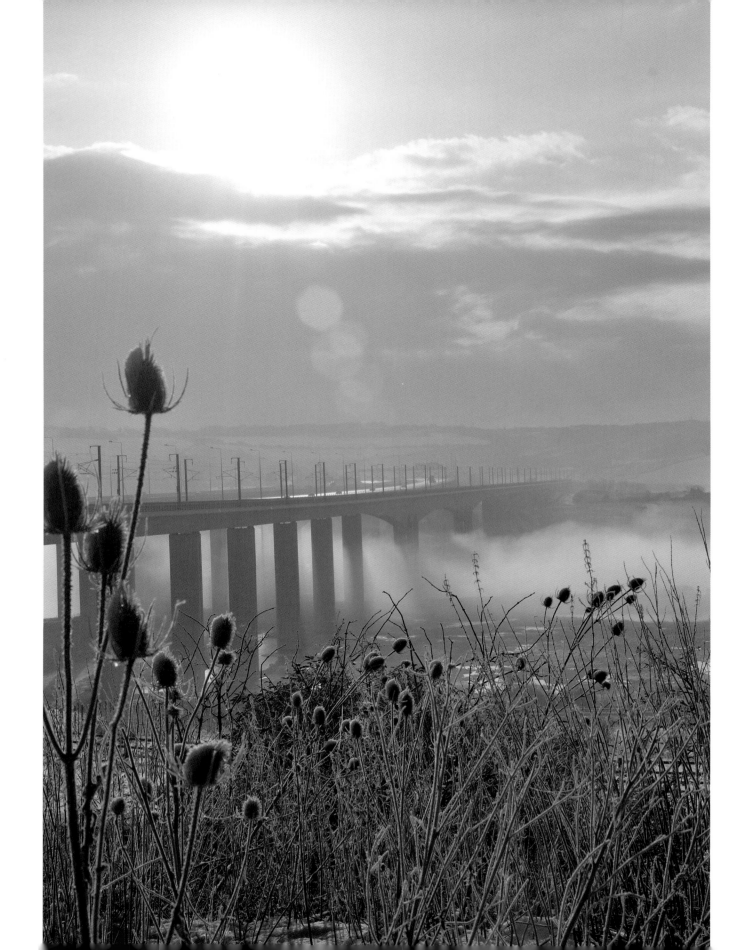

CLASSIC VIEW YOUTH CLASS WINNER

SAMUEL BAYLIS

Winter Wonderland, Medway Viaduct at Rochester, Kent, England

This was taken on a misty morning just after it had snowed. The bridge always makes an interesting picture and the play of light on the mist made it seem really mystical and dreamlike. The frost on the thistles in the foreground also adds to the atmosphere.

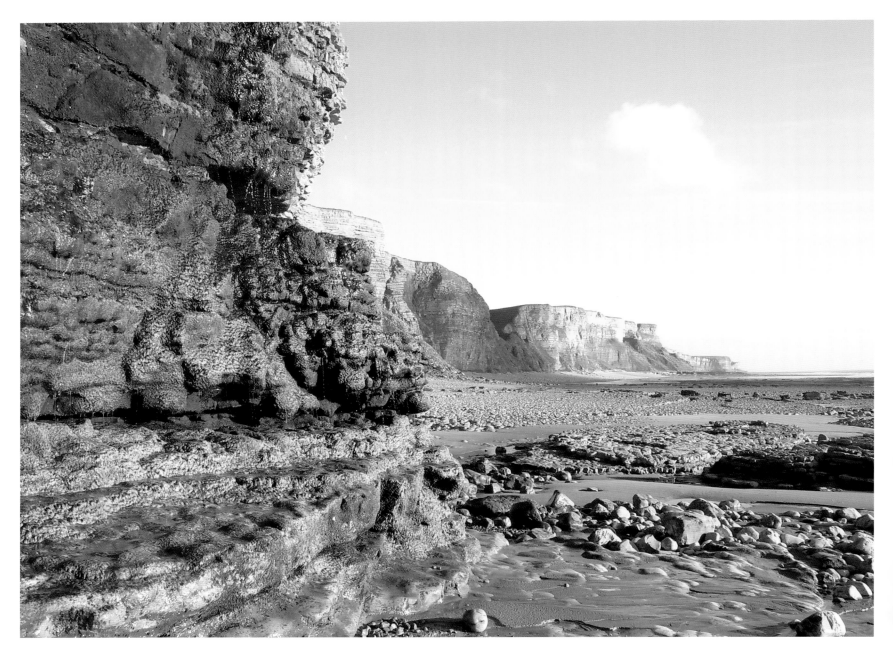

GARETH HUXTABLE

Dunraven Bay, South Wales

I was on a day trip, with my Dad, to Southerndown beach and I always take a camera. Although Southerndown is beautiful, when we walked over to Dunraven Bay, it took our breath away. The wavy lines of the rock strata on the shore, with a backdrop of 100-ft cliffs and an exceptionally blue sky, enabled me to take some really nice photos from the cliff tops. We walked miles along the beach and, on the way back, I decided to take this photo as the bright green moss added extra colour.

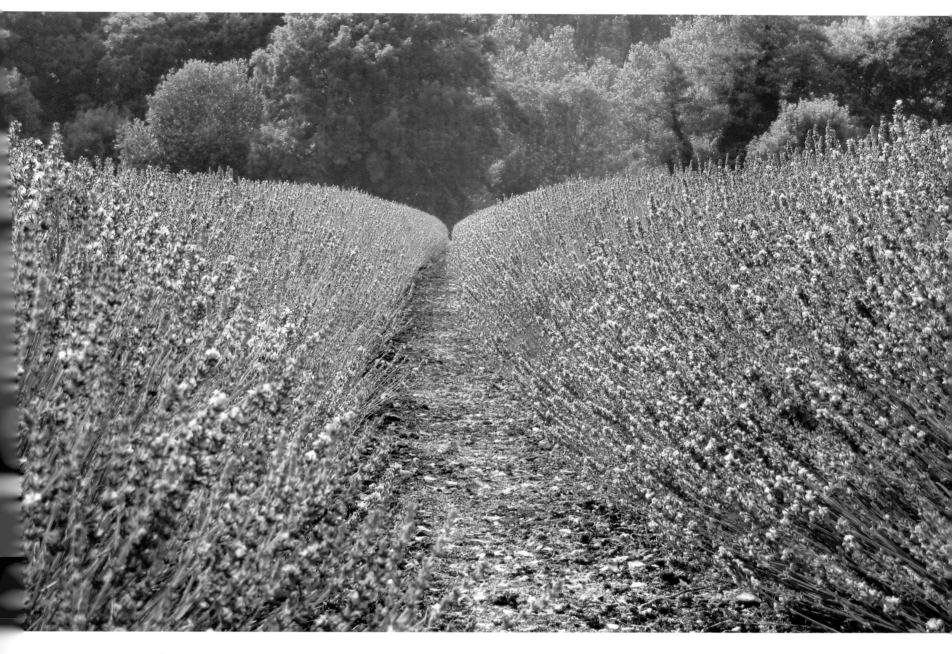

JOSHUA CURNOW

Lavender fields at Castle Farm in Kent, England

The lavender fields are part of Castle Farm in Shoreham, near Sevenoaks in Kent. I lay down on my tummy to take the picture at the edge of the field. I wanted to take a photo that showed the path between the plants going up and down the hills. I like the bright colour of the lavender in this picture.

LIVING THE VIEW
adult class

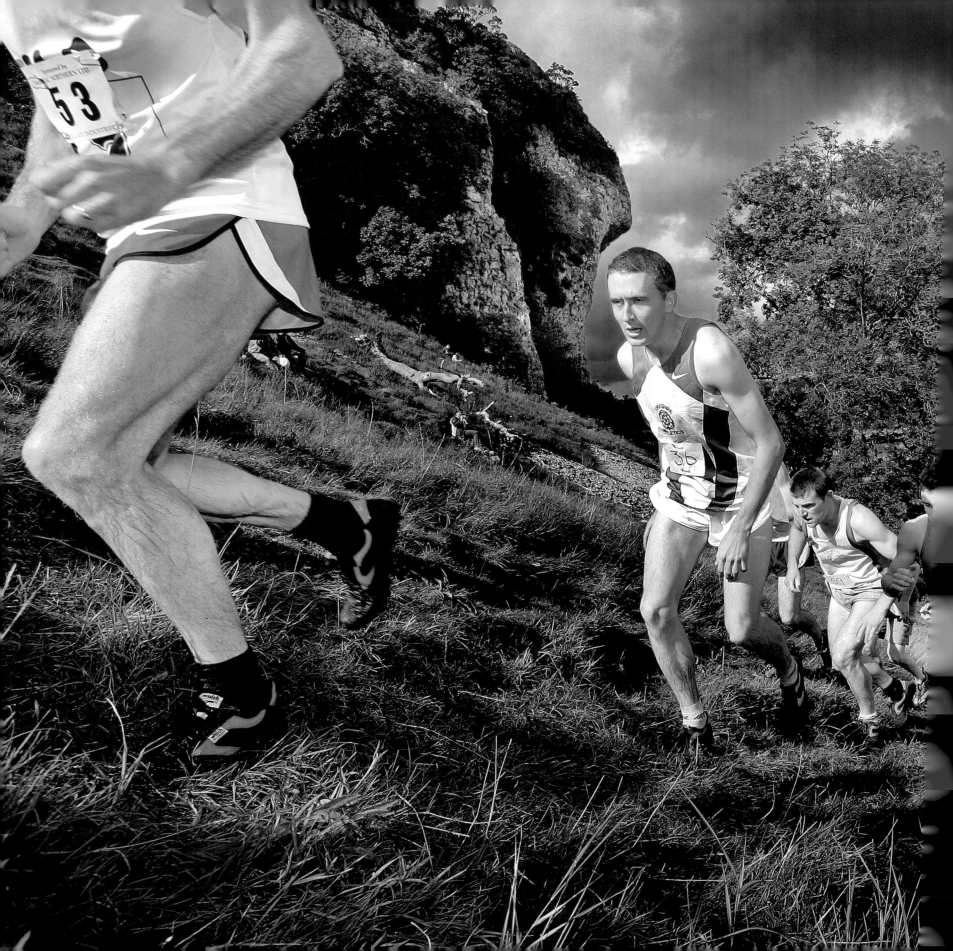

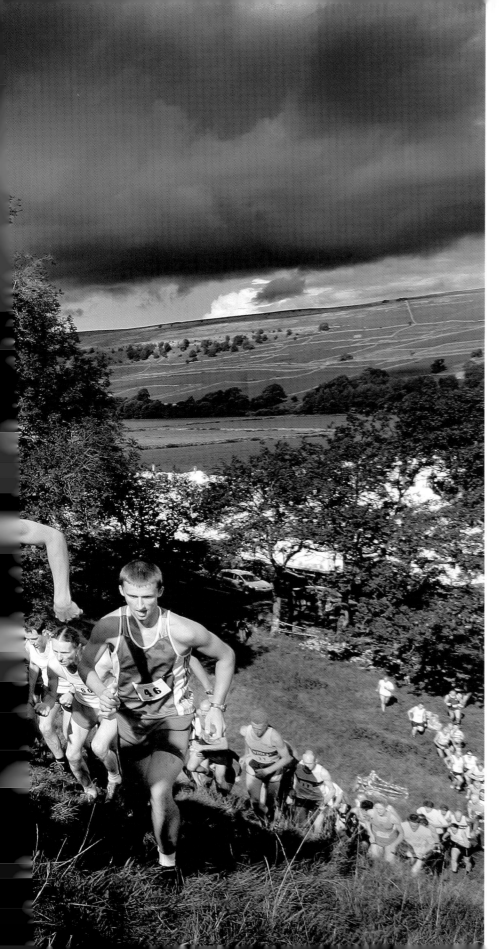

LIVING THE VIEW ADULT CLASS WINNER

STEPHEN GARNETT

The Kilnsey Show fell race, North Yorkshire, England

For hundreds of years the sport of fell running has been an integral part of shows and events in northern England. Here, the Yorkshire Dales offers a stunning backdrop as these hardy runners ascend Kilnsey Fell, as part of Kilnsey's annual traditional agricultural show.

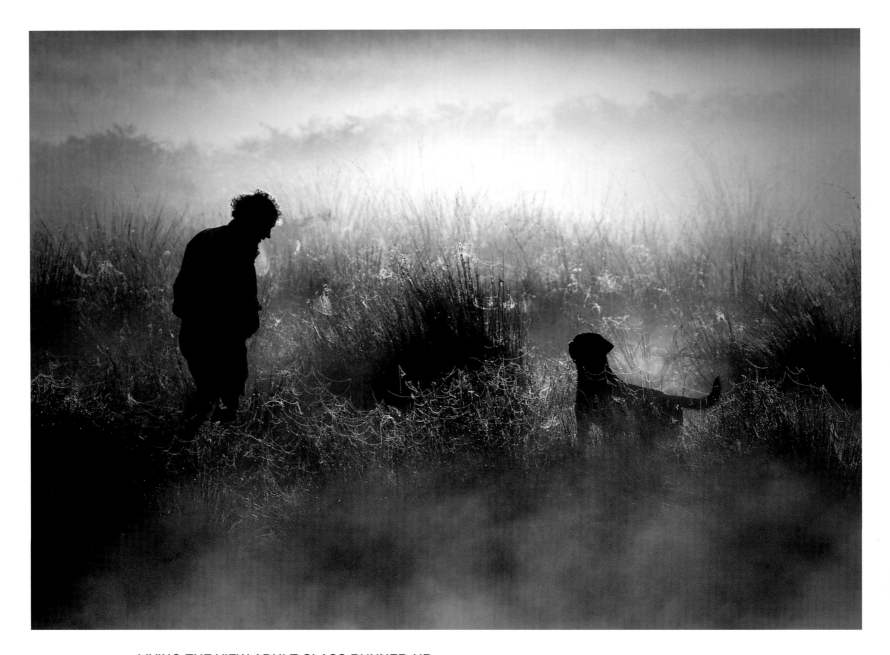

LIVING THE VIEW ADULT CLASS RUNNER-UP

ALEX SABERI

One man and his dog, Richmond Park, London, England

This was a chance encounter whilst shooting early one morning. I just love autumn with its mists and quality of light. For me, I loved the backlit cobwebs along with the dog's need for his master's approval.

Judge's choice Damien Demolder

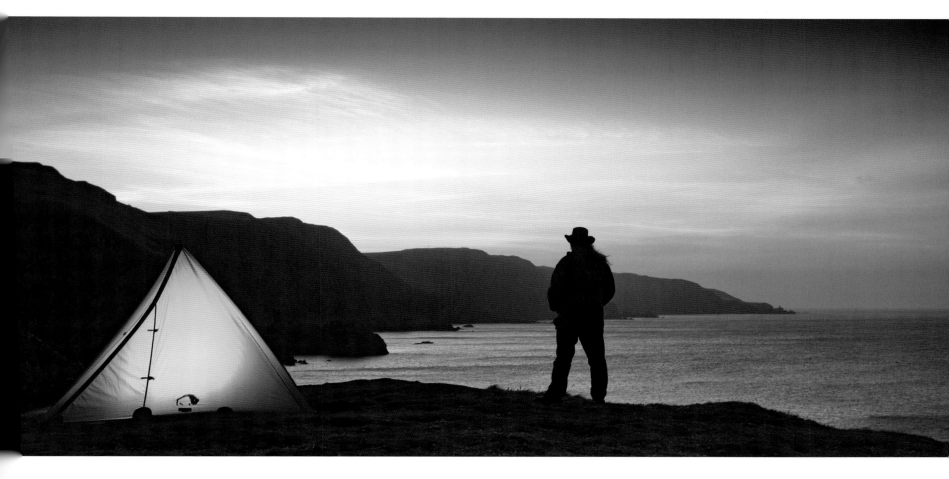

GARY WAIDSON

Wild camping on St Abbs Head, Scotland

I like to take my time when I am photographing the landscape and sometimes I enjoy camping near a location to really get a feel for the place. Sadly there are not many places in England where this is permitted these days so a trip to Scotland, where the outdoor access code allows for responsible wild camping, is a double pleasure for me. I had wanted a shot that captured that wild feeling for a while and as the sun was setting over St Abbs Head, I saw this opportunity. I rummaged through my backpack for a head torch and propped it up to illuminate the side of the tent against the dark headlands. The camera, on a timer taking bracketed shots, was set on a tripod, which meant that all I had to do was go and enjoy the view. It was a tough job but somebody had to do it.

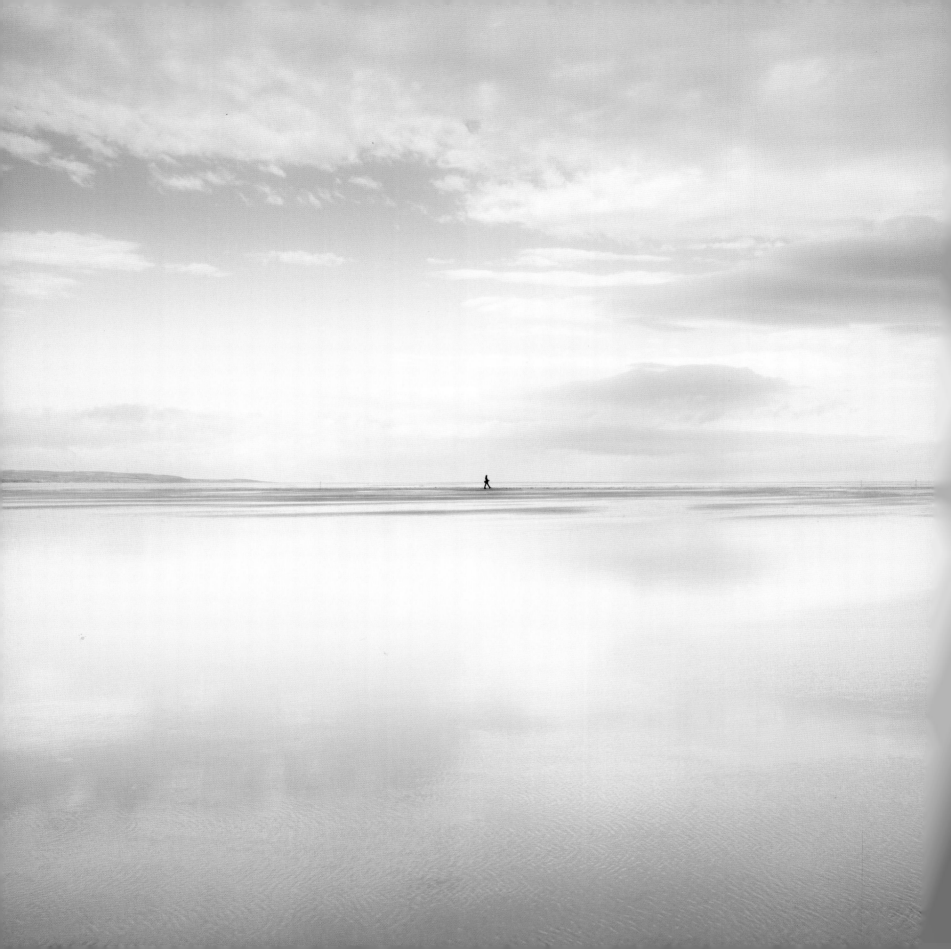

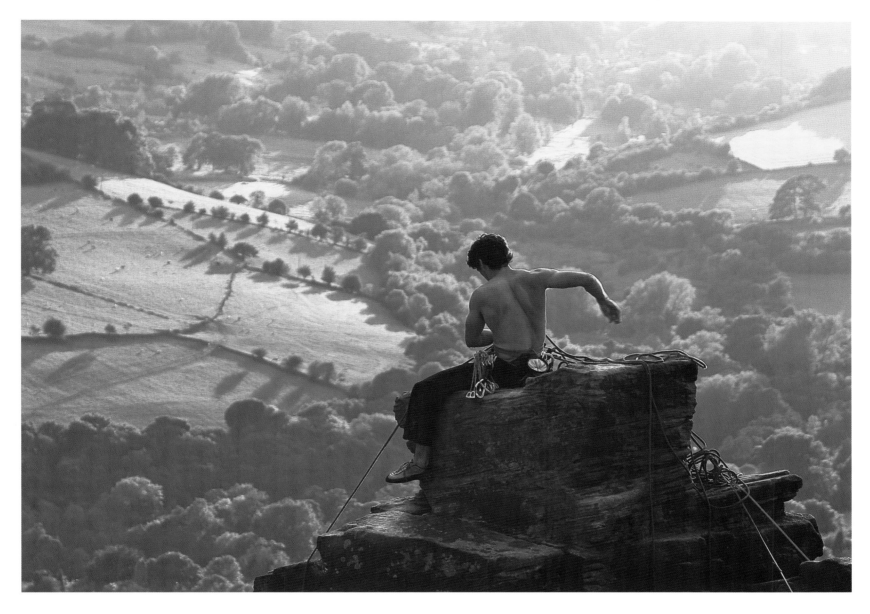

PETE BRIDGWOOD HIGHLY COMMENDED

Walking to Lindisfarne, Northumberland, England

A tidal causeway joins the Holy Island with the mainland, and becomes crossable at low tide. There is quicksand here, so there was a degree of hesitancy in creating this image. I positioned myself on the sands and as the water splashed around my ankles, I waited for an appropriate 'Pilgrim' to cross the causeway. I have broken some compositional 'rules' to introduce some subtle tension, placing the woman at dead-centre and the horizon exactly half way up the image.

LES FORRESTER HIGHLY COMMENDED

The Climber on Curbar Edge, Derbyshire, England

Originally I went to Curbar Edge in the Peak District to catch the sunset but, walking along the Edge, I spotted this climber on top of a rock called the Pinnacle. He just stood out so well backlit by the low evening sun; just one of those opportunities not to be missed.

CRAIG EASTON ···›

Paragliding over the Dee Estuary, Merseyside, England

The beautiful Dee estuary separates England's Wirral peninsula and the coast of North Wales. It is one of the most important wetland sites in northwest Europe and it's not just the wildfowl and waders that take to the skies here. Eighteen-metre-high boulder clay cliffs, at the Viking settlement of Thurstaston, make the perfect launch pad for paragliders who take flight over the sandcastles and fishing boats in the peaceful estuary below.

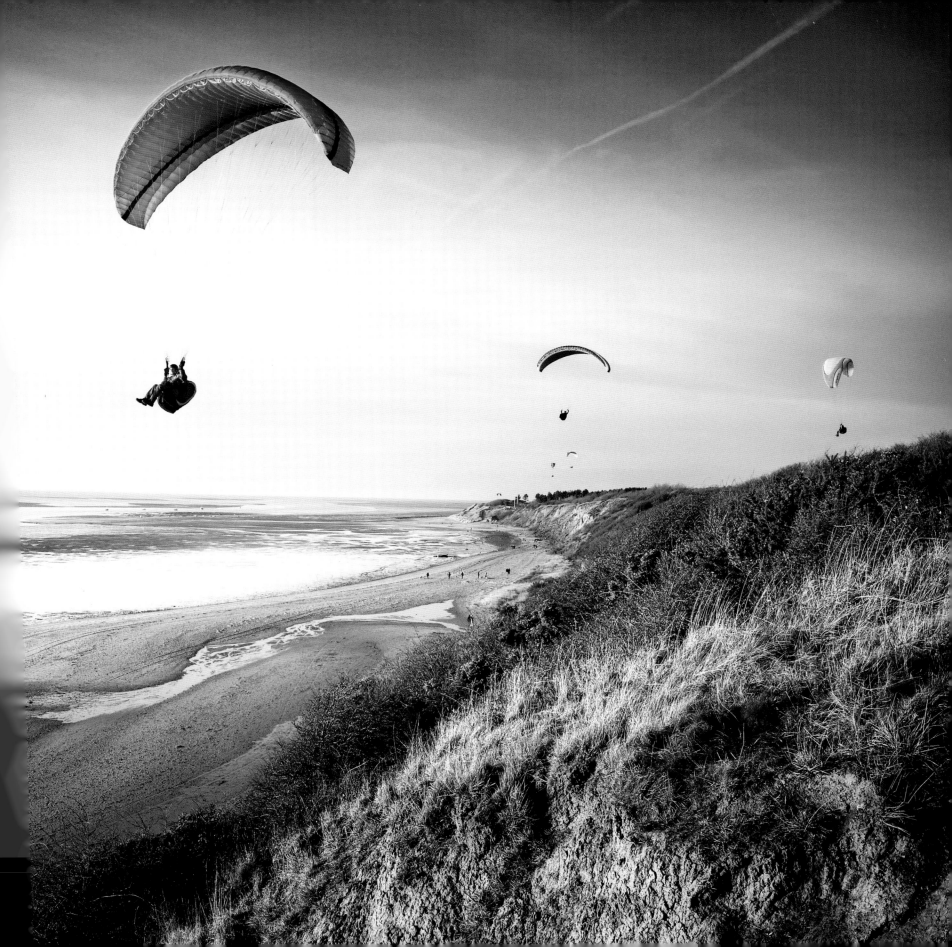

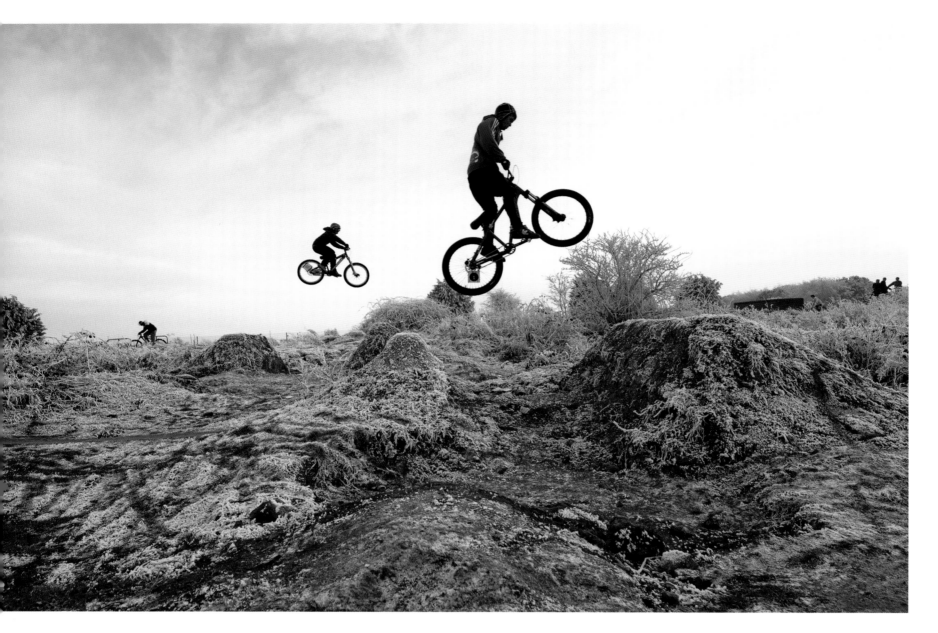

🌴 **CHRIS LEDGER**

BMX jumpers, Shoreham-by-Sea, West Sussex, England

I spotted the BMX park from the train. The cold water of the nearby harbour had kept the temperature down by an extra degree or two so that the morning frost had lingered all day. Clearly, the park's iron-hard ground held no fears for the local lads as they were out in force. Having walked back from the next station, I soon switched from photographing the landscape to photographing them in it. Indeed it was they who suggested taking a shot as a pair of them tackled two adjacent jumps at the same time. Lying low, it took several attempts before I had a shot in which their relative positions within the overall framing worked. (And no, there isn't any photo trickery here; they really were jumping that high.) Better yet, a third biker heading back around the park proved a happy accident that, for me anyway, nailed it.

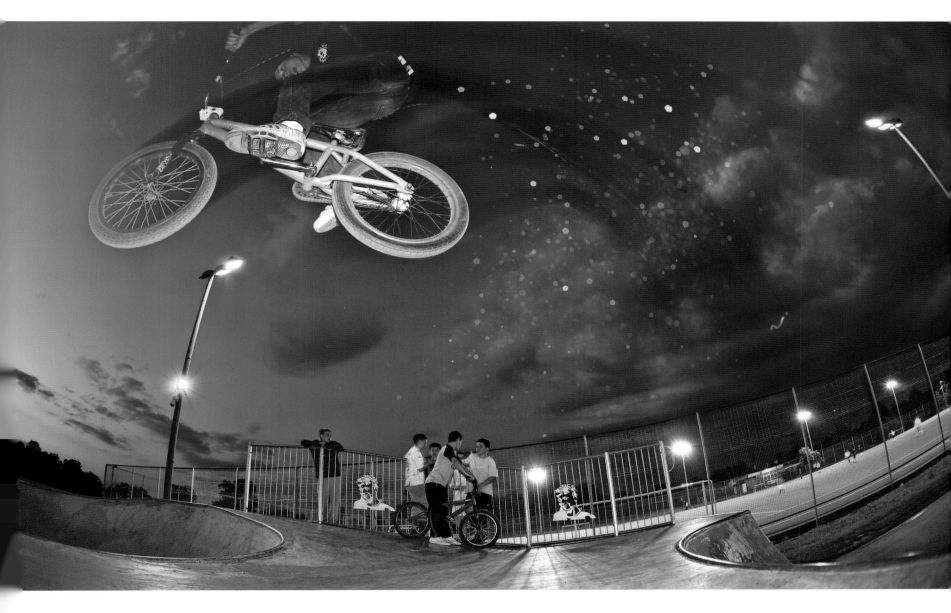

✝ JONATHAN LUCAS

The Conversation, Potter's Bar, Hertfordshire, England

BMXers congregate at a skate park. Engaged in animated conversation, or perhaps mild argument, they seem oblivious to the tricks being executed by their peer, expert rider Tom Brand. For these kids, who have grown up in an urban environment, there are no waterfalls, lakes, hanging gardens or canyons. Theirs is largely a world bereft of those riches. A world filled with the contours of concrete bowls and the flat, comforting green swathes of synthetic football pitches. It is, however, their landscape – one that they enjoy and thrive within and, dare I say, would be lost without.

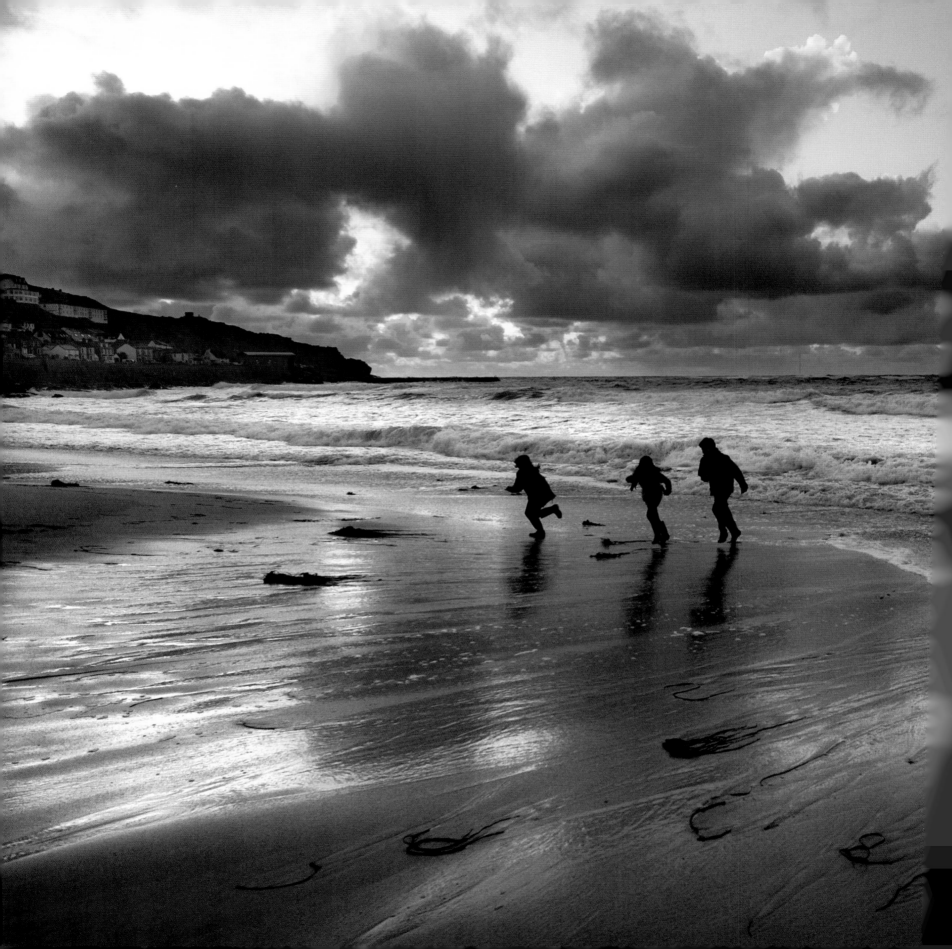

GORDON SCAMMELL

Run! Sennen, Cornwall, England

While walking back to the car park, after a long day photographing surfers on the beach at Sennen in Cornwall, I heard some laughter behind me. I turned and saw this magical combination of running children, the setting sun, dramatic clouds and the sea. Luckily I still had my camera to hand. Perfect!

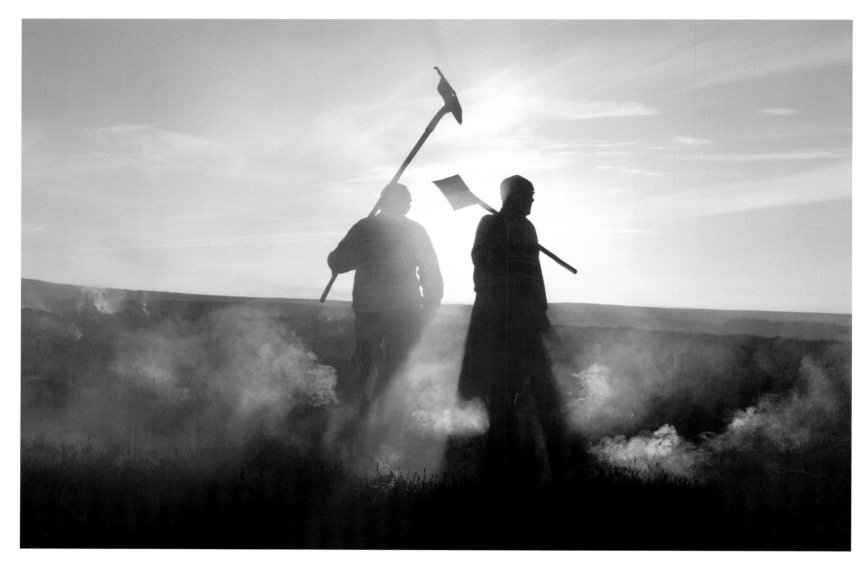

JAMES SWAN

Heather Burn, Blanchland, Co. Durham, England

Even when on fire, the moors can be one of the most beautiful surrounds and, when the ever-changing winter light combines with the age-old custom of heather burning, it makes one realise just how beautiful and precious they are. Burning, as a form of moorland management, allows new heather shoots to grow for the grouse to feed on which, in turn, bring in money to reinvest in the moorland. Without the grouse shooting and the management that goes into the moors it is unlikely that we would see them as they are today.

GORDON FRASER ⟶

Giant's Causeway, Co. Antrim, Northern Ireland

This image was taken on a glorious, sunny day in August at the Giant's Causeway whilst I was on a photo walk with friends.

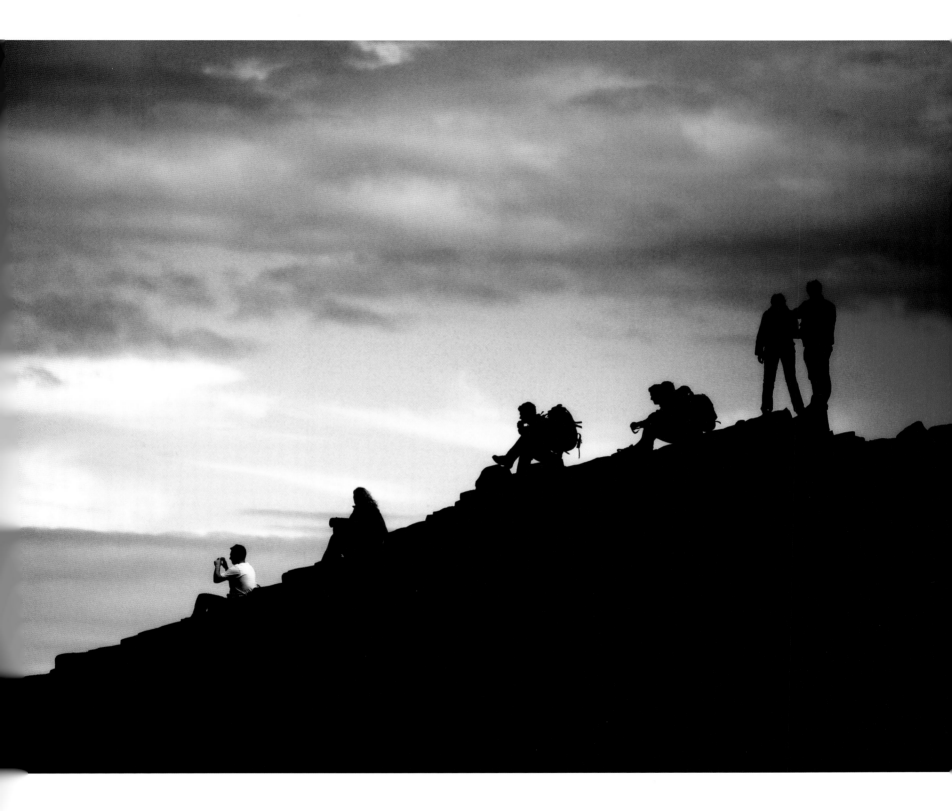

⚡ GRAHAM HOBBS

Autumn cycle ride, Kingston Lacy, Dorset, England

This avenue of beeches near Kingston Lacy House is about 170 years old and an increasing number of trees are being cut down for safety reasons. I had decided to record it through the seasons before too many more gaps appeared. By November, I was six months into the project and knew where to go for the best runs of trees, but they weren't always the ones with the best colour. I finally decided on this view, but I felt that it still needed a focal interest and a sense of scale. The first miracle was when a cyclist came pedalling down the hill, providing both; the second was that he was not joined by any motor traffic as he reached the perfect place on this normally busy road.

ROGER CLEGG ⋯⊱

Sycamore Gap, Hadrian's Wall, Northumberland, England

This picture of Sycamore Gap is a combination of planning and luck. Hadrian's Wall at this point runs ENE to WSW presenting a short period around midsummer when a good sunset picture is possible. The first year I tried to get the picture poor weather prevented it. The second year on midsummer night the weather was perfect. At dusk, fragmented cloud stretched across the northern sky gloriously illuminated by the setting sun. The walkers were the 'luck' completing the picture. Slow shutter speed has slightly distorted them into elfin-like figures. Sycamore Gap is the most distinctive and recognisable feature of Hadrian's Wall and the southern end of the Northumberland National Park; this photograph gives an almost graphic image of this iconic and most recognisable landmark.

Northumberland National Park Authority – Best image

Northumberland
National Park
Authority

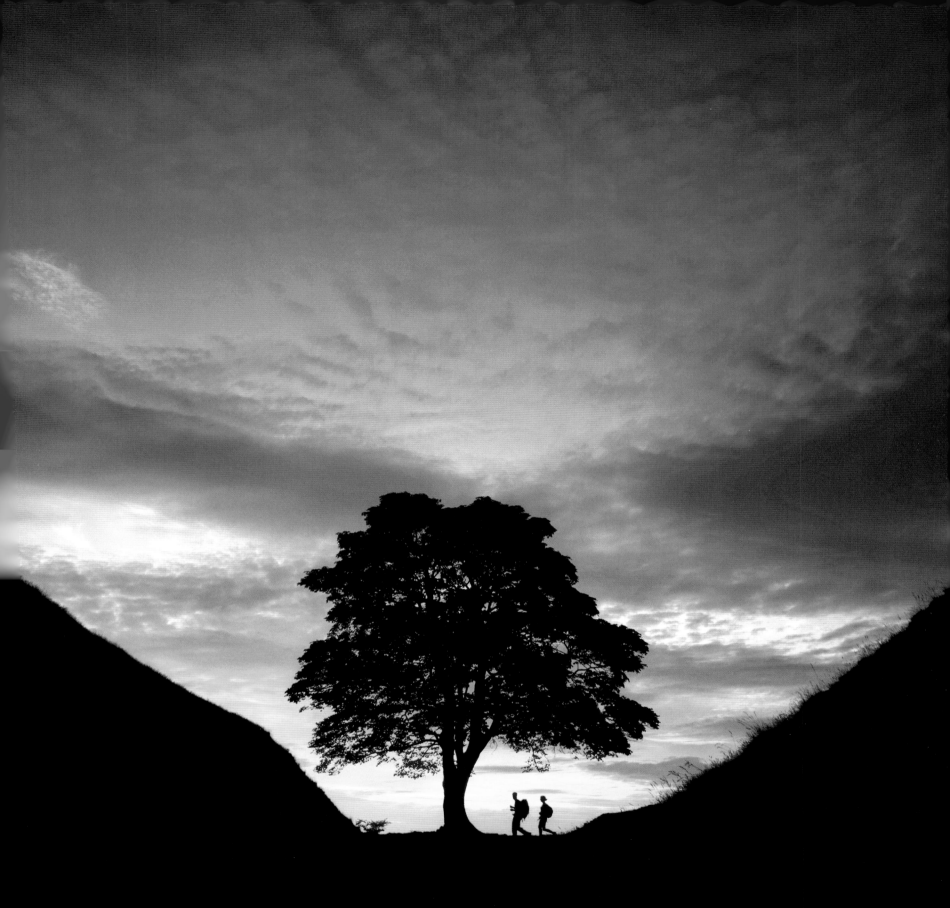

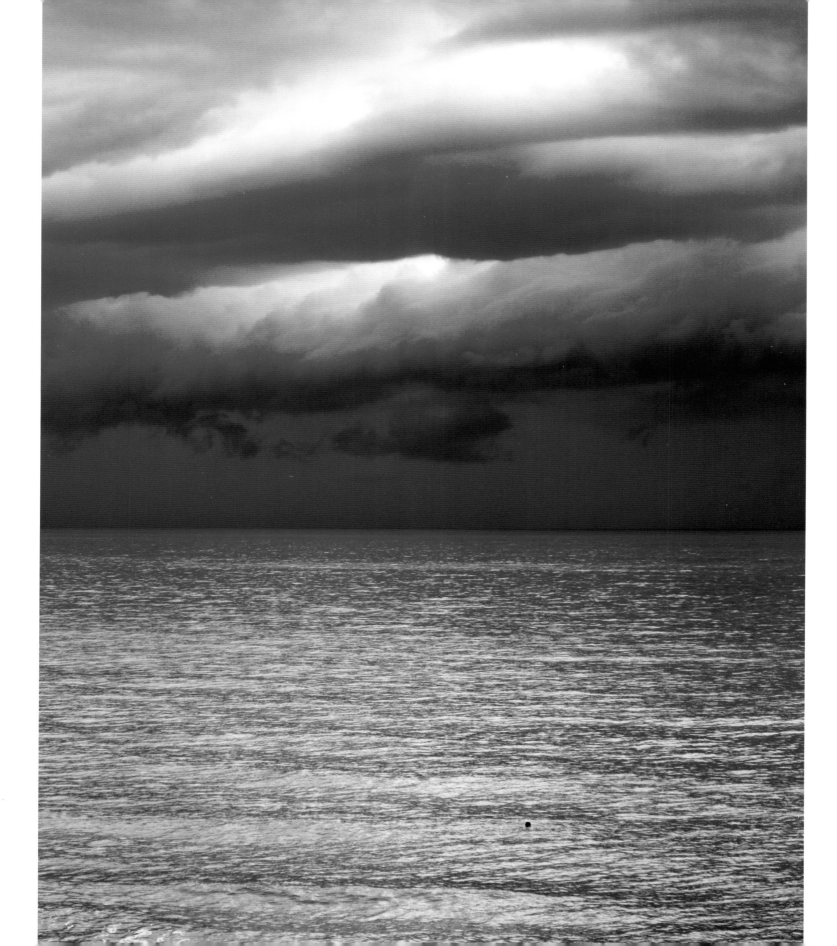

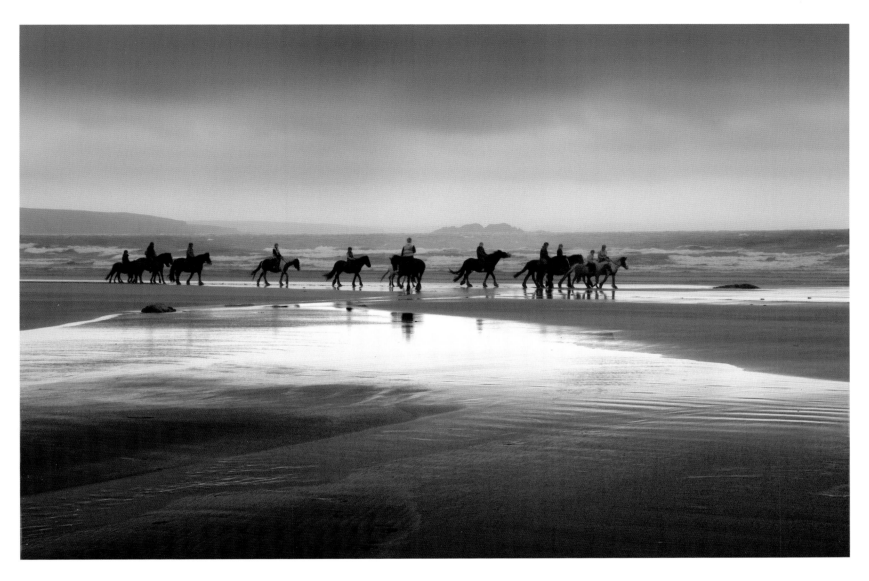

:::◄ MATT KING

The Swimmer, St Leonards-on-Sea, East Sussex, England

Within ten minutes of taking this picture, the wind was howling, the sky turned grey and it started to pour with rain. This tranquil moment of calm before the storm was a beautiful and unusual sight, perfectly complemented by a lone swimmer heading out to sea.

⚓ BRIAN GRIFFITHS

Riding school, Pembrokeshire, Wales

It was a cold, wet July day in Pembrokeshire. I saw these horses coming and knew they would make a good picture, but I needed a strong foreground. I ran over to a patch of water just in time to get the shot. A minute later they were gone.

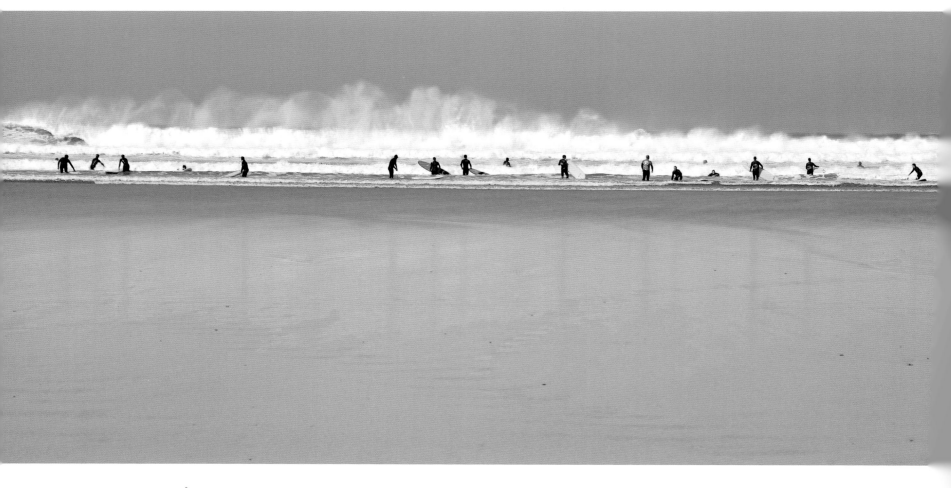

STEVE REW

Surfers at Watergate Bay, Cornwall, England

I was attracted by the spray blowing off the rough sea and the surfers silhouetted against the white water. The two red surfboards contrasting against the line of yellow boards added to the impact of the shot.

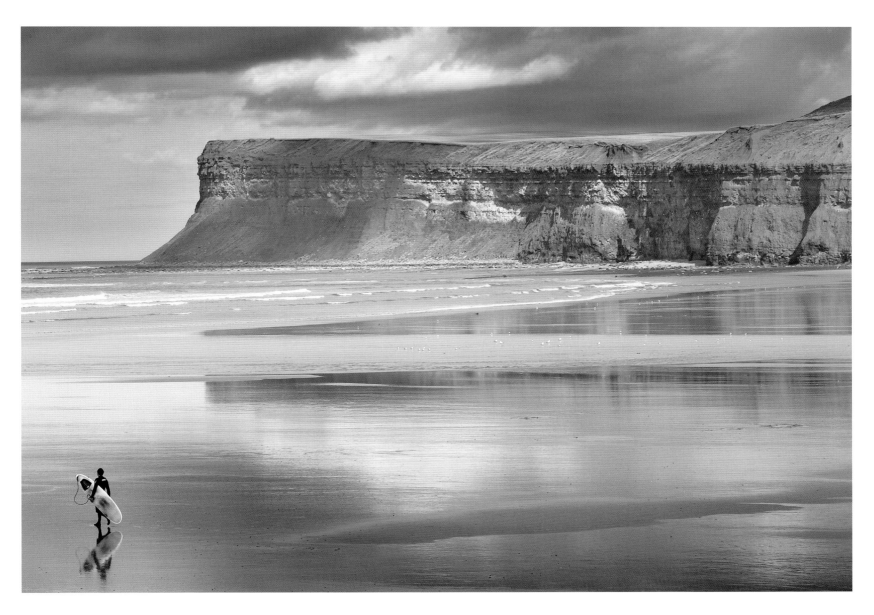

✈ IAN SNOWDON

Heading for the surf, Saltburn-by-the-Sea, North Yorkshire, England

As I live close to the area where the photograph was taken, you get to know your 'hot spots'. This particular evening was one in a million. The tide was low, but it had left enough surface water to pick up all the reflections and colours that the gorgeous, low evening light was casting. I set up my tripod and composed my 'visual' shot from the nearby pier. I didn't have to wait long, as the obliging surfer appeared perfectly in the frame. I took seven frames and felt this was the best. As yet, not a professional – but one can dream!

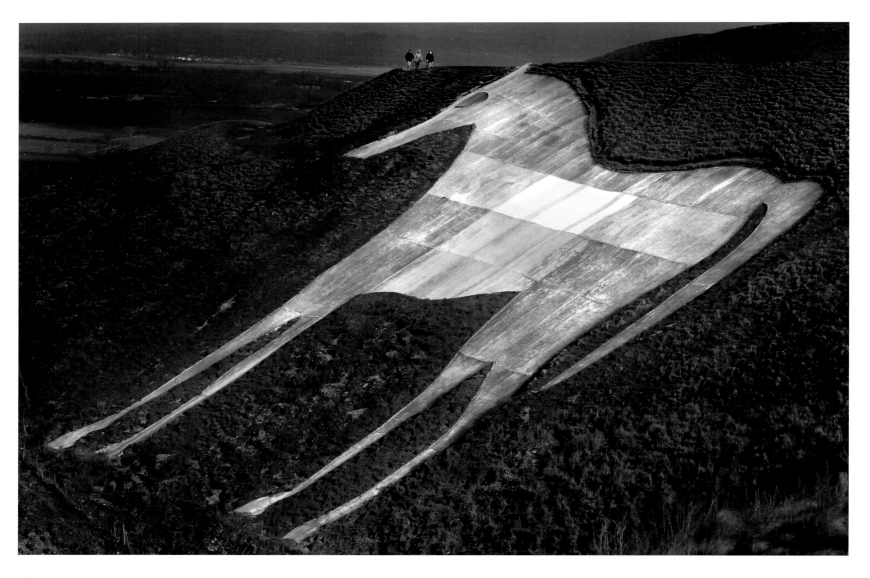

☝ MAGDALENA STRAKOVA

Westbury White Horse, Wiltshire, England

I was travelling with my friends around the UK and desperately wanted to see some of the famous chalk horse hill figures, because I am a keen horse lover. We chose the Westbury White Horse, because it was on our way to Exmoor National Park. We were rather disappointed to find out it is no longer made from chalk – the horse is covered with concrete to reduce the maintenance costs. But still, the horse is really a nice one and it looks great on the hill. To really appreciate the size of the figure, you have to put a scale on the picture. Since there is a path close to the horse, it was not that hard – I just had to plan where to stand and wait a little for a group of people to come. I like the way the hill figure dwarfs the human figures.

PETER SMITH ⋯⟩

Mountain biker near Acton Bridge, Cheshire, England

In the North West, we had experienced a long run of poor weather, but on this late winter afternoon the sun had broken through the clouds creating light and cloud movement that was simply breathtaking. Although a 35-minute journey, the location was perfect and so worth the dash to capture such fleeting conditions. I set my tripod aside so I could achieve an ultra-low viewpoint on the deck of the footbridge. I had just made a final check on composition and focus when the mountain biker suddenly appeared on the horizon. Instinctively, I released the shutter and captured the moment. He looked as if he had just won his event in the full golden glory of the setting sun. We chatted and it turned out he works in the photographic industry on Merseyside. Then dusk fell.

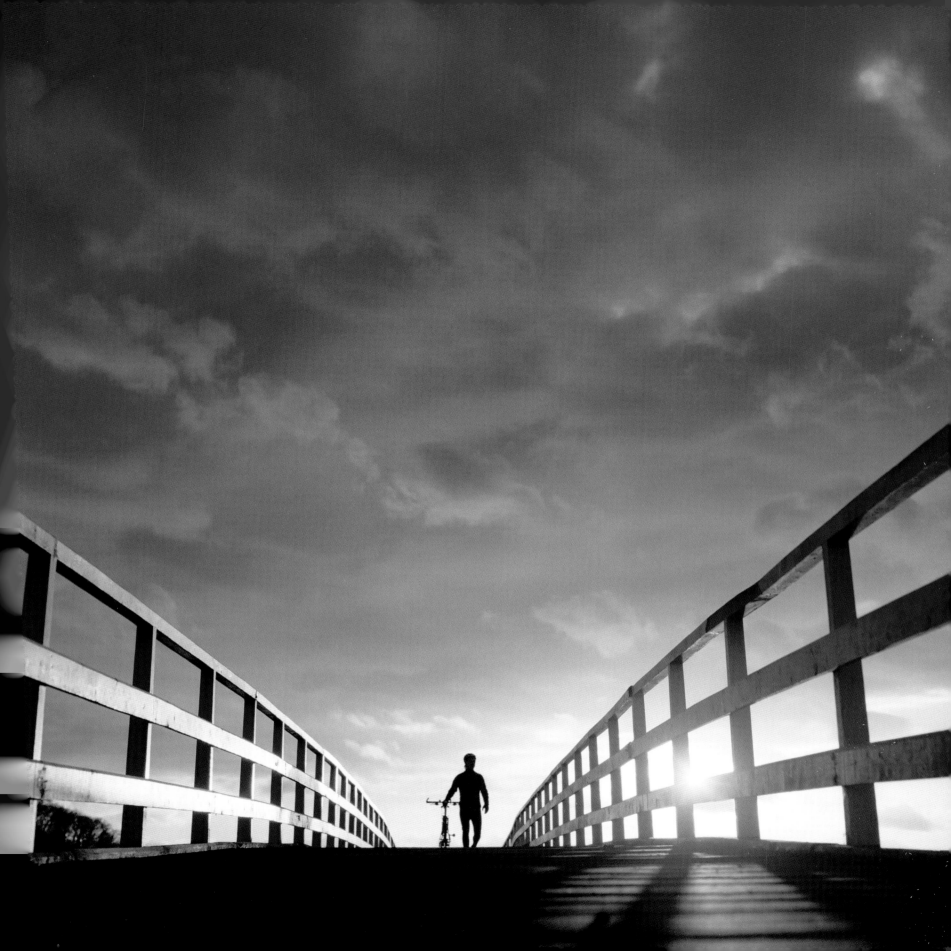

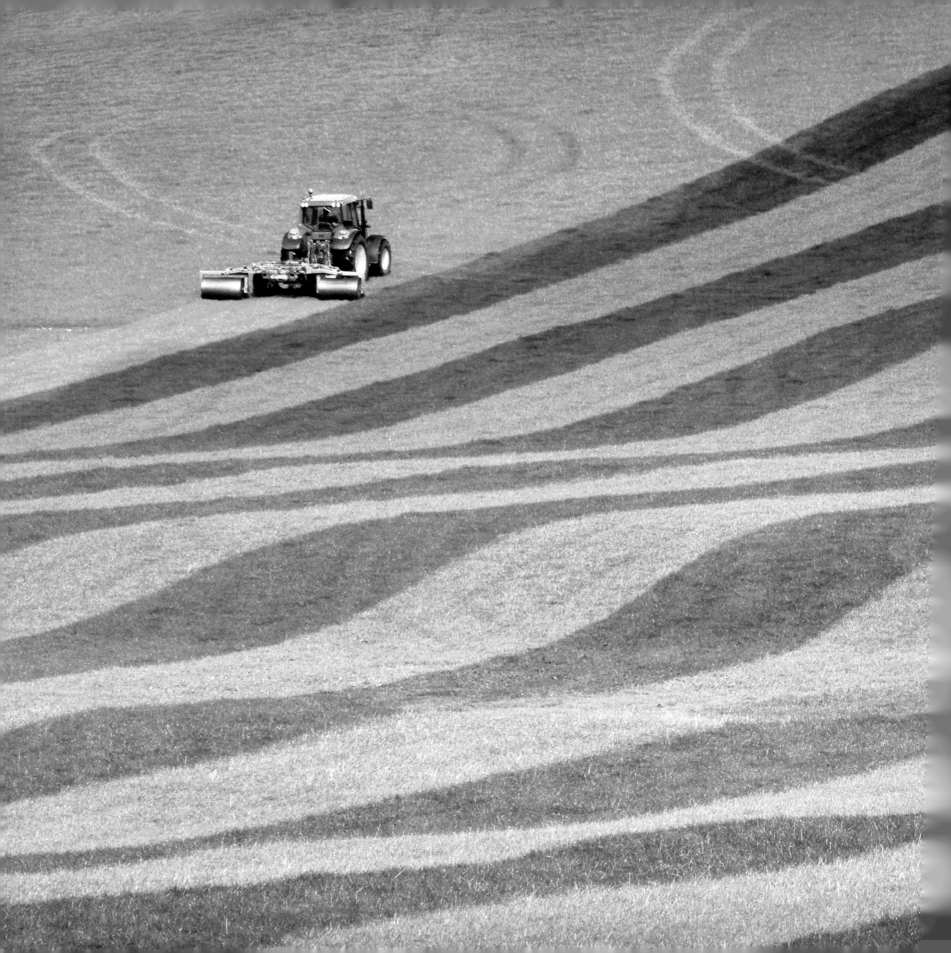

ANNA WALLS

One man went to mow, Kimmeridge, Dorset, England

I was on my way to Kimmeridge Bay, with a group of friends, one evening in April, when this beautiful field caught my eye. I particularly liked the way the undulations of the land distorted the stripes and the warm evening light warmed the whole scene.

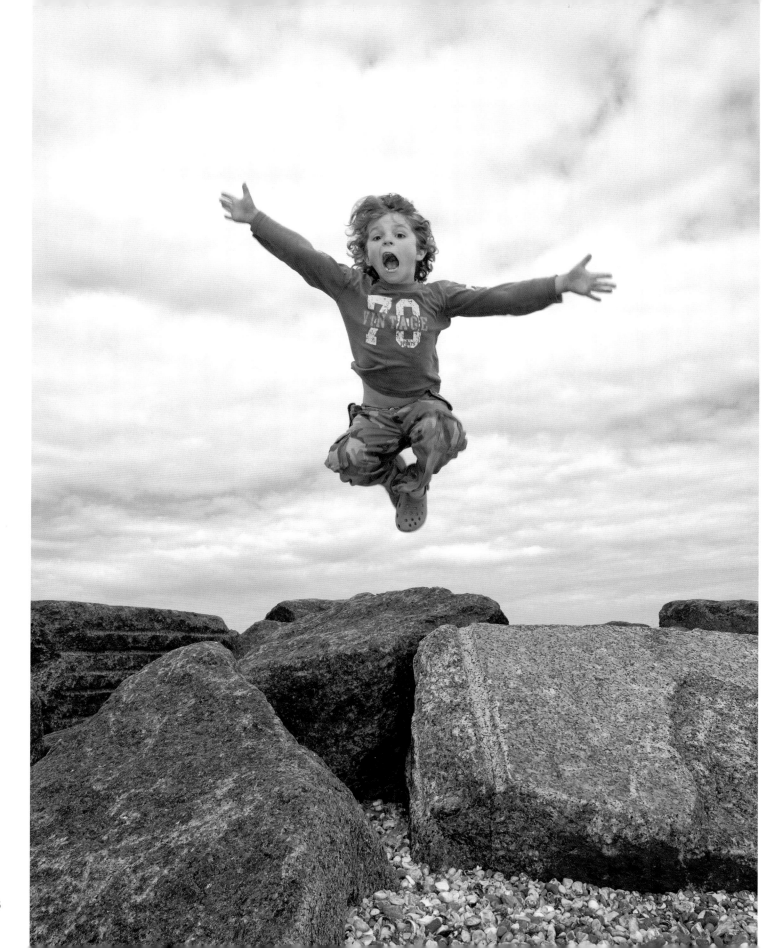

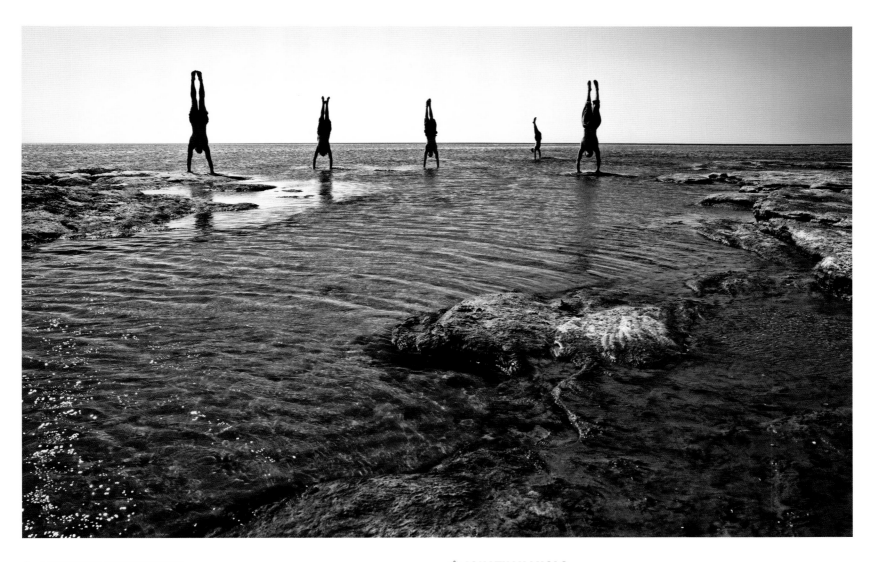

LAURENCE CARTWRIGHT

Frequent Flyer, on the rocks at Shoreham, West Sussex, England

Taken with my brand new camera on the beach at Shoreham-by-Sea. The picture is of my son, William, who jumped about half a dozen times while I chose the best settings and angle. William is an exuberant boy and I love this picture because it captures his excitement and joy at the act of leaping into the air.

JONATHAN LUCAS

Sculptures, Wirral, Merseyside, England

Traceurs perform a handstand in unison at the place they love to practice. The Wirral in Merseyside offers much for freerunners with its unusual mix of wonderful natural beauty and suburbia. This spot in Hoylake is a favourite for its variable formations and undulating terrain. My aim was to positively influence what nature has created with the presence of the athletes and to leave the viewer with the sense that this scene is actually improved by the spatial balance created by their forms.

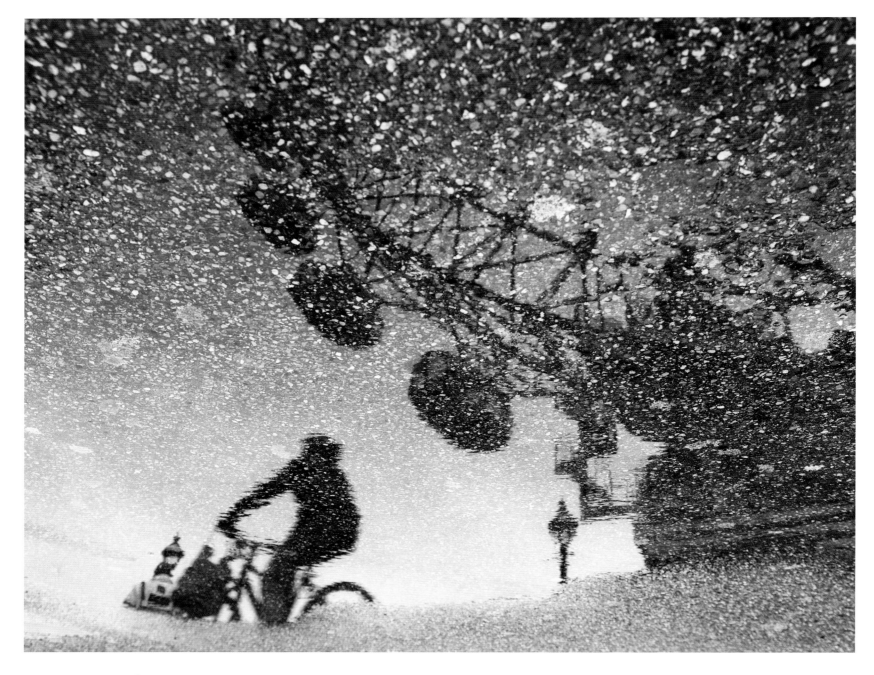

✦ **ALEX SABERI**

Eye after the storm, London, England

Part of a series of photos that I made called 'London reflected in the rain'. What I loved about this photo was that the ground had small coloured pebbles that in the reflection looked like a snowstorm. I wanted to capture people going past and waited for a cyclist.

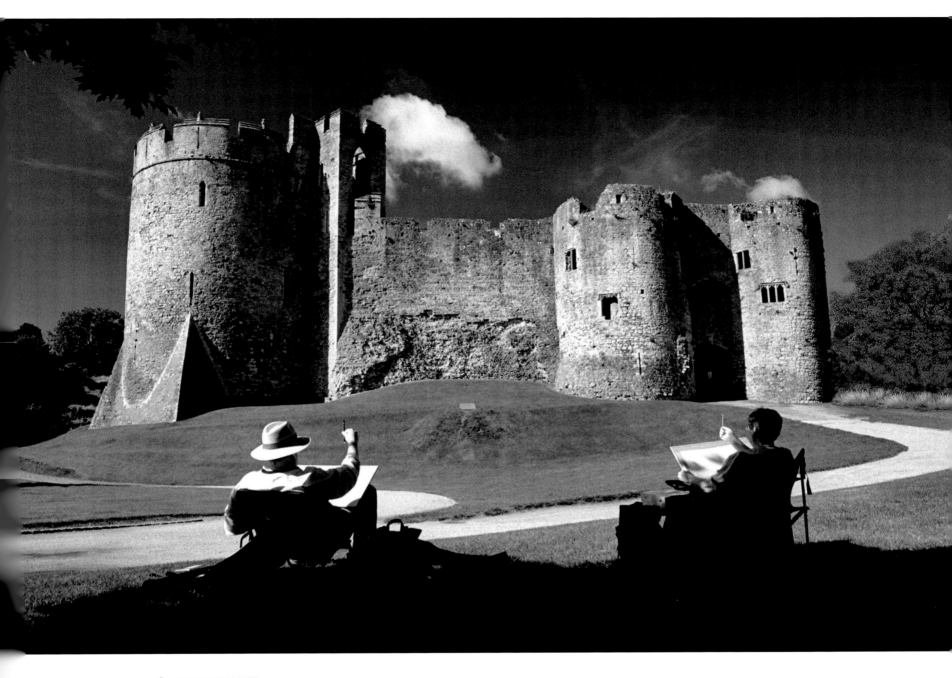

CHRIS BRYANT

Artists measuring up at Chepstow Castle, Wales

Chepstow Castle always draws me. I suppose it's the ancient high towers that seem so precariously perched on the bank of the River Wye. It looks so lonely standing there, a herald of times past, of lives long gone, an alien in the contemporary world. By chance, on this particular bright spring morning, a small group of artists were preparing to commit the stout towers to canvas. They were oblivious of my presence as I watched and made my own picture.

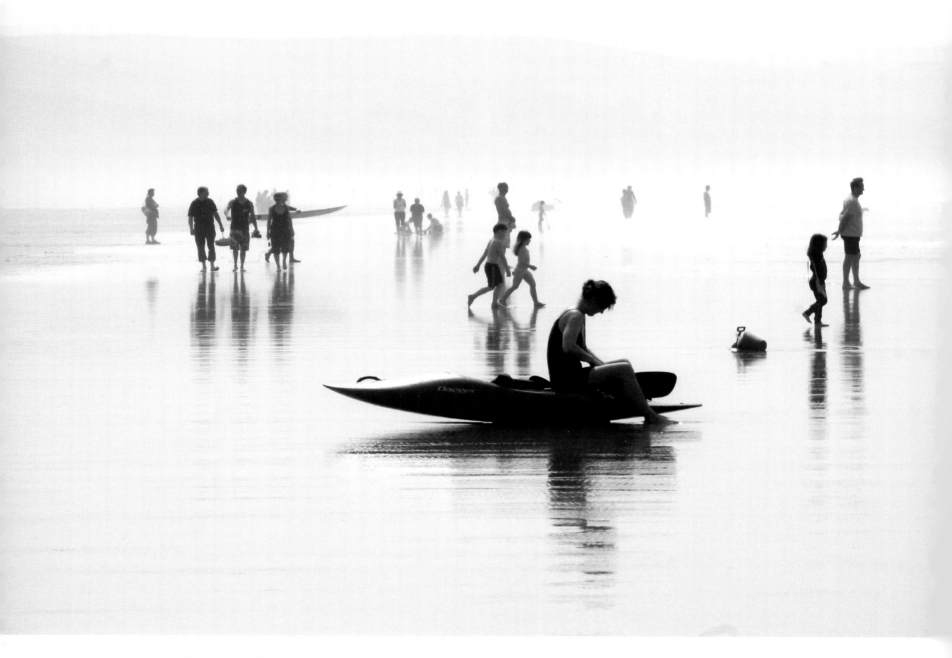

RICHARD HARRIS

Beach Life, Woolacombe, North Devon, England

I'd only been using a digital SLR for a few months and was experimenting with the various settings when I captured this photograph in Woolacombe. Coming from a creative background, I wanted to use the camera as more of an artistic tool and not just to capture great pictures. I set the ISO deliberately high, so that the added noise would create a sort of painterly effect. It was a warm hazy Saturday morning and about midday. There was an excitement on the beach – something you could hear but not see. As the mist started to rise with the sun directly above, I had a few seconds before the moment had gone.

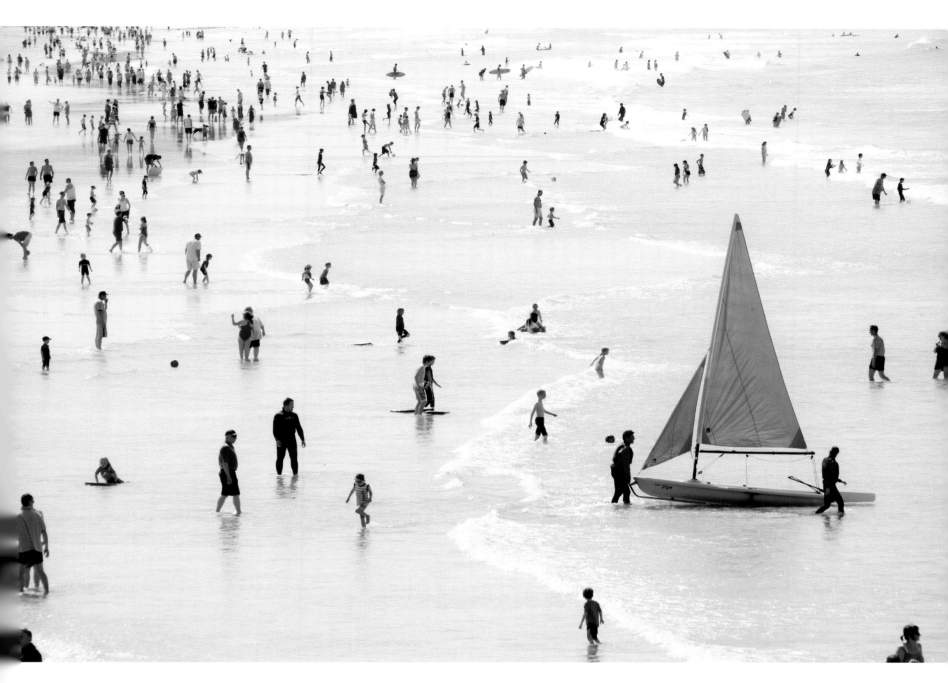

🕆 MARK BARTON

Portstewart Strand, Northern Ireland

This image was taken on a trip to Portstewart on a hot and sunny day in May. Having spent time there before, I knew that the Strand Beach would be full with people enjoying the good weather. I went to a location overlooking the beach. Just when I arrived the blue sailed boat was being launched, which I just got into the shot. A moment later, the boat was away.

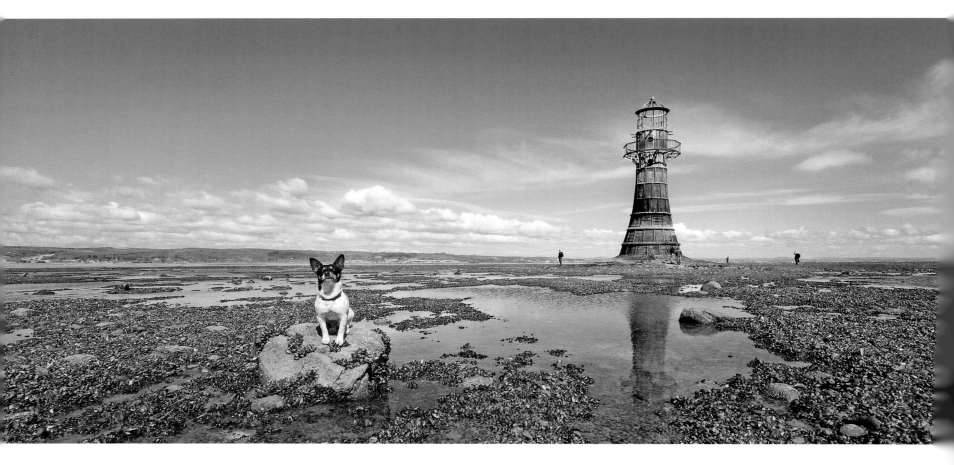

⚓ TOM ROBERTS

Whiteford Lighthouse, Gower Peninsula, South Wales

This solitary cast-iron beacon doesn't really catch the eye from a distance but, having checked the tides, walk the two-mile stretch of sand for a more intimate view and you'll not be disappointed. Towering 6oft above the Loughor estuary, this relic of Victorian maritime history is quite unique and the effect of erosion and rust on its algae-stained and barnacle-encrusted plates enhances its photographic potential. The composition you see here is a favourite of mine from this location. It isn't the norm by any means but it's the involvement of Eric, my dog, that makes the picture work for me. Fortunately, the antics of a soaring seagull held his attention for the split-second when the shutter fired.

JONATHAN LUCAS ⋯⊹

Physical Artistry, Wirral, Merseyside, England

Daniel Ilabaca, one of the world's best freerunners and exponents of parkour (the art of free movement) performs a backflip off the Red Rocks at Hoylake on the Wirral. He has grown up in this area and knows these landmarks well, helping him to fine-tune his discipline. These natural features offer much variety to a freerunner, while at the same time evoking respect and love for their natural beauty. In this image I take great pleasure from the harmony of shape between man and geology, the corrugated layers of rock contrasting with Daniel's characteristic poise and grace – together skimmed by a radiant sun highlighting their contours.

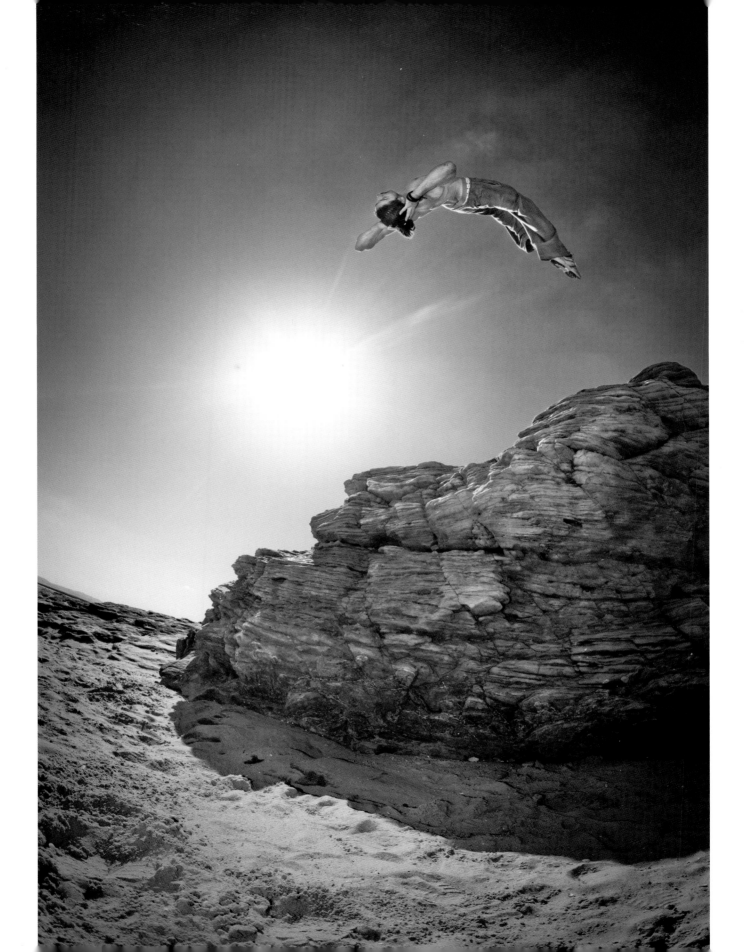

MARCUS McADAM ⋯⋯⟩

Footprints at Talisker Bay, Isle of Skye, Scotland

This is a picture of my wife, but she was too light to make deep footprints in the sand, so I made them and then had to walk the long way round to get back behind the camera.

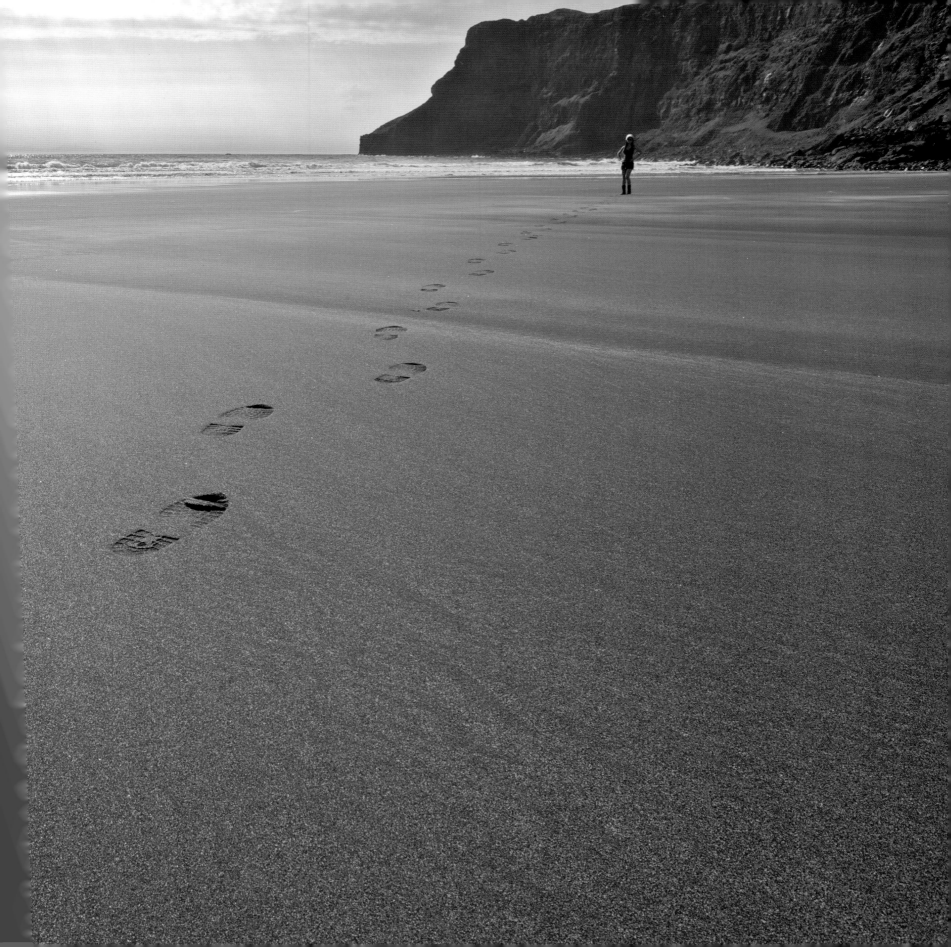

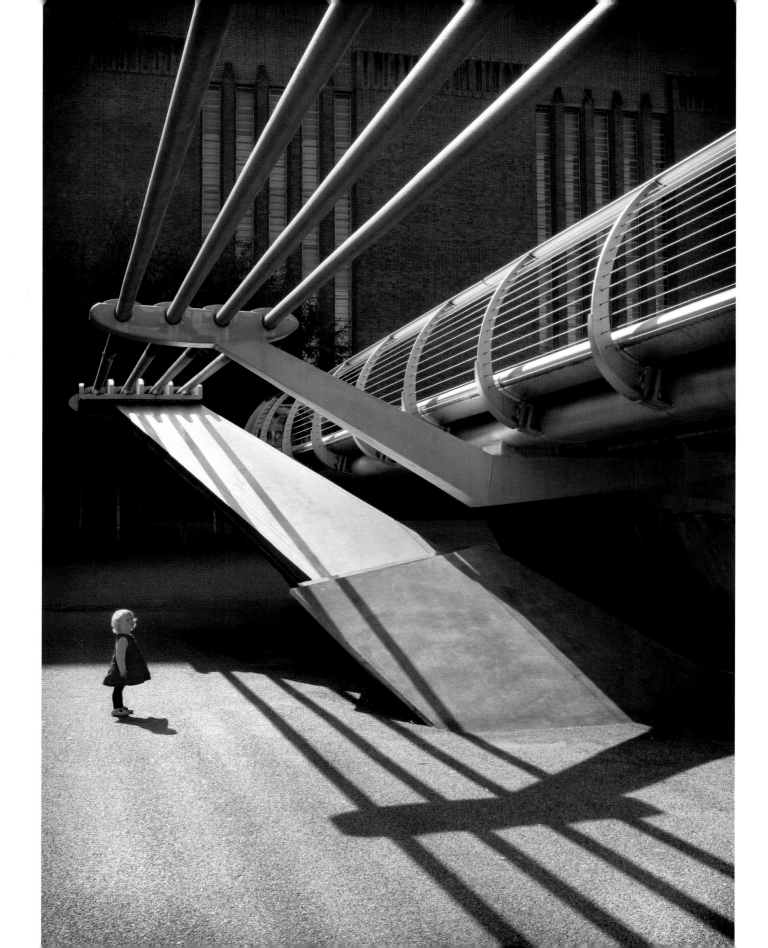

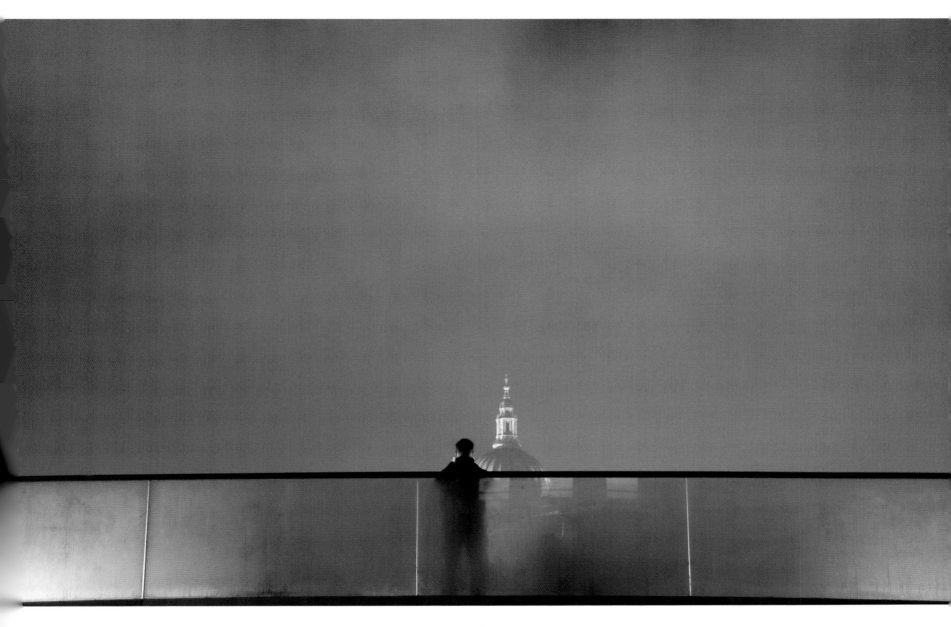

ROSIE ALDRIDGE

Millennium Bridge at noon, London, England

I was struck by the strong midday shadows cast by the bridge. As I was taking the shot, the young girl ran into view. By chance, something caught her attention just at that moment and she looked up.

DAN LAW

Millennium Bridge, London, England

A tourist pauses to take a photograph of St Paul's Cathedral from the Millennium Bridge in Central London. This picture was taken in the late afternoon just a few days before Christmas.

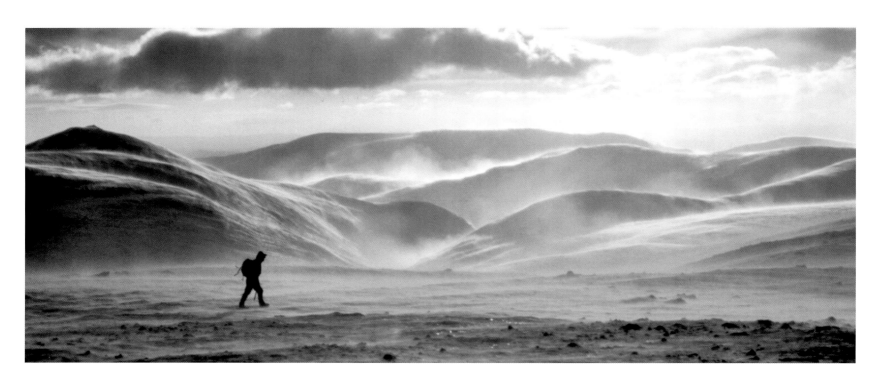

CRAIG WELDON

Spindrift in Glenshee, Perthshire, Scotland

As we ascended this hill, each step released a demon of energy, screaming across the landscape at calf height. Eventually, approaching the broad, shallow spine of the top of the hill, the entire landscape was shifting around us like the surface of the sea in a hurricane. Stinging needles of ice attacked our exposed skin, and we turned heads into our hoods against the onslaught. The spindrift was like daggers, and yet, when we eventually lifted our battered eyes, the beautiful scene you see in this picture surrounded us: smooth, sculptured hills rendered soft to melting point by their fuzzy surfaces, a vast landscape ennobled by wastes of blown snow rising into the air, threatening a battering to those foolish enough to wander their otherwise nondescript slopes.

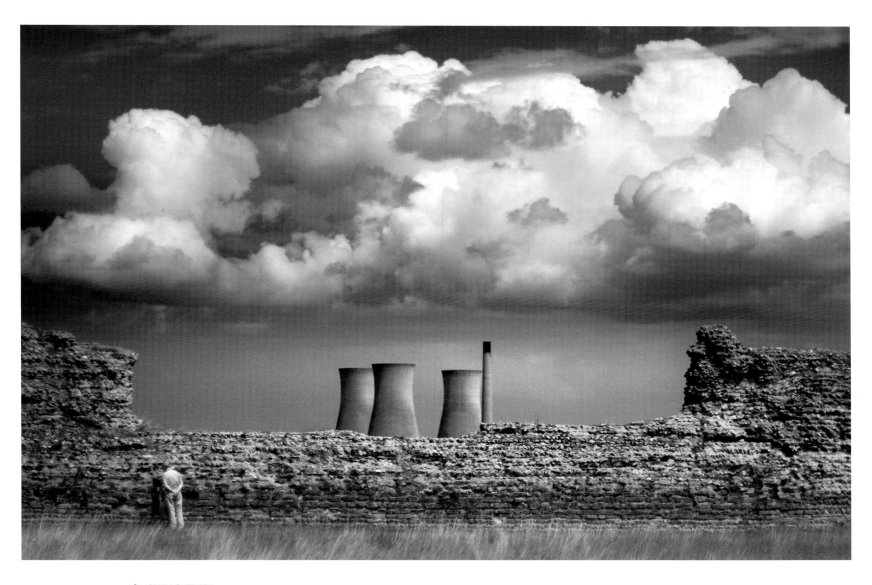

CHRIS FRIEL

Richborough Roman Fort, Kent, England

Taken during a wet morning, wandering around the fort. The power station made me take my camera out and the man studying the wall was a bonus.

DAVID HUTT ···↯

Clevedon Pier in November, North Somerset, England

My Uncle Alan, 85 years old, slow but as upright as the lamp post. We went for a gentle walk along the beautifully restored pier at Clevedon. The late autumn sun was crisp and clear, throwing the forms into sharp relief. As my uncle walked along the decking, he and his shadow formed a harmony with the lines and angles on the pier, which made me take the photograph. Black and white seemed the obvious choice.

130

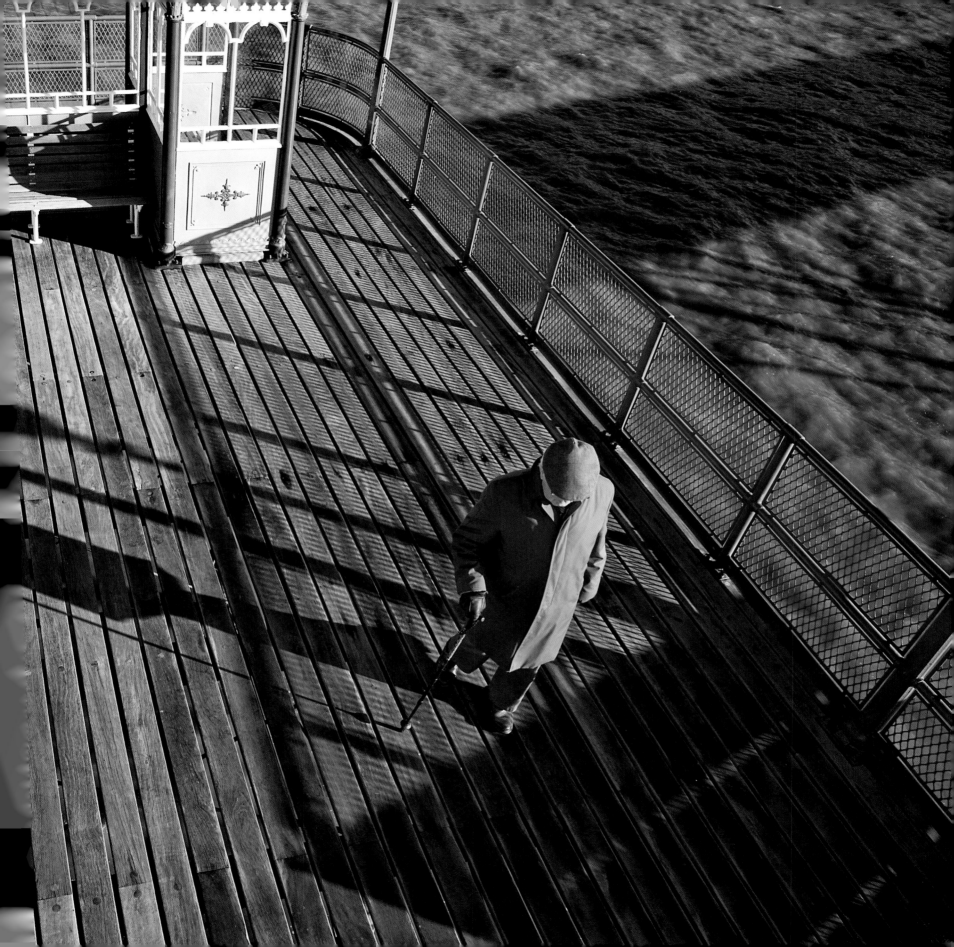

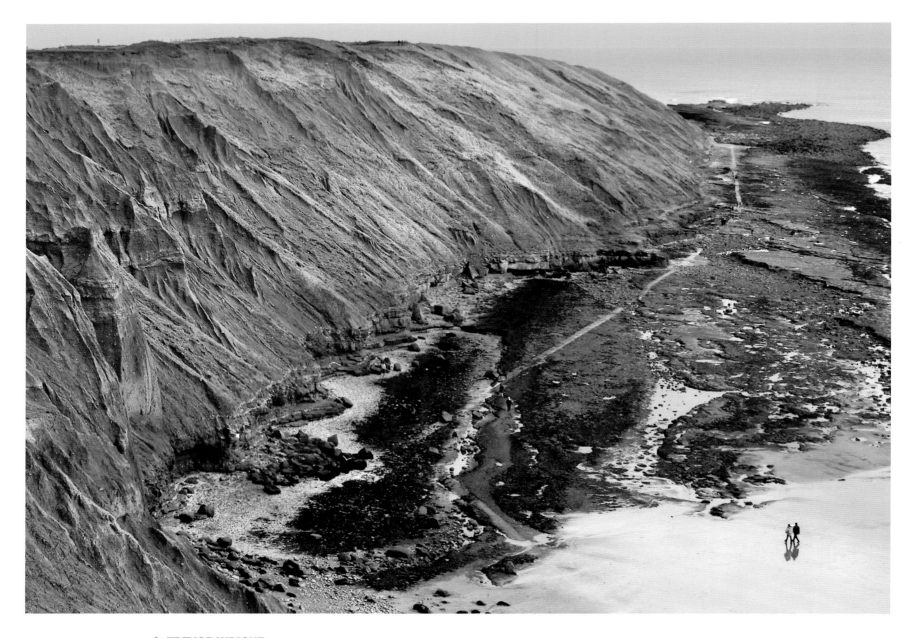

⁎ TREVOR WRIGHT

Filey Brigg, North Yorkshire, England

I arrived at Filey almost by accident. I 'needed' a day out to take some photos; working full time, I get precious few chances. I'd never been to Filey Brigg and, being based in York, I drove east and found myself there before I knew it. This shot was one of many taken that day. It was January so the day was cold and there were few people about. As I walked along the top of the Country Park, this view caught my eye — the texture of the cliff, the starkness of the shore at low tide — then I noticed the couple walking, which gave a sense of scale. Their reflections in the wet sand were I think, a bonus.

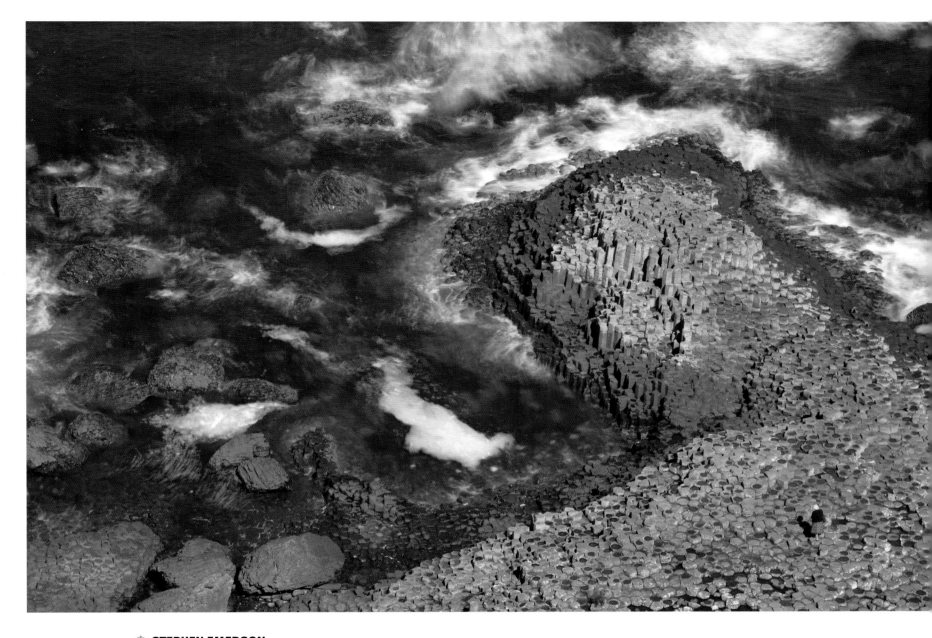

STEPHEN EMERSON

The Eighth Wonder, Giant's Causeway, Co. Antrim, Northern Ireland

I chose this elevated view from the cliffs that overlook the Giant's Causeway as it provides a different perspective on this famous landmark. Using a 10-stop ND filter, I experimented with different shutter speeds to obtain a good speed on the water. A woman entered the frame and her inclusion gives some scale to this geological wonder. She stood in this spot motionless for about three minutes taking in what used to be dubbed by many as the 'Eighth Wonder of the World'. The sheer strangeness of the place makes this a 'must see' for any traveller to Northern Ireland.

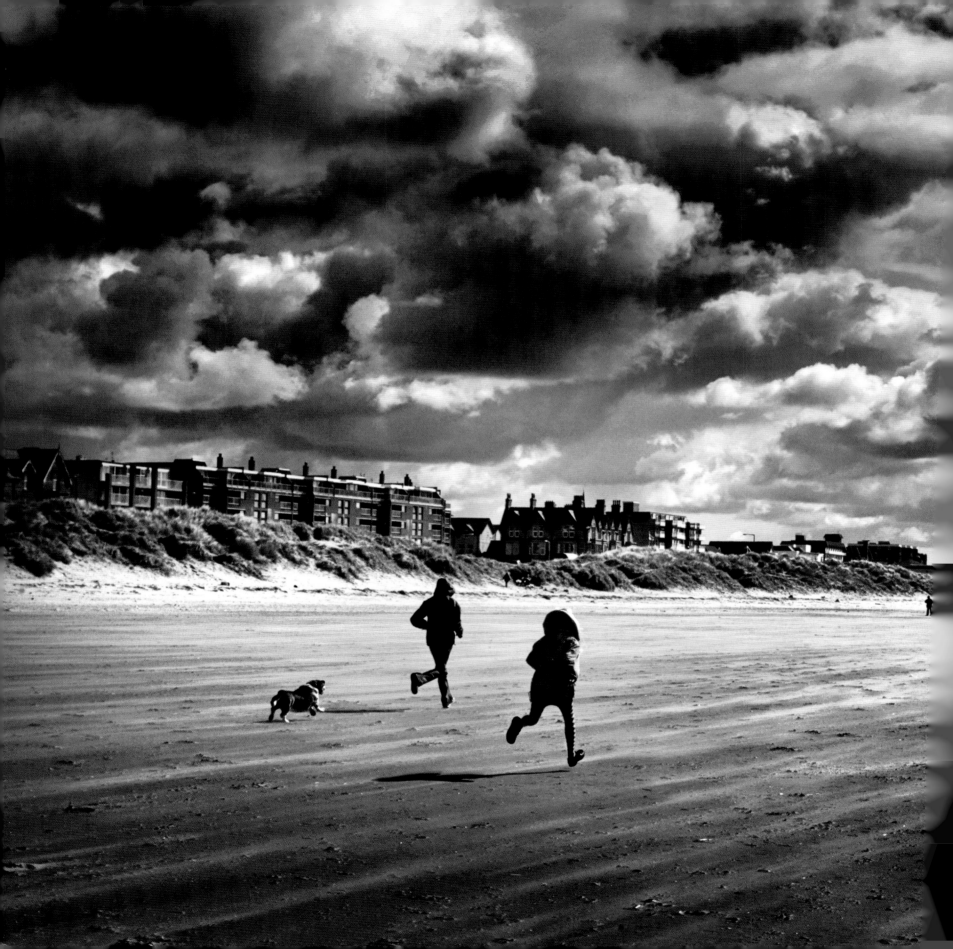

⟨···· **JEFF ASCOUGH**

Running for cover, St Anne's-on-Sea, Lancashire, England

I was out walking the dog with my family on the beach, a couple of miles up the coast from where I live. As it was cold, we had started to head back to our car when the sky started to darken and the wind began to blow quite fiercely; it was obvious that a storm was on its way. Knowing how quickly a storm can materialise near the coast, my wife and daughter decided to make a run for the pier to get some cover, with the dog in hot pursuit. I had my camera with me and saw the potential of a picture. I liked the ominous sky, quite unlike anything that you see inland, and the sand being blown about making ghostly patterns on the beach. I took several images and this was the most successful, with the symmetry of my wife and daughter running together. This is a very personal picture for me and hangs in my living room at home.

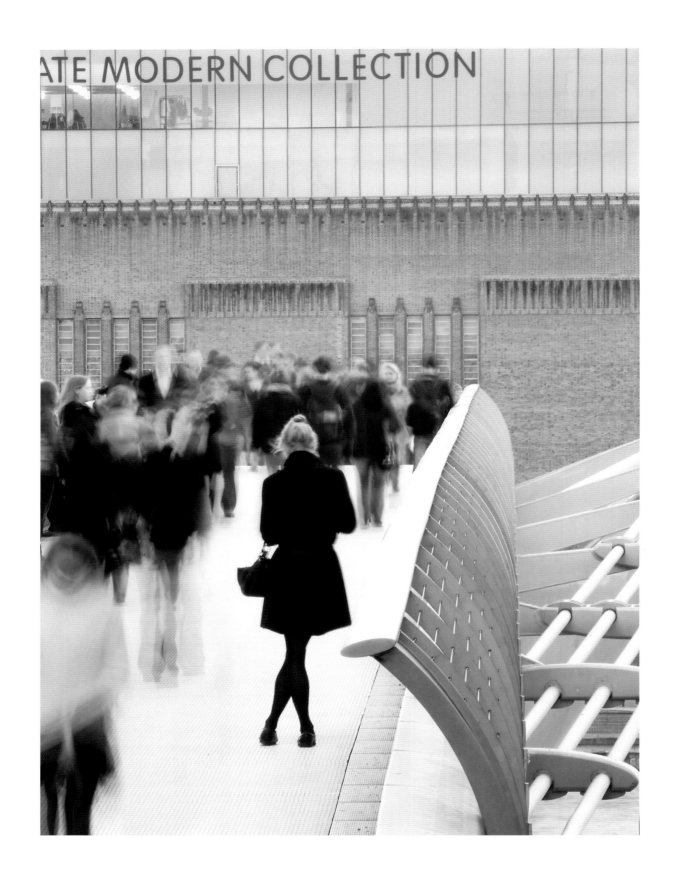

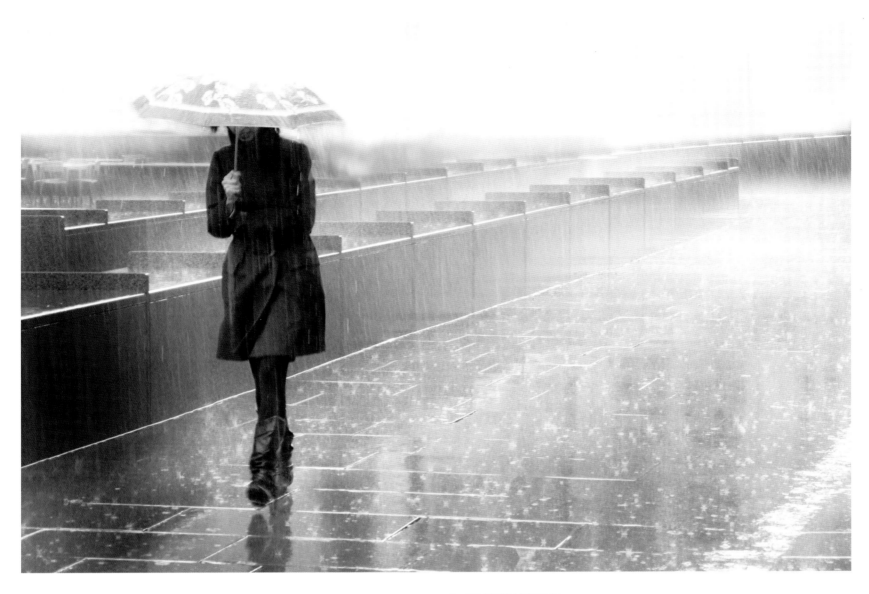

⤺ ANDREW DUNN

Trapped in a moment of time, Millennium Bridge, London, England

A woman frozen, stationary, on the Millennium Bridge as the rest of world passes her by. I don't know what stopped her in her tracks, what she found so absorbing — perhaps a text message from a friend, a relative, a lover — good news, bad news, we cannot tell — but she was trapped in her own thoughts, hardly moving a muscle, for several minutes, before moving on and rejoining the general hustle and bustle of London life.

⤙ MARTIN ERHARD

Downpour in the City, London, England

After an appointment in the City, I was making my way past the Gherkin building when there was a sudden cloudburst. Along with everyone else I ran for shelter but looking back down the street saw this solitary girl braving the elements with just a flimsy umbrella. I grabbed the camera from my bag and just managed to capture this one image before she passed. A simple, almost abstract shot right in the heart of London; a minute later the sun came out and the street was bustling with people again.

Judge's choice David Watchus

LIVING THE VIEW
youth class

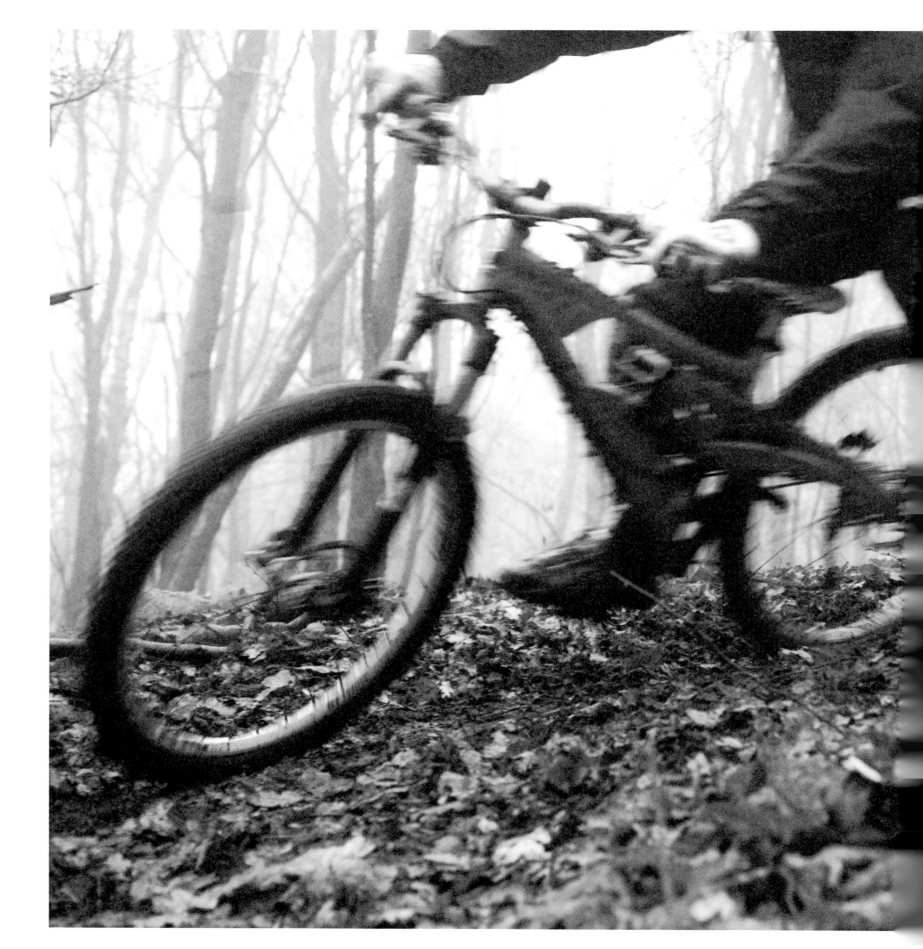

LIVING THE VIEW YOUTH CLASS WINNER

⋖⋯ GERRY WILSON

Slipping and sliding on Hindhead, Surrey, England

Alone, a rider thunders down the longest downhill trail in Hindhead, a maze of twisted roots, ultra steep off-camber sections, tight turns and two-wheel-drifting insanity. Shrouded in the thickest and most ominous mists of the year; all this accompanied by the background soundtrack created by the strangulated moans from green laners. TRUE GRIT.

141

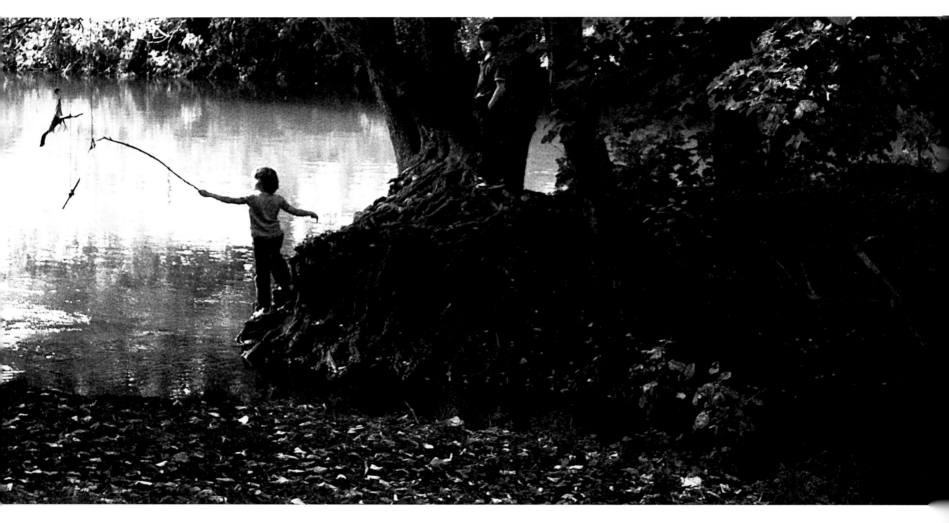

Childhood Memories... Darley Park, Derby, England

This scene of two kids playing caught my eye. I felt that with this photo I captured the 'decisive moment' – and I really like the feeling of freedom and excitement that the image gives. I feel that my photo gives a great idea of how nature can be enjoyed – how we can truly 'live the view'.

LIZZIE DRAVNIEKS ⋯▸

Foreland Fields, Bembridge, Isle of Wight, England

On a trip to the Isle of Wight, my friend and I were exploring the coast at Bembridge. We found this concrete path stretching out into the water and decided to walk along it. A very large wave came racing towards us and I just managed to catch this shot as the spray burst over my friend.

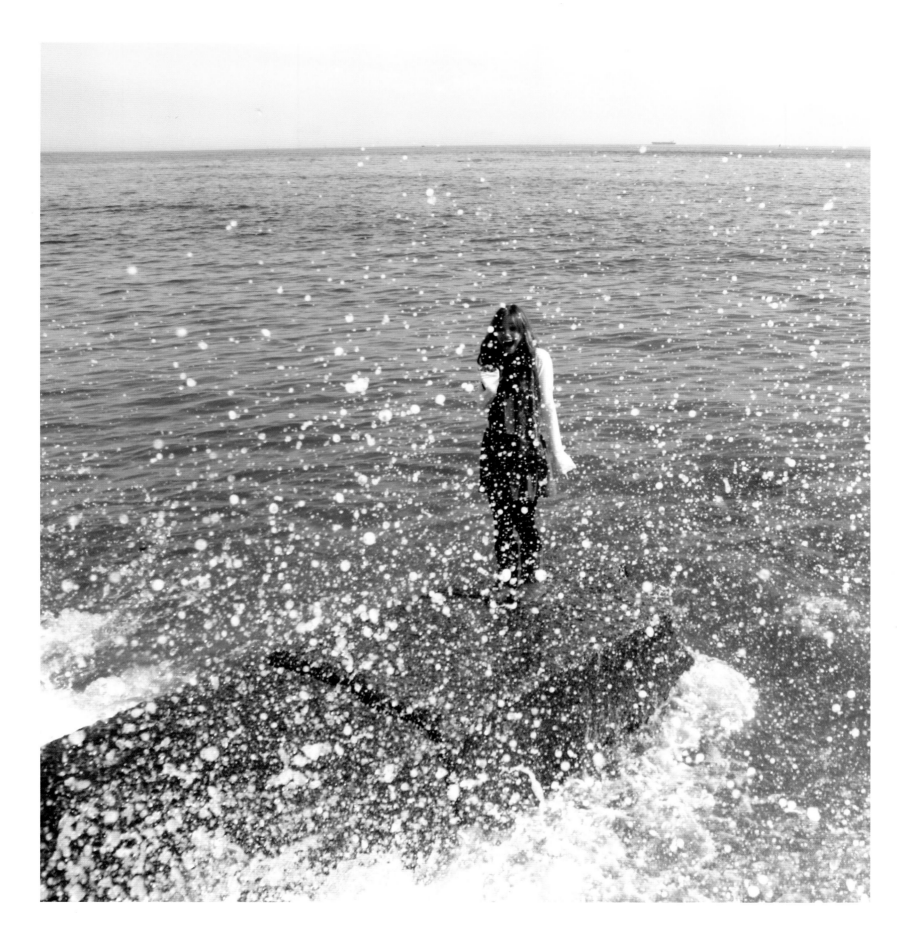

YOUR VIEW
adult class

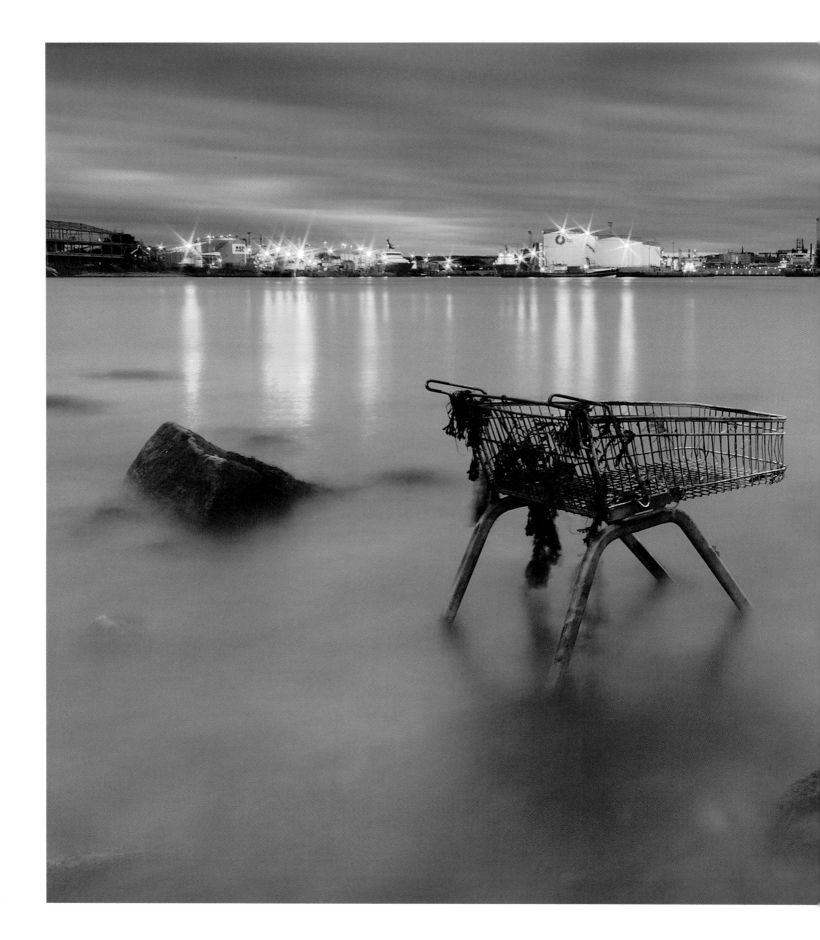

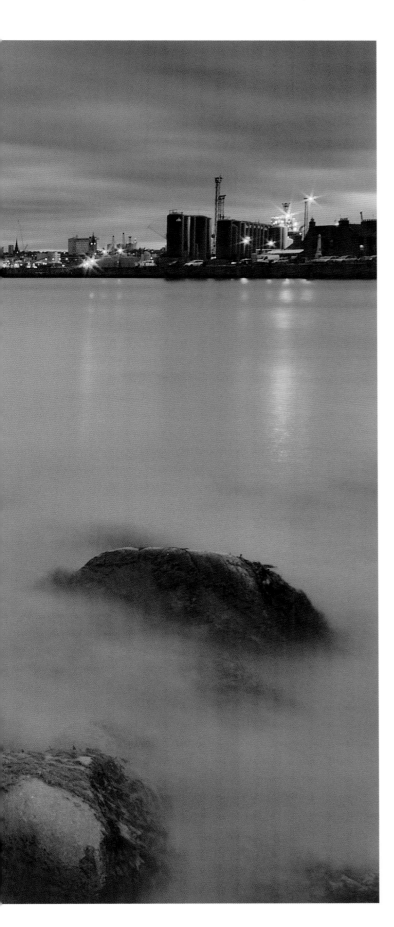

YOUR VIEW ADULT CLASS WINNER

⟨··· JOHN PARMINTER

Food for thought, Aberdeen Harbour, Scotland

What do we throw away into our seas? I often go down to Aberdeen's harbour for sunset and, on this occasion, I spotted a discarded shopping trolley at my favourite spot. I thought it would make an unusual foreground interest; then I decided to make it the focus of the image and try to portray a message. I waited for the sun to set, which lowered the ambient light so I could use a longer shutter speed, as I wanted the trolley to be distinguishable from the incoming tide. Maybe it isn't the prettiest landscape image I have taken but I think it has some of its own beauty and hopefully a message as well.

147

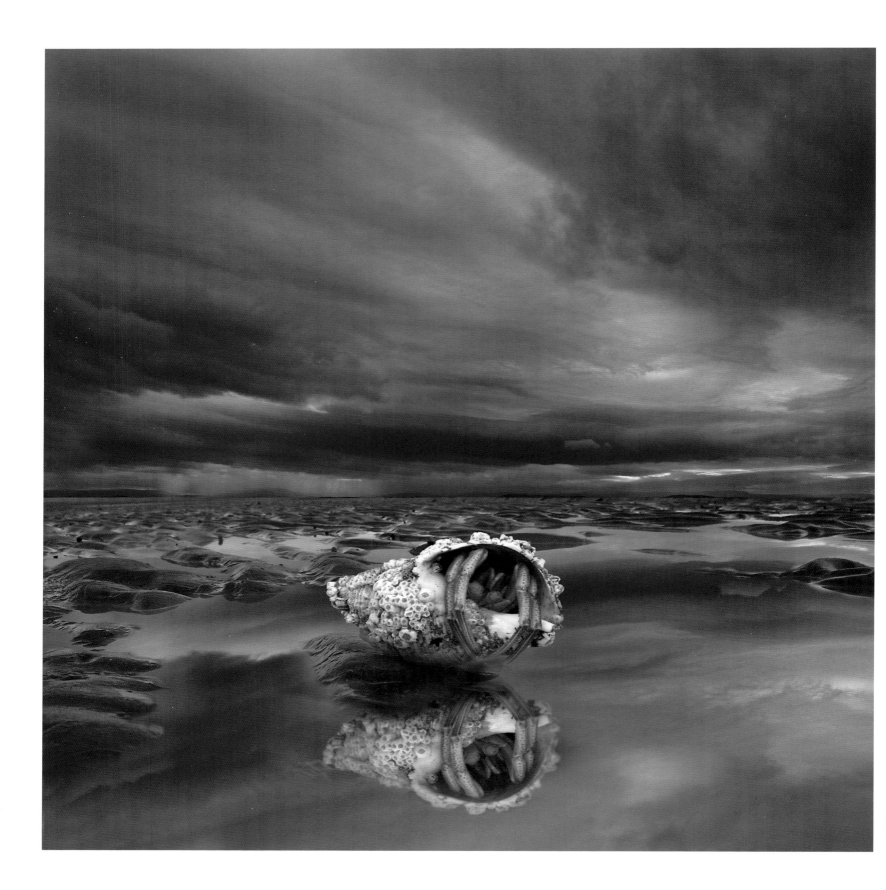

YOUR VIEW ADULT CLASS RUNNER-UP

BRIAN GRIFFITHS

Hermit crab, Gower, Wales

A friend of mine found this beautiful creature and called me over. Moments later the heavens opened and we all got soaked.

Judge's choice John Langley

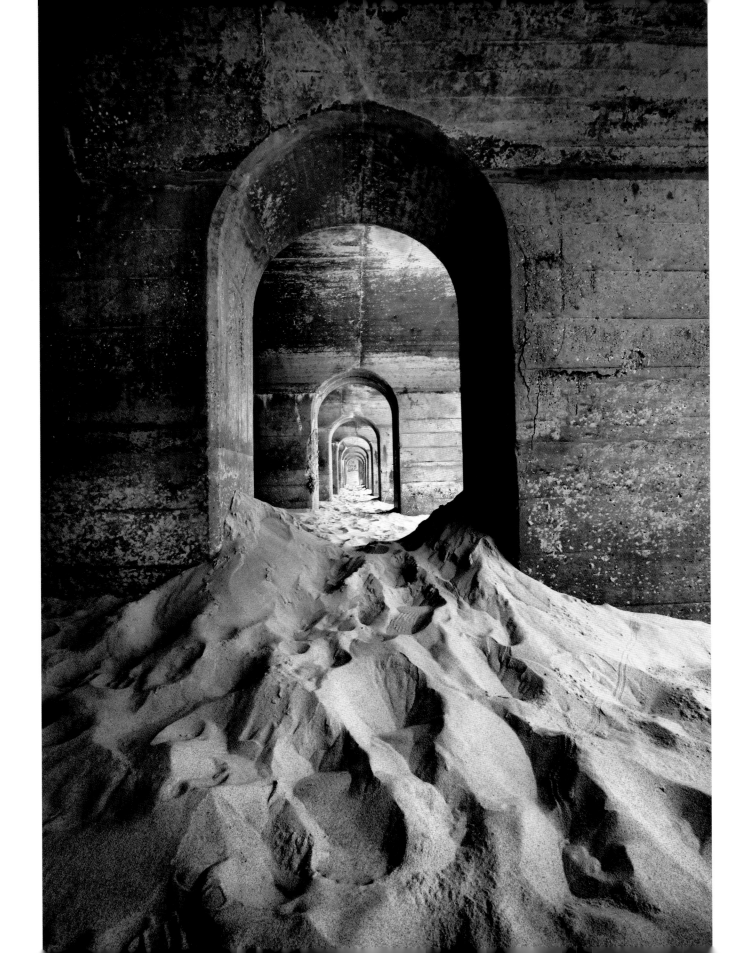

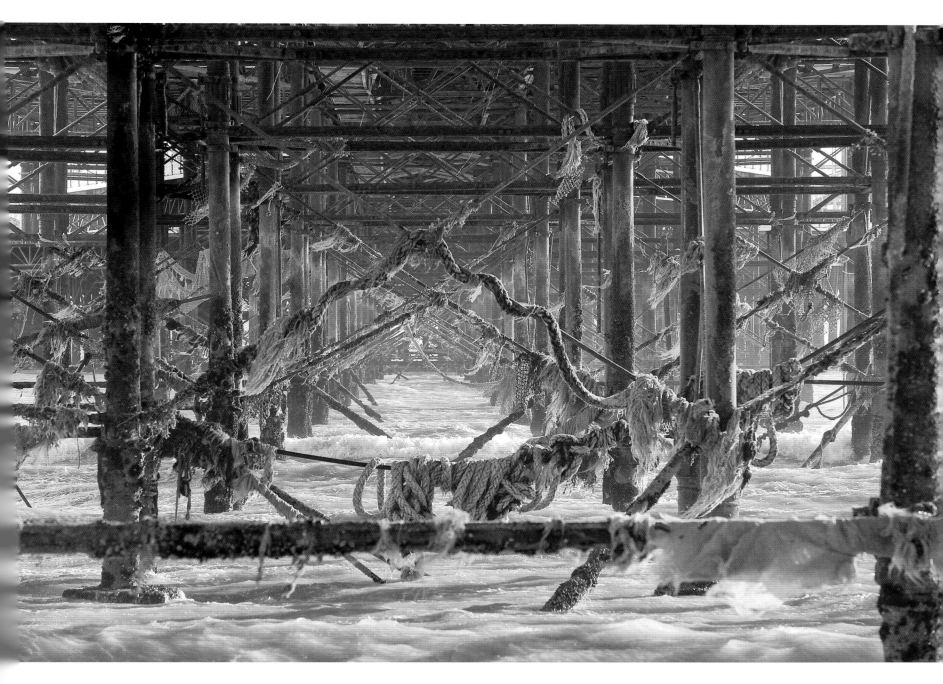

◄··· PAUL KNIGHT HIGHLY COMMENDED

Folkestone arches, Kent, England

The side lighting modelled the shot beautifully, but the principal element for me was the sand spilling through the arch.

⸙ PETER STEVENS HIGHLY COMMENDED

Under the pier, Brighton, East Sussex, England

This image was taken under Brighton pier on a late afternoon in March. The sun was low in the sky, cutting across the scene to reveal, in brilliant colour, the many ropes and rags caught on the pier's ironwork. There were many people up above, enjoying the pier, but only a few enjoying the view from below.

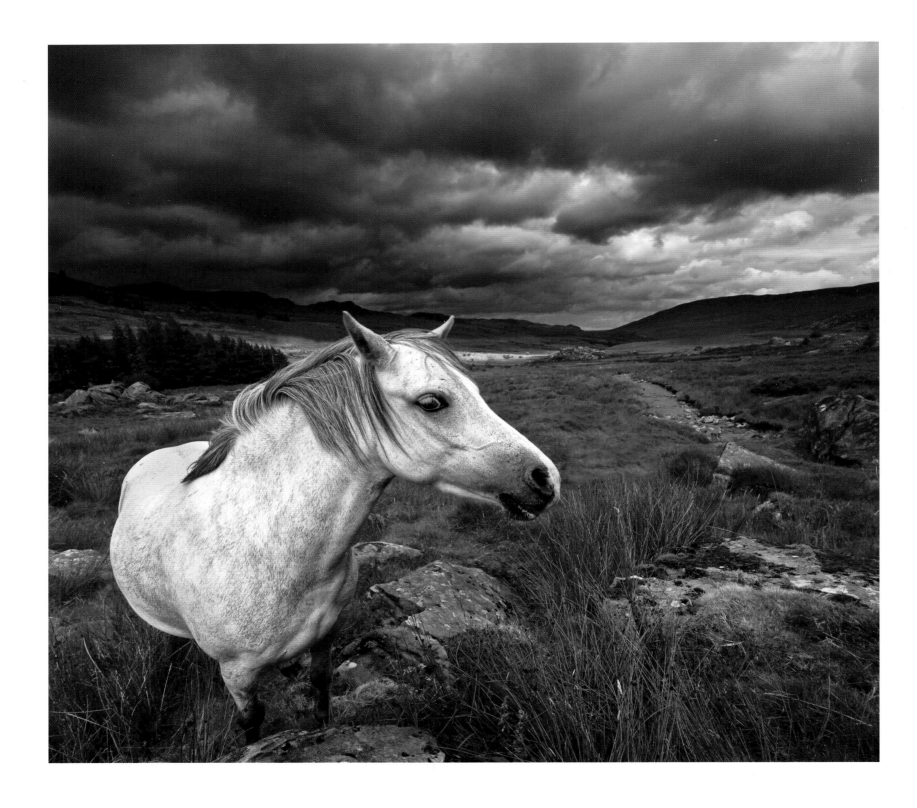

MATTHEW HALSTEAD Highly commended

The Horse Whisperer, Snowdonia, Wales

...and its gaze pierced deep into my soul. The shot was taken during a holiday in Snowdon. I was hiking down through a valley in very rainy conditions, when, out of the deluge, I was surprised by this beautiful horse. For a five-minute spell, the rain stopped and I managed to fire off a few quick shots before the horse cantered off and the rain started again. It was a very surreal experience, made more so by the bleak weather and wild mountain landscape.

Judge's choice Paul Hamblin

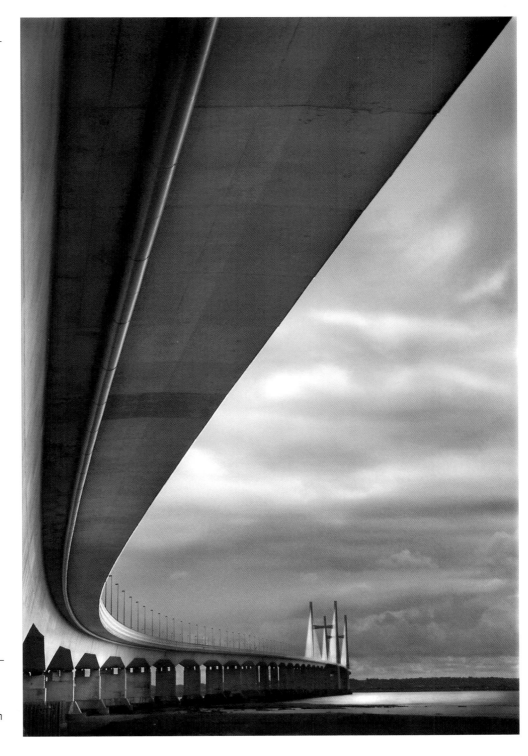

BRIAN GRIFFITHS Highly commended

The Second Severn Crossing linking England and Wales

I waited a long time for the light and clouds to be right; then I lay flat on the ground in order to get the curve of the bridge to fit the frame.

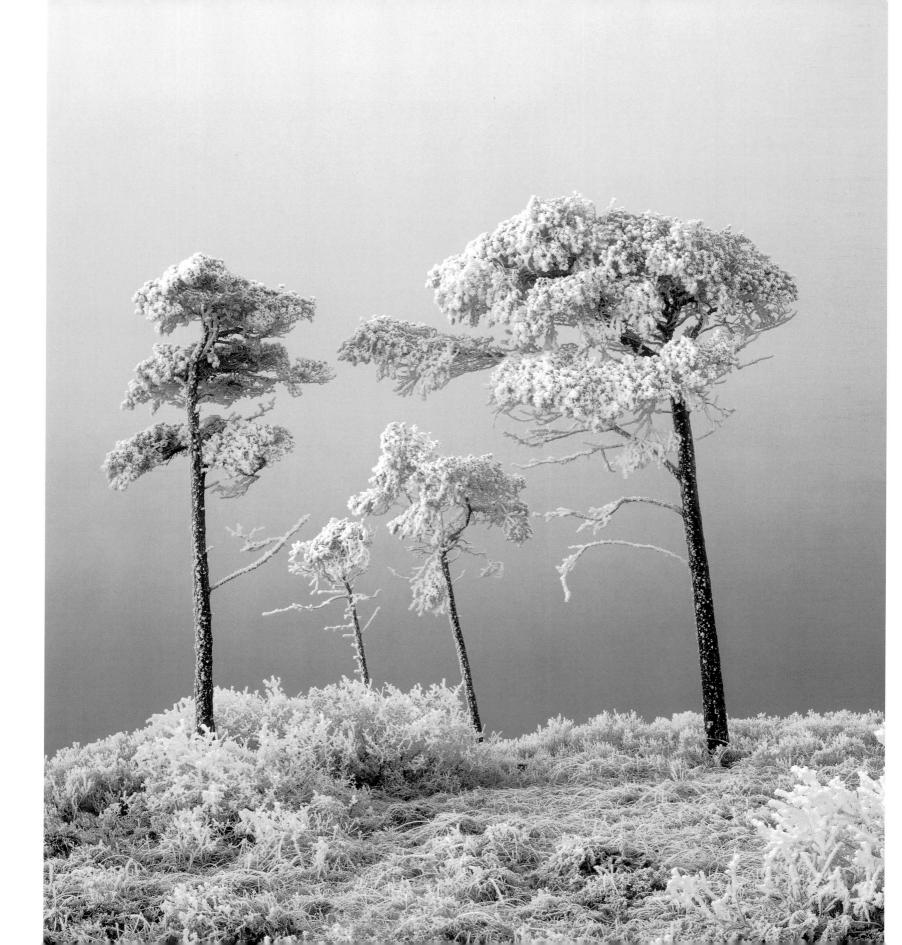

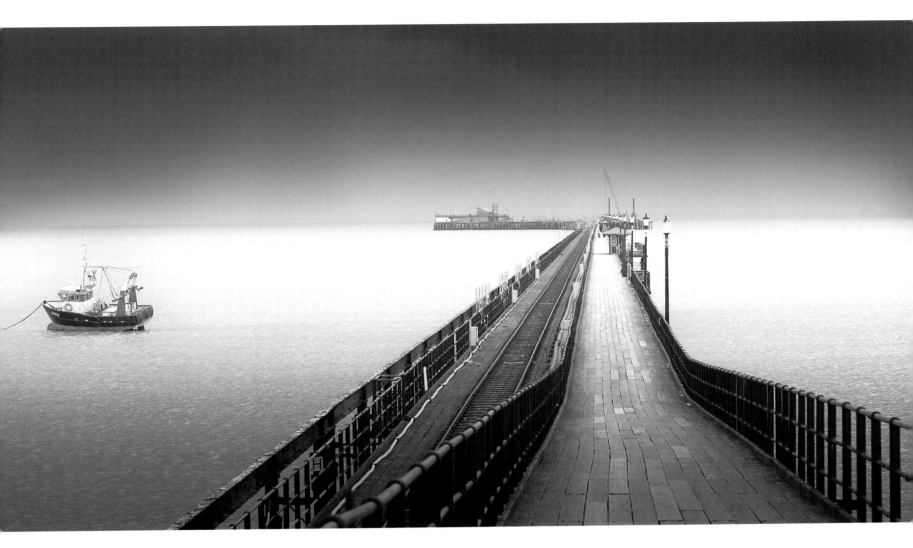

IAN CAMERON　　　　　　　　　　HIGHLY COMMENDED　　　　**PETER STEVENS**

Family Tree, Loch a' Chroisg, Achnasheen, Scotland

I have photographed this charming family group numerous times. 'Father' tree seems to be ushering the two 'children' along while 'mother' tree is beckoning them with a long wooden 'finger'. All of them are surrounded by freezing fog and, with temperatures as low as minus 21 degrees Celsius for the third day in a row, the build up of hoar frost was close to two inches deep. Four months later, I still have restricted feeling in two of the fingers on my right hand.

Judge's choice Patrick Llewellyn & Kos Evans

Pier and boat, Southend-on-Sea, Essex, England

At 1.25 miles in length, the pier at Southend-on-Sea claims to be the longest leisure pier in the world. This image was taken in February, on a bitterly cold day. The air was crisp and clear which seemed to add extra sharpness to this graphic scene. I was immediately struck by the simplicity of the shapes, and the ideally positioned fishing boat under the protective wing of the pier.

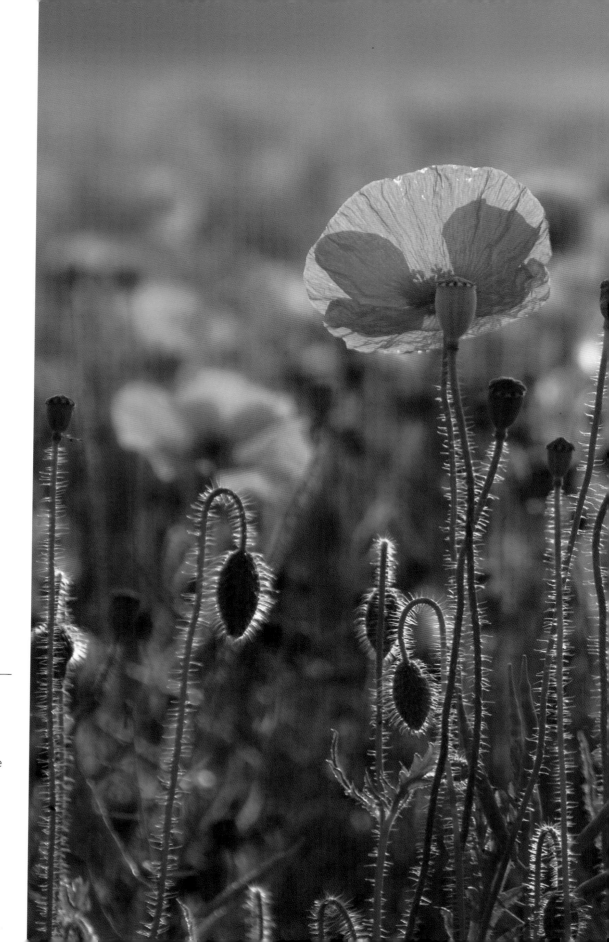

DUNG HUYNH ⋯⊱

Poppies, Boxley, Kent, England

I left my house in London at 2am and arrived in Boxley village before dawn. I made my way to the poppy field in semi-darkness and waited for the sunrise and then took advantage of the early sunlight that beautifully illuminated every single hair on the poppy stems. I used a shallow depth of field in order to throw the background out of focus, so giving more emphasis to the backlit poppies.

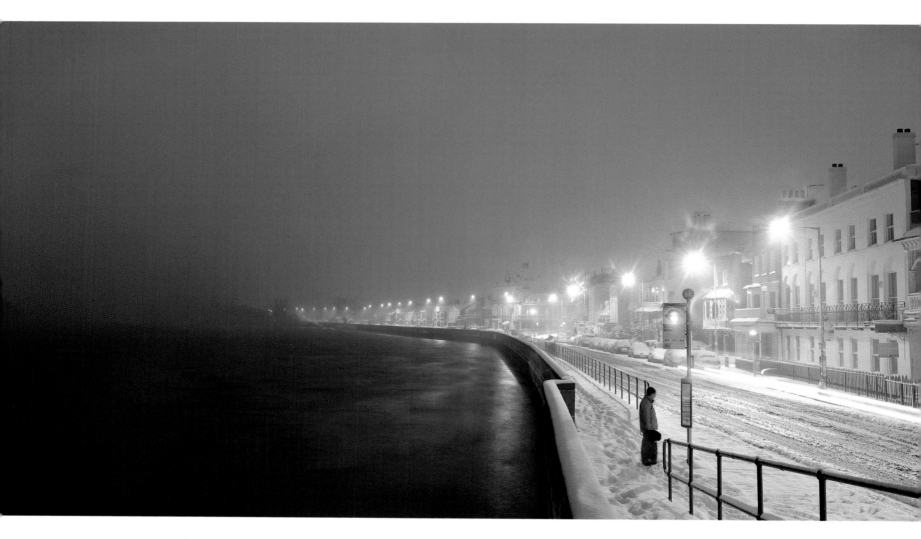

⚓ DUNCAN SOAR

Barnes Terrace in the snow at dawn, London, England

On the day of 2009's heaviest snowfall, this man was patiently waiting for the bus at dawn to take him to work, little knowing that London's transport network had ground to a halt. Barnes Railway Bridge provided the perfect bird's eye view of the scene, with the Thames looking like a stormy sea and the streetlights of Barnes Terrace snaking away into the fog.

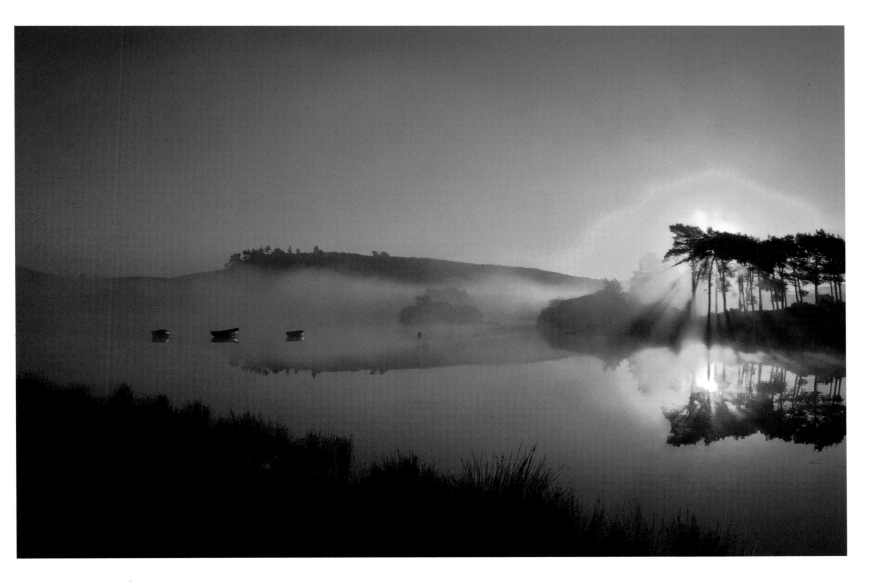

✤ ERIC WYLLIE

Knapps Loch in autumn, Kilmacolm, Scotland

The Knapps is a two-minute walk from the village of Kilmacolm and is used by the locals, who walk their dogs or fish in its little loch that is full of trout. It is an attractive, if unremarkable, spot by day but, in the early morning as the sun rises over the small hills behind, it is transformed — bathed in colour, often with mist and beautiful reflections. I had noticed the particular beauty of the place two years previously and, often when the weather report seemed favourable, would get up early and head over there with my camera. Then one morning, I stumbled into this scene. I don't go very often now; I have precisely what I was always looking for just here.

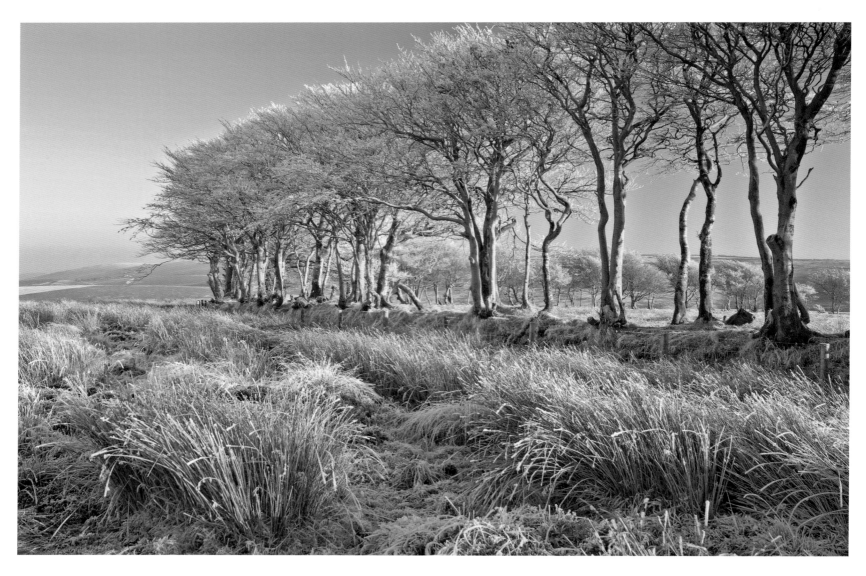

DON BISHOP

Hoar frost, Porlock Common, Somerset, England

I was out exploring the Exmoor National Park on a cold winter's day as I thought that some very pleasant winter images would be possible. I drove along the road from Exford to Porlock Common, towards the coast, and noticed the white frost-covered trees from a distance giving an instant 'wow factor'. I set up my camera and tripod at a low level to give the image good depth as I wanted to be able to see the frozen grasses, the trees growing out of the bank and the distant rolling hills that are all very iconic of this part of Exmoor. The angle of the light gives the image a warm glow despite the intense cold.

**Exmoor National Park Authority –
Best image**

RICHARD BURDON ⋯⋗

Frosty morning, Costa Beck, Pickering, North Yorkshire, England

I woke up to a bright, frosty December morning, so I couldn't resist a walk down to the local beck. The light on the frosty grasses caught my eye and I loved the way they stood out from the shadowy background.

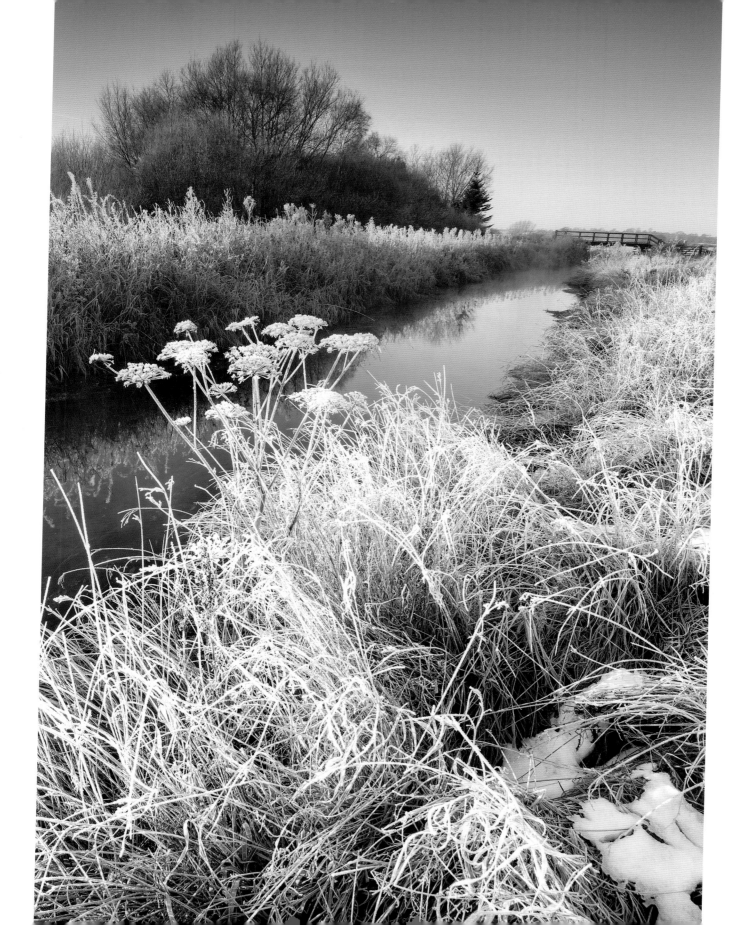

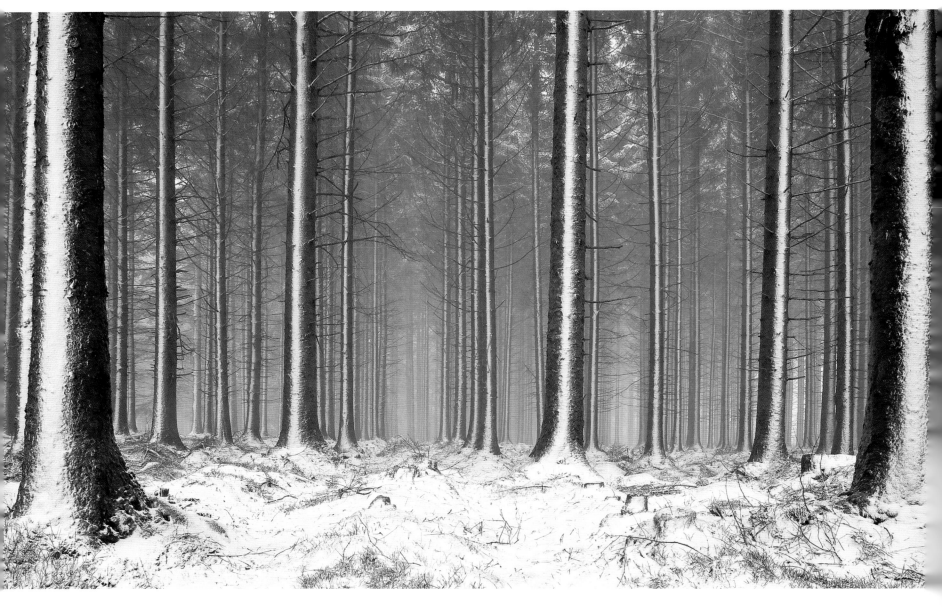

MARK LAKEMAN

Bellever Binary Barcode, Dartmoor National Park, Devon, England

An ear-shattering crack, shortly followed by a rather loud rumble of thunder as another winter weather front pushed over. I knew what was coming next — a major snow blizzard. Excellent. In the middle of Bellever Woods, quite some distance from the car, my footprints slowly disappearing. Love it.

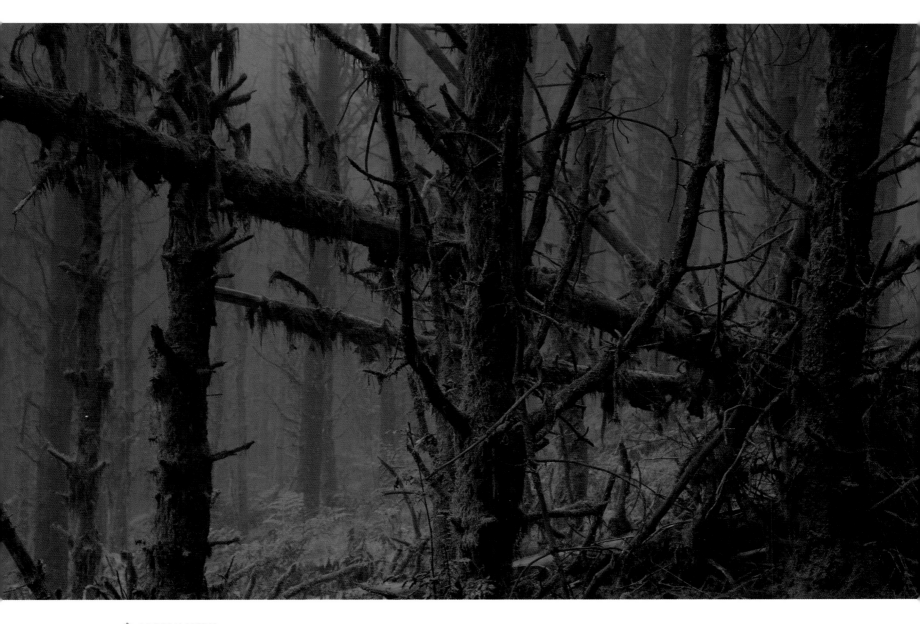

ADRIAN LYON

Brooding forest, West Wales

I was staying with friends who have a cottage on Forestry Commission land in west Wales. It's an isolated spot with no electricity and is surrounded by forest, which rears up behind the property and has been left largely unmanaged. As such, it's an eerie place at the best of times but throw in a dark, misty autumn day and the dense forest takes on an altogether more sinister, brooding feeling. I like this scene because it shows a different side of our varied landscape and one that can take on a different character every day.

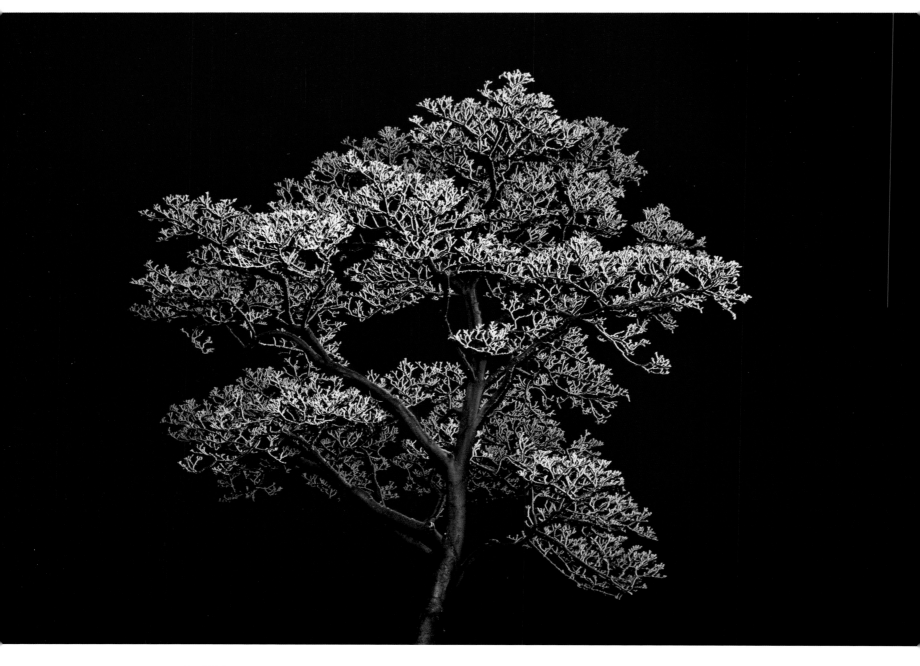

✝ NIGEL HILLIER

Frosty tree at night, Widdop, West Yorkshire, England

It was the first day of the New Year. Driving home on a cold winter evening, I stopped near Widdop Reservoir to shoot some images of the area. It was around 5pm and already getting very dark. I made many images that evening but this shot seemed to be the most striking. The lone tree, set apart from the rest, was beautiful against the dark, bleak sky. I used two flashes, one on-camera and one held high directed at the tree. This highlighted the frost-covered branches.

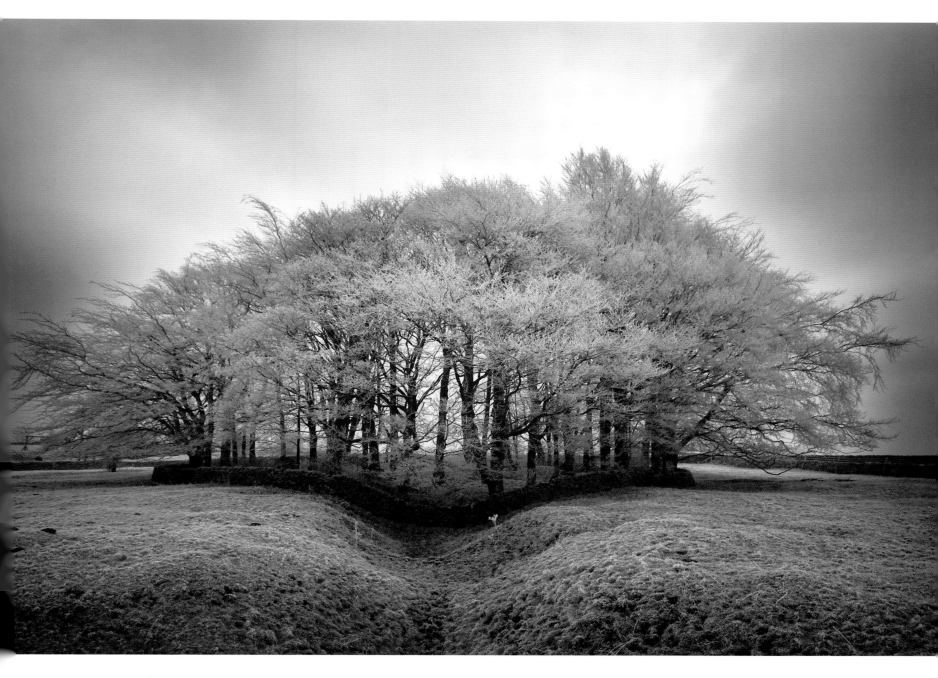

ANDREW TUCKER

Frosty tree stand at Magpie Mine near Sheldon, Derbyshire, England

This image was taken at the old Magpie Mine, early on a very cold and frosty New Year's morning. I probably should have been sleeping in after the long night before, but it was a stunning morning!

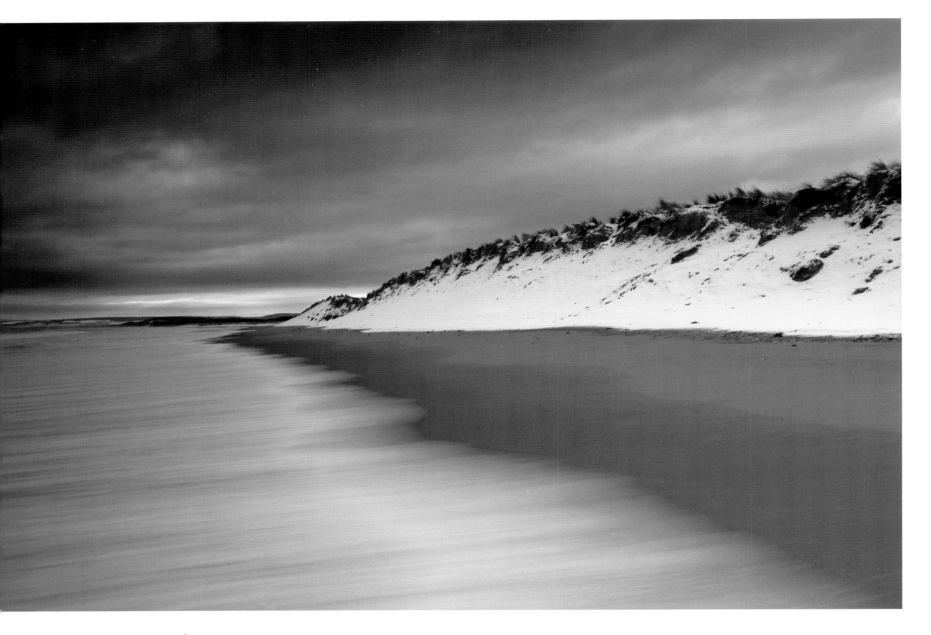

✝ DAVID LANGAN

East Beach, Lossiemouth, Moray, Scotland

A freak flurry of snow on a November Sunday morning had me out with the camera early. Leaving Lossiemouth for Speyside, I was struck by how unusual the local beach looked with snow-clad dunes. I immediately headed there to find a rapidly incoming tide. I wanted a simple composition and was drawn to the vanishing point created by the strip of sand sandwiched between the Firth and the white dunes. Realising this made a rather dull and static photograph I set up the camera in the intertidal zone to capture some dynamic movement. With the waves up around my knees and the rising sun momentarily colouring the dark clouds I had a real sense of urgency to get the timing right as the waves rushed in. A few shots later the image on the back of my camera surpassed my initial pre-visualisation.

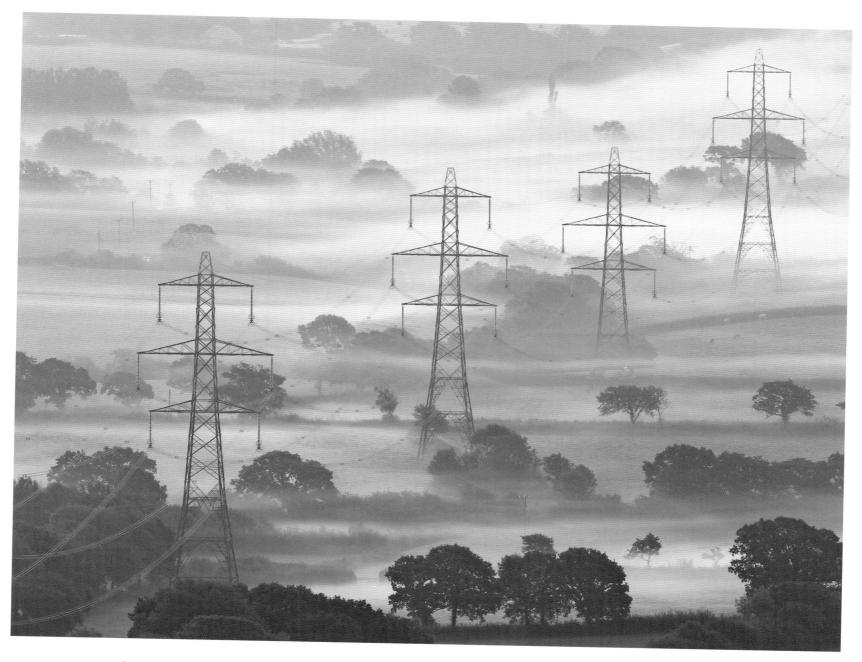

ADRIAN BICKER

Pylons on a misty morning, Marshwood Vale, Dorset, England

While you can be certain when the sun will rise, you can never be sure whether there will be mist across the fields. This was a good morning, with a thin veil of mist and a clear eastern horizon. With the first rays of light came a gentle breeze that ruffled the mist, forming it into a soft wave that floated slowly from left to right. Wait until it rolls behind the last pylon and... fire the shutter release.

DAVID STREETER

Hove, East Sussex, England

It's rare for Brighton & Hove to get snow; let alone thick, deep snow that 'sugar coats' everything. On the morning of 2 February 2009, that's just what happened. Trains and buses were cancelled; roads and schools were shut. There was nothing for it – but to go and enjoy it. We all wrapped up – it was still snowing – and went down to the Hove seafront to see what was happening. Some people were still struggling in to work on foot, but most people had given up and were having fun, throwing snowballs and building snowmen – we built a 7-ft one with other people. It was a great atmosphere with a very 'Brighton spirit' going on. Someone had added a smiley to a lifebelt cover. It caught my eye, and put a smile on my face too! I eventually met the lady who did it and gave her a copy of the picture.

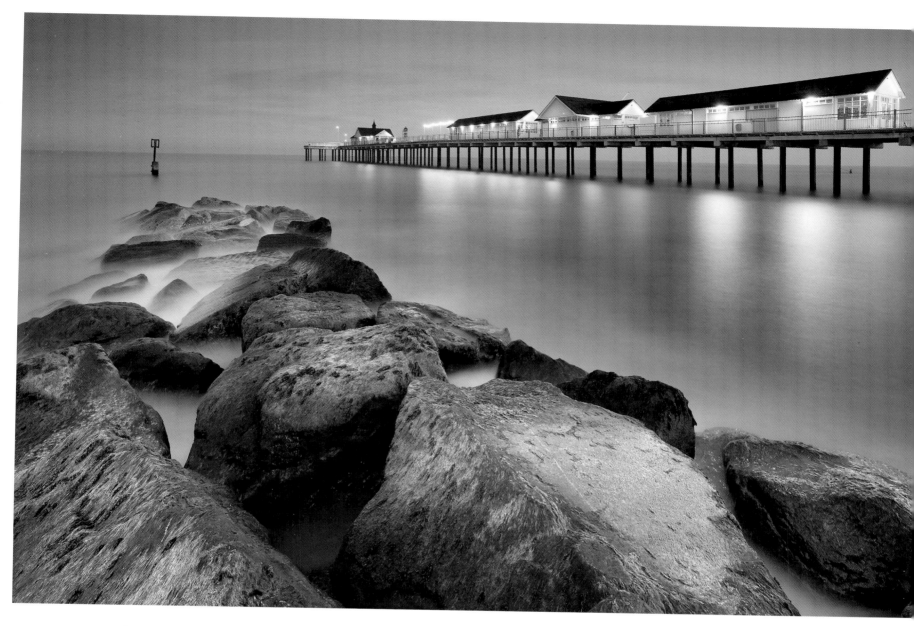

LEE RUDLAND

Southwold Pier at dusk, Suffolk, England

Being on the east coast a dawn session was always an obvious choice for Southwold Pier, until I discovered the magical glow of the pier lights one evening. The combination of low ambient and tungsten light created a high contrast scene that I thought could translate well into black and white. The following evening I arrived on location, set up the tripod, composed the shot and waited for the light to drop. About one hour after sunset the conditions were perfect. The lights from the pier illuminated the rocks and a long exposure smoothed out the waves to give an almost glass-like effect.

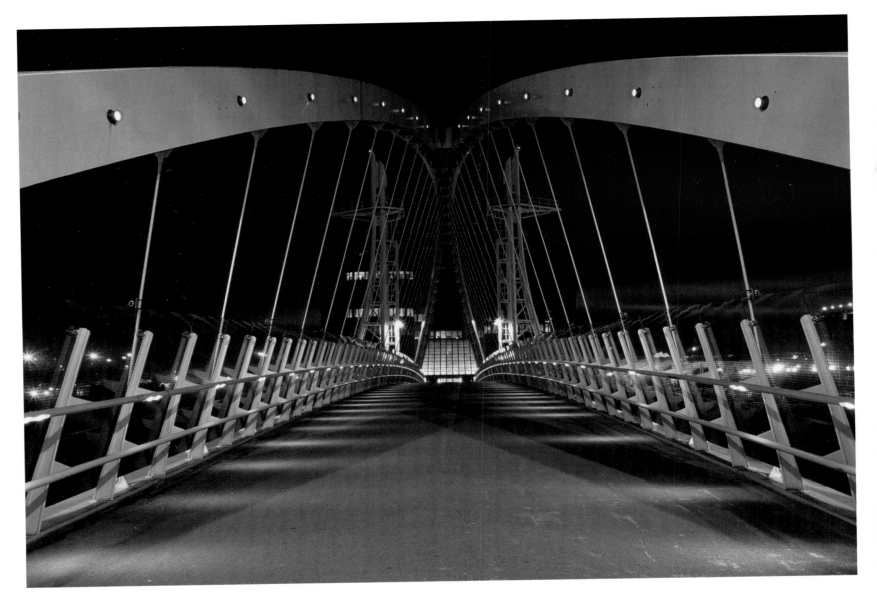

⚑ ED PAVELIN

Lowry Bridge, Salford Quays, Manchester, England

The Lowry Bridge in Salford is a fantastic piece of modern architecture. It's also highly photogenic, especially at night when it's beautifully illuminated. I loved the symmetry of this view, straight along the bridge, and the effects of light and shadow on the asphalt surface. Although there were a number of pedestrians and cyclists crossing the bridge whilst I was photographing it, a long exposure of one and a half minutes ensured that they didn't appear in the final image.

ANITA STOKES ⋯⋗

Camber Sands, East Sussex, England

I had been out all day taking photos along the south coast. Right at the end of the day, I decided to make a quick detour to Camber Sands before returning home. It had been a glorious day but extremely windy and, by the time I had made my way to the sands, the wind was so strong I could hardly stand up! The sand was flying and stung as it hit my face. I began to think that the detour had not been such a good idea. Then I spotted this fence poking out of the ever-shifting sands. The light was fantastic, the best it had been all day and, with the lengthening shadows of the late afternoon, there was the image I had been looking for.

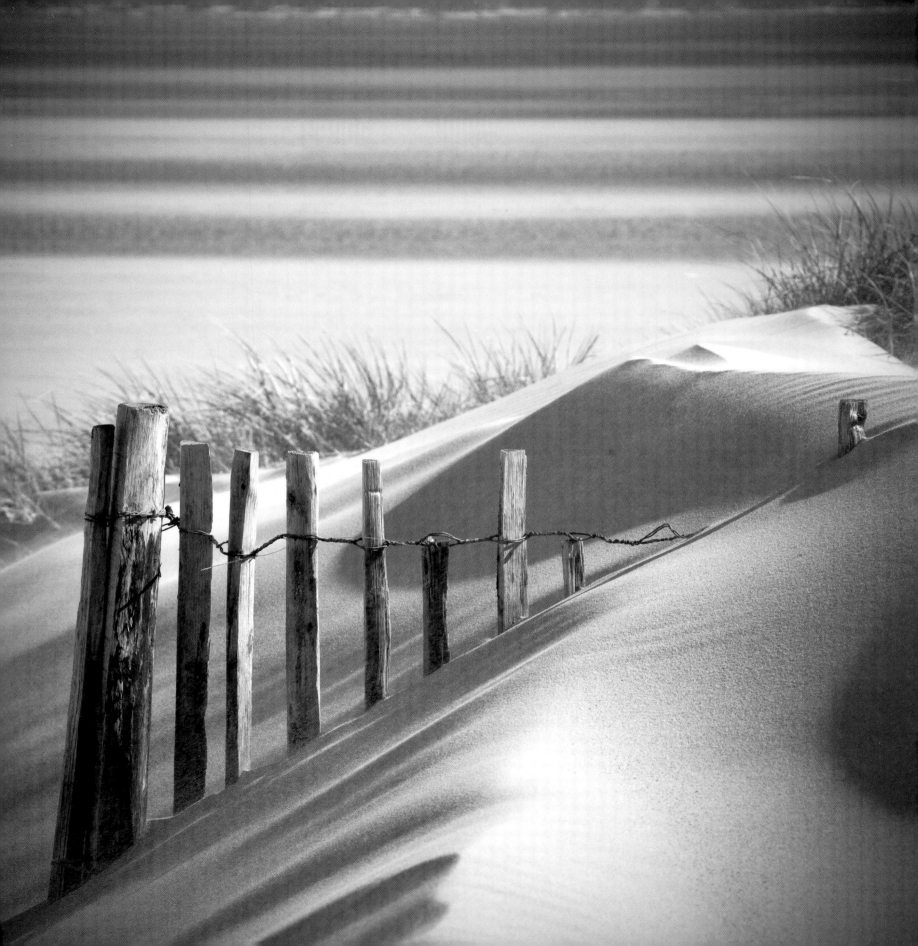

STEEN DOESSING

Transform, Portslade, East Sussex, England

This image was shot on a late summer morning. The sunshine was stark and so I had to use a polarizer on top of a 13x Neutral Density filter.

MELANIE MUKHERJI

The Old and the New, Talacre, Wales

I have a fascination with both lighthouses and wind turbines. Here, on the beach at Talacre, on a wild morning, both were catching the light. The contrast of the derelict, graffiti-covered lighthouse against the turning blades of the turbines caught my eye, bringing to mind decay and regeneration.

⚑ KEVIN BEECH

Evening light, Saltburn-by-the-Sea, North Yorkshire, England

As I was walking back to the car, along the cliff tops, I passed the tram lift and was immediately struck by the geometry of the buildings and the pier stretching out to sea like a giant horizontal obelisk. It had been a frustrating day, trying to photograph the pier and surrounding landscape from 'ground level' without much success. The weather had been overcast and dull on this late January day and the light was failing fast, but I couldn't resist this one last shot. For me, the two brave souls striding down the windswept pier for their last fix of sea air was the little touch that complements the image and turned a disappointing day into a rewarding one.

GARY WAIDSON

The Sunset Way, Lindisfarne, Northumberland, England

I first spotted this line of posts, marking the Pilgrim's route westward across the sands, back in 2006 as I was driving onto Lindisfarne and immediately realised the potential for an interesting sunset shot. I returned later that day but, as is so often the case, I didn't quite get the light I really wanted. Naturally, when I returned to the area earlier this year, a better shot was high on my wish list. I checked the tide tables, the weather forecast, the timing and position of the sunset and the chances seemed good. Nothing else to do in the end but wait and see what happened as the waters rose up around my ankles and the sun sank down towards the horizon.

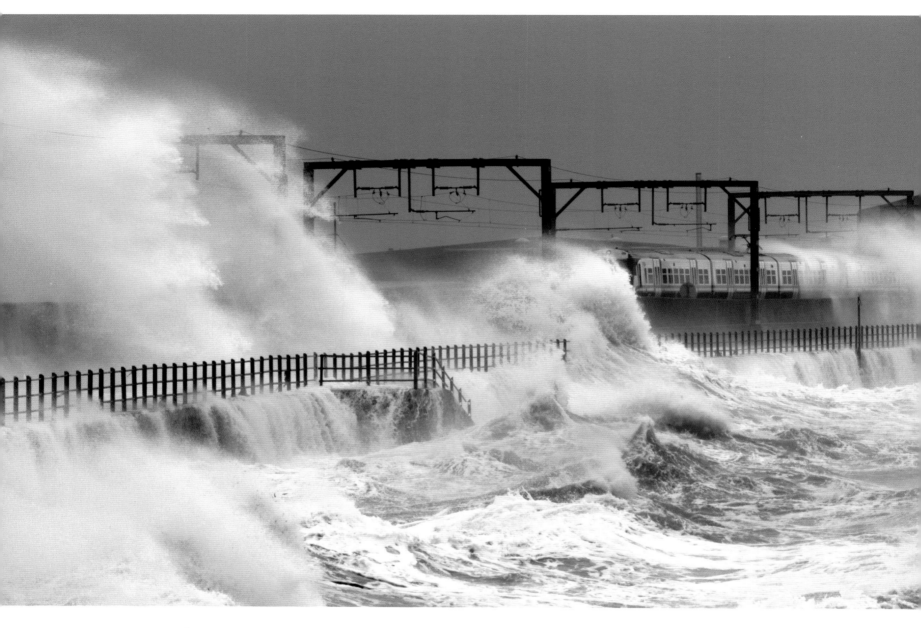

PETER RIBBECK

I'll take the bus! Saltcoats, Ayrshire, Scotland

This area, to the south of Saltcoats, is well known for huge waves when the conditions are right. I had been checking the weather forecast and realised the storm-force winds from the southwest and the high tide looked promising, so the decision was made to give it a go. I arrived with my wife and children in tow and was happy to see I had made the right decision. I could see the train in the distance so braced myself against the winds using a small wall as a bit of shelter. I could see some big rollers coming in and prayed they would coincide with the train. As the waves slapped hard against the promenade wall they exploded upwards and were quickly blown against the side of the train. Two more waves followed suit just in front of the train, making it run a watery gauntlet. I could not believe my luck the timing was perfect… although I think the train driver and the passengers would beg to differ!

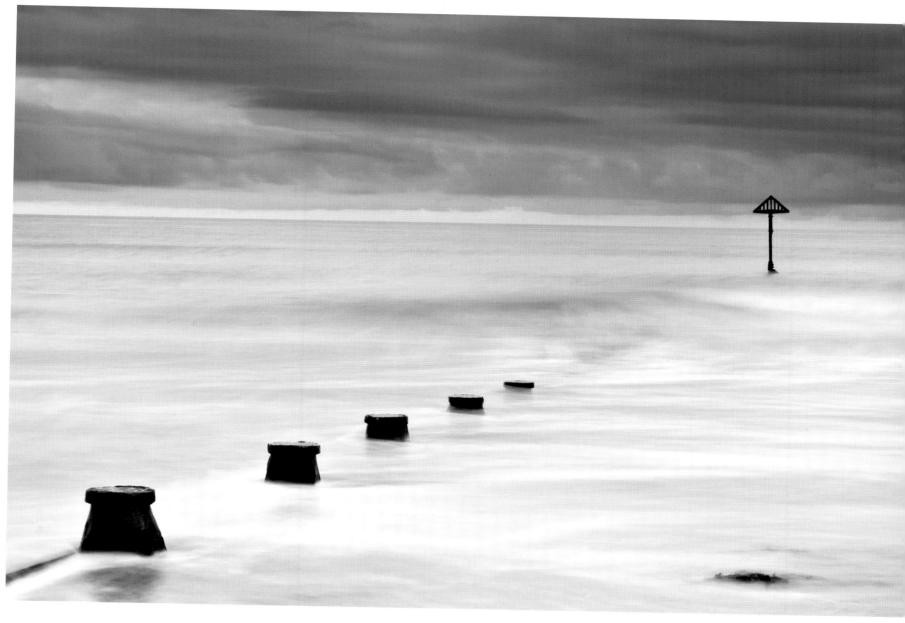

🕆 PETER PATERSON

Groyne, East Wittering, West Sussex, England

I was on a short trip to the south coast of England. It was mid-morning on a dull, overcast, rainy day and so I decided to use a slow shutter speed to give a feeling of motion to the incoming tide. I had to use ND filters to get the effect I was looking for. I particularly liked the line of the groyne leading out to the post with the triangular top.

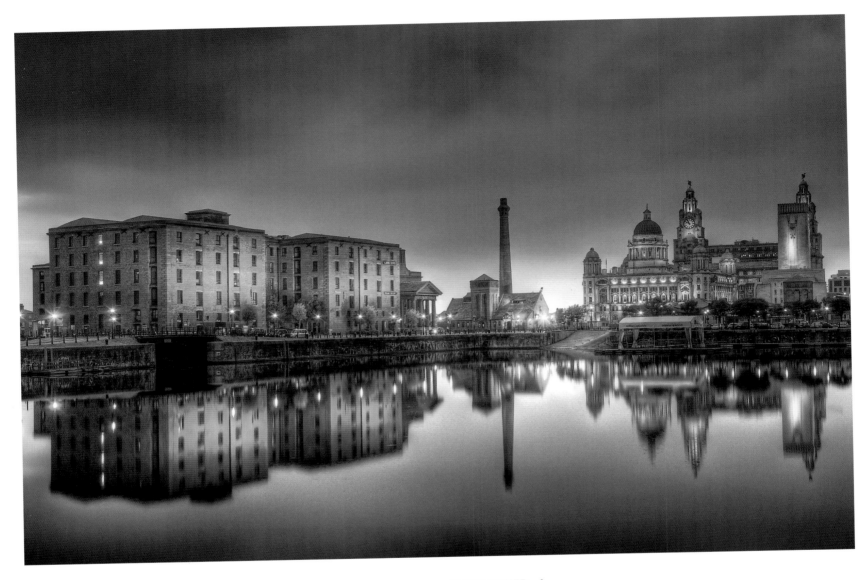

↑ GARY McGHEE

Salthouse Dock, Liverpool, England

A windless evening gave me the perfect opportunity to capture the reflection of these historic buildings.

MARK BAUER ⋯▶

The Old Pier, Swanage, Dorset, England

It was a dull, grey day, so I shot with a black and white conversion in mind. I used a 10-stop neutral density filter to achieve a long enough exposure – five minutes – for the water to record as a smooth, almost glass-like surface. This revealed reflections in the recorded image that, due to the movement of the water, were not visible to the naked eye.

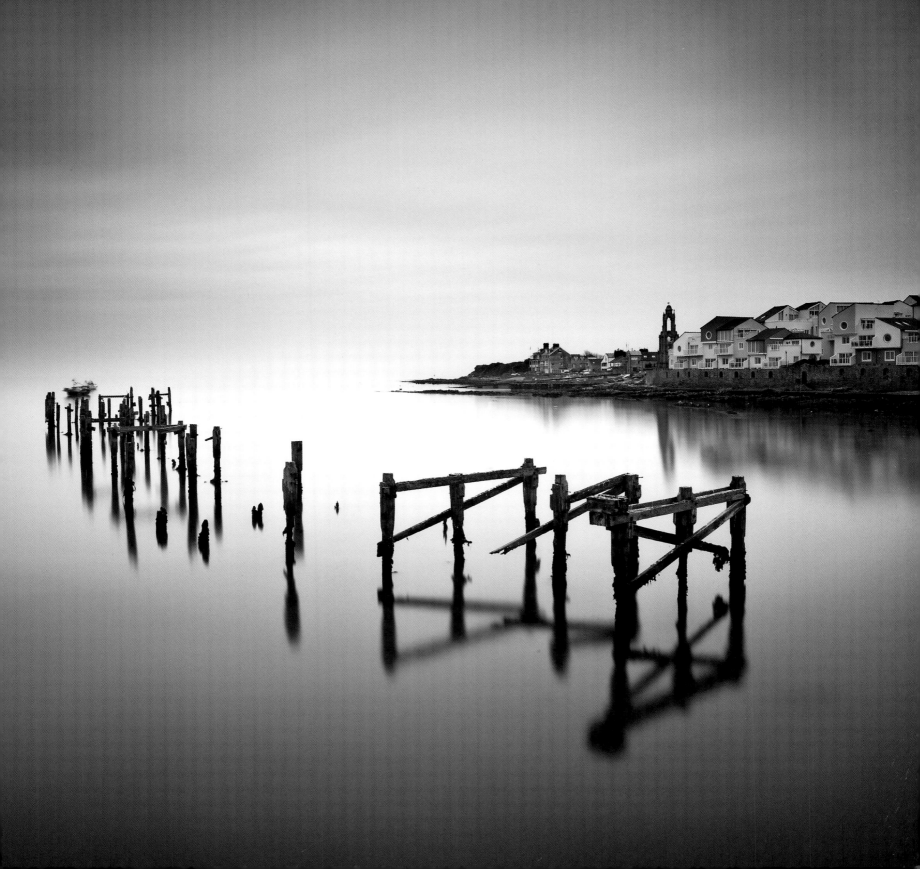

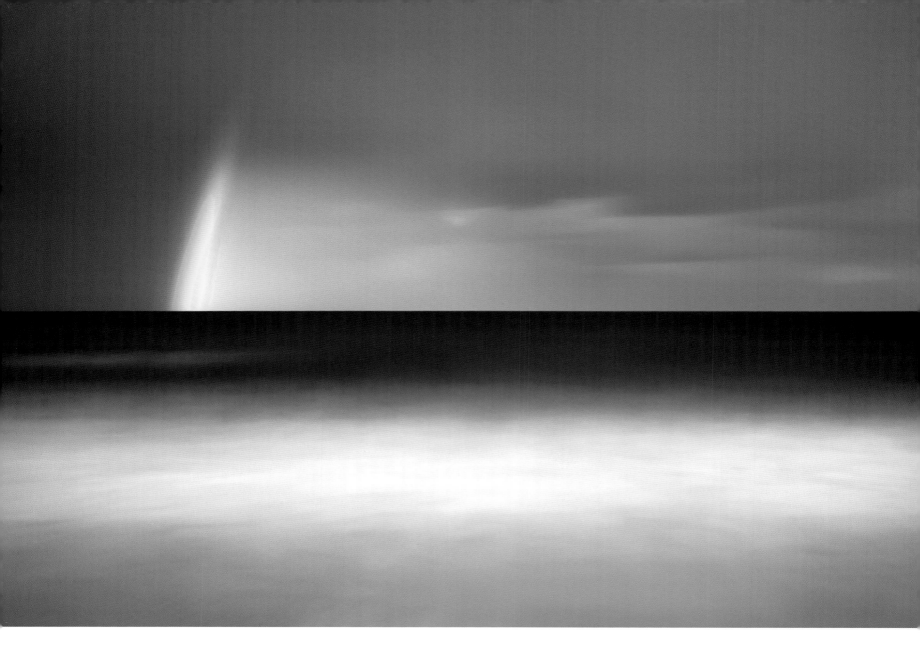

JASON THEAKER

Always chasing something, Sandsend, North Yorkshire, England

This shot is an experiment that I made to try and find alternative views on the amazing conditions I was presented with at Sandsend last winter. I used a one-minute exposure to distort the moving elements and this is the result. I particularly like the way this image draws out my conceptual nature, namely that there are no solid elements present (well, apart from the horizon and considering that is water, even that's debatable) and that everything is changing within the shot. For me this speaks of the ever-changing fragile world we live in and, ironically, I find security in the continual metamorphosis of the differing natural elements.

ANDREW PAGE ···⫸

Obelisk on Welcombe Hills, Stratford-upon-Avon, Warwickshire, England

I'd visited in the autumn and thought how good this view might look at first light on a cold, frosty, winter morning. I was intrigued by the sheer mass of the towering beech tree and the idea that names, carved in the tree trunk for posterity, could be echoed in the names carved on the war memorial beyond. The composition and lighting completed the picture for me.

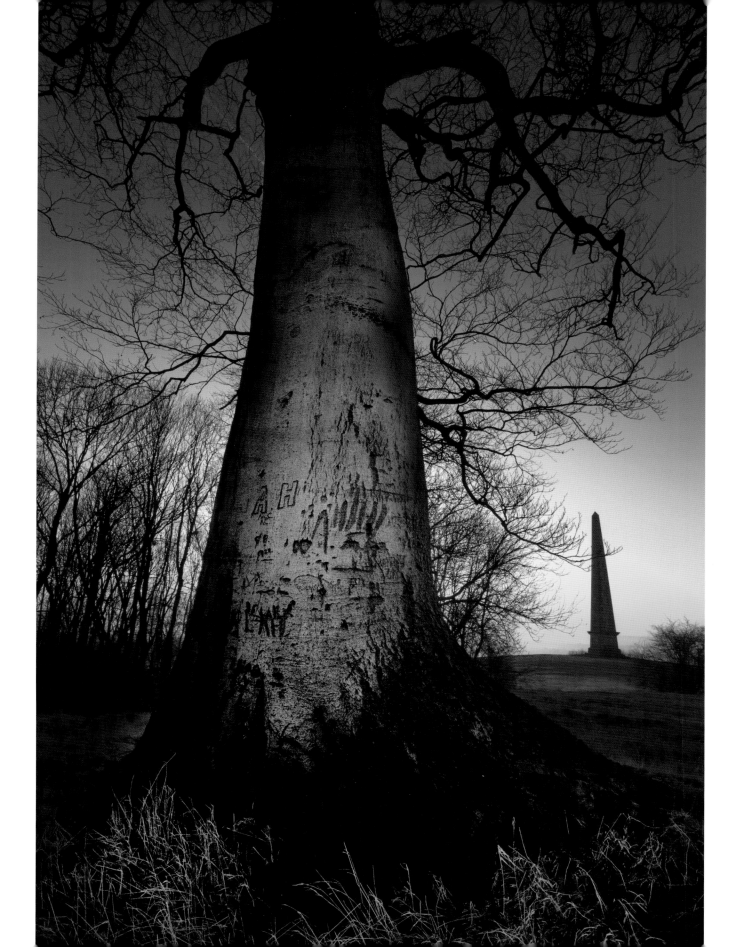

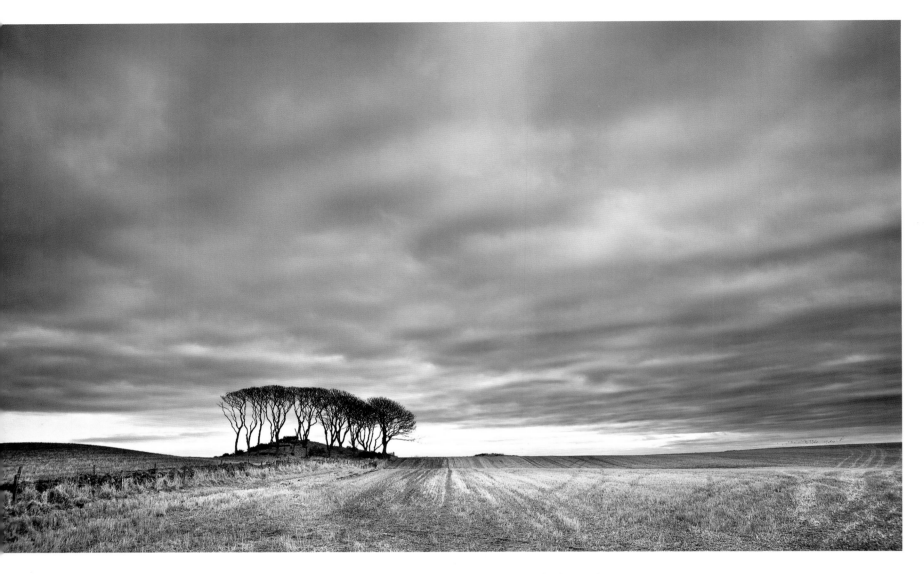

PETER PATERSON

Copse, near Stonehaven, East coast of Scotland

The image was taken when I was on a short trip to the northeast coast of Scotland. While travelling to the town of Stonehaven, I noticed the small copse of trees from the road. I decided to return the next morning to see if I could get more favourable light. What inspired me to take the image was the isolation of the group of trees against the morning sky combined with the lighting on the surrounding fields.

MIKE BONSALL ···>

Into the unknown, Pezeries Point, Guernsey

I'm really interested in the way that these manmade stone slipways become one with the natural landscape as, over time, they become subject to the slow process of erosion. By the time I took this image, it was almost dark but I could see that a small patch of brightness in the sky could provide me with just enough illumination to light the scene. I worked out that I would need to set an exposure of four minutes, which resulted in that small patch of brightness being drawn beautifully in an arc across the evening sky.

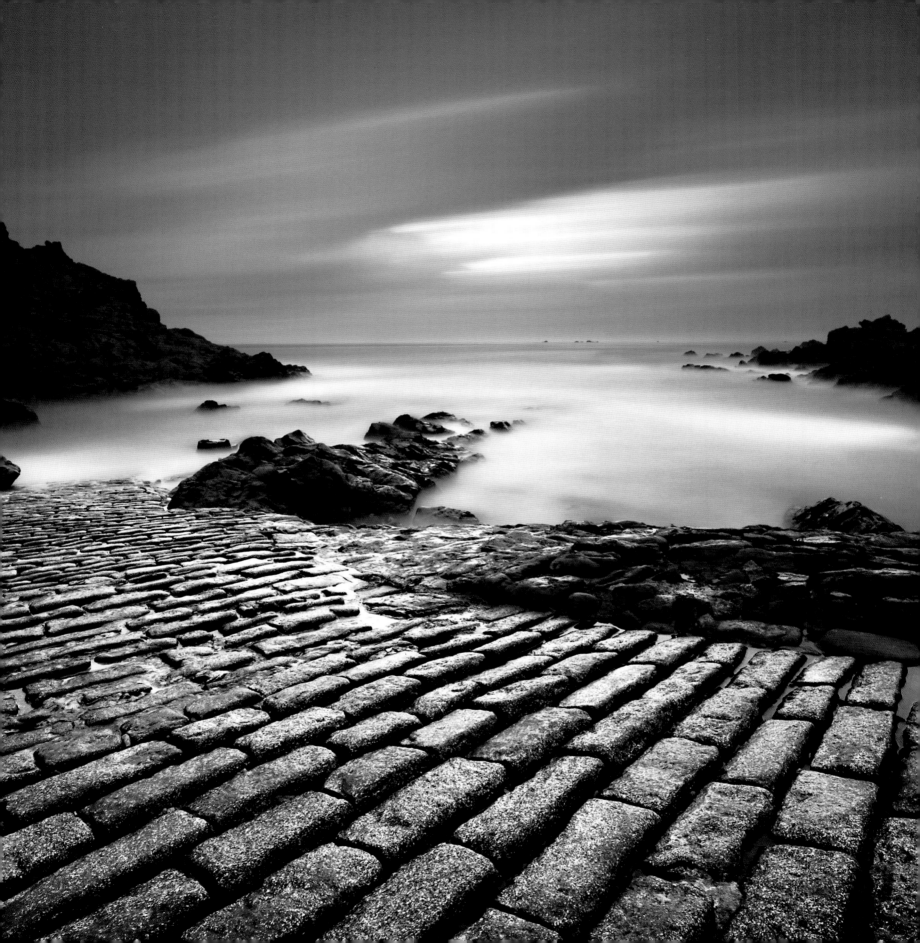

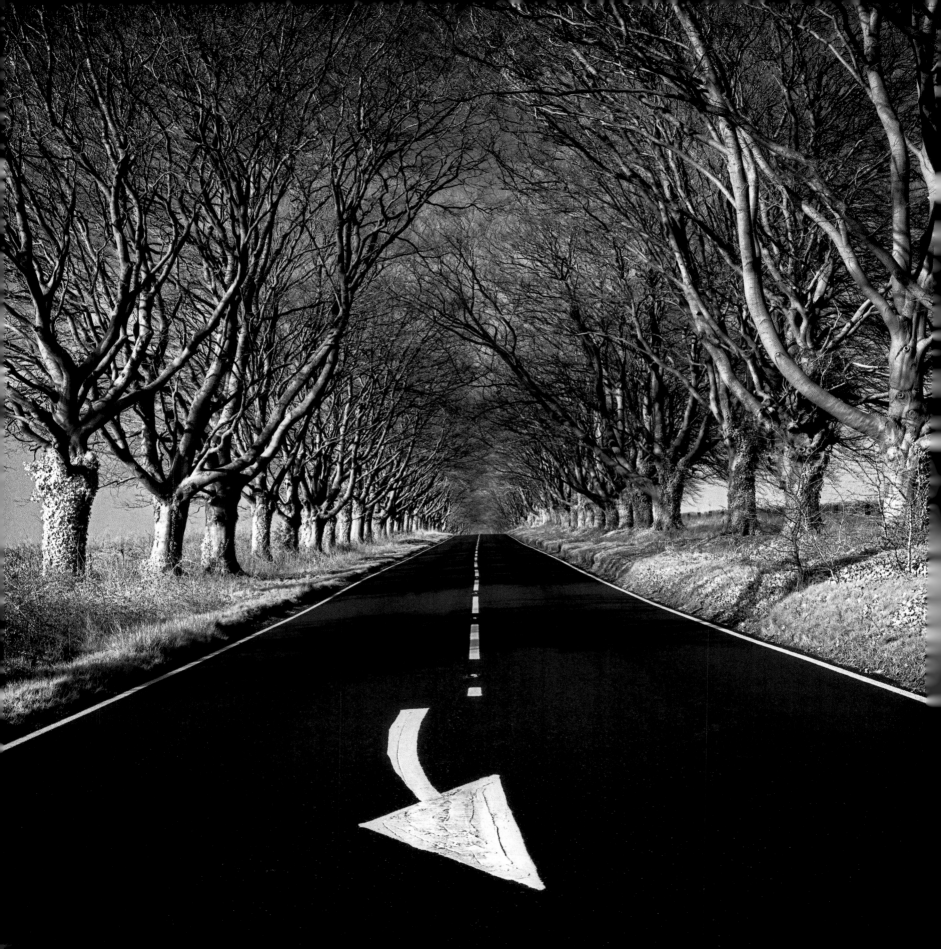

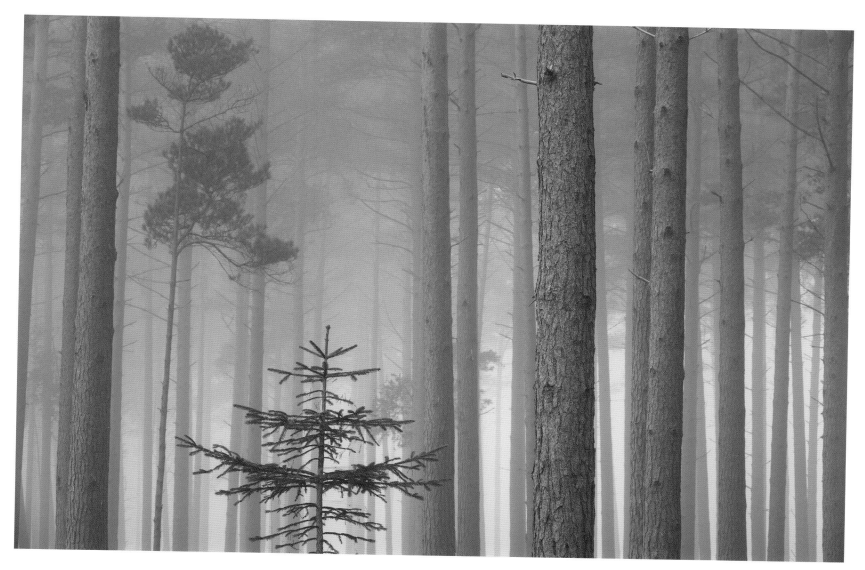

DAVID LOTHIAN

Winter evening, Dorset, England

I was driving back to London on a beautiful, crisp winter evening, having spent the weekend on a colour shoot on the Isle of Purbeck, when I was struck by the strong dynamic created by the trees and road in front of me. I pulled onto the grass verge and hurriedly set up before I lost the rapidly fading light, deciding to shoot black and white infra-red film to enhance the graphic nature of the scene. Although the photograph has sense of tranquillity, the road was, in fact, quite busy and I only had time to shoot one roll of film as I was using exposures of several seconds and was constantly moving out of the way of the approaching traffic at the last possible moment.

ADAM BURTON

In the Company of Giants, New Forest National Park, England

Pine woodlands make great subjects on foggy days. The vertical lines created by the uniform tree trunks provide a clean composition that is further simplified by dense fog. As I walked this woodland, I found myself wanting to photograph in all directions but I held back and continued searching for an extra element for my composition. I soon came across this young sapling, dwarfed on all sides by towering tree trunks and immediately recognised its potential as my main focal point. I purposefully excluded all traces of the forest floor in my composition as this would keep the image clean, simple and help the attention to concentrate on the sapling and tree trunks.

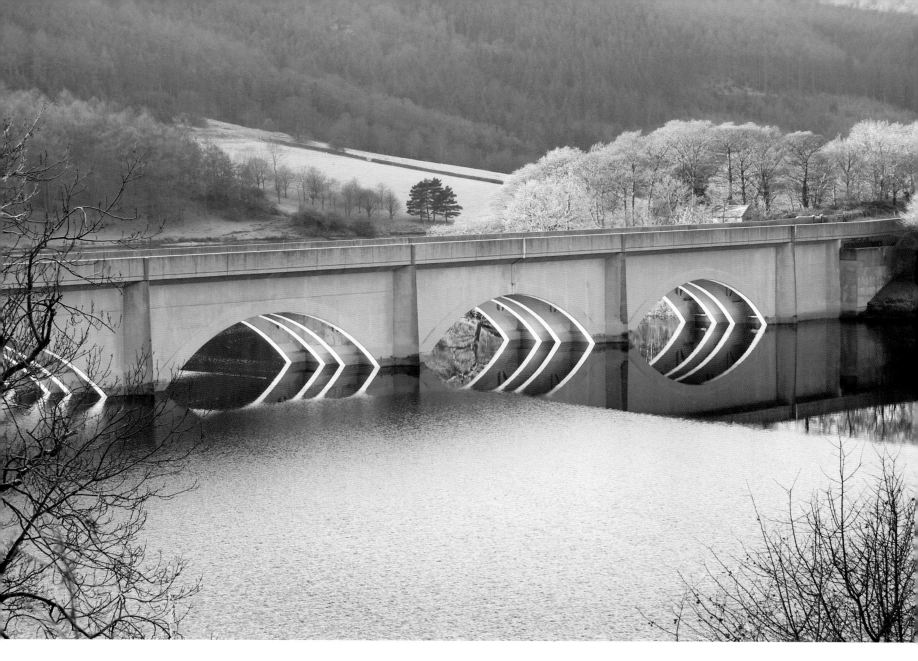

JAMIE SMITH

Ladybower Reservoir, Peak District, Derbyshire, England

I was taken trout fishing by my father to Ladybower Reservoir many a time when I was a small boy. As a result, the reservoir and viaduct became etched in my mind and now, as a photographer and a walker, I enjoy the views from the surrounding hills and paths. Arriving on this cold and frosty morning, the views were outstanding, so calming and clear that it was a delight to stand and take them in. To me, the viaduct is an important part of the Peak District.

Peak District National Park Authority – Best image

PEAK DISTRICT
NATIONAL PARK AUTHORITY

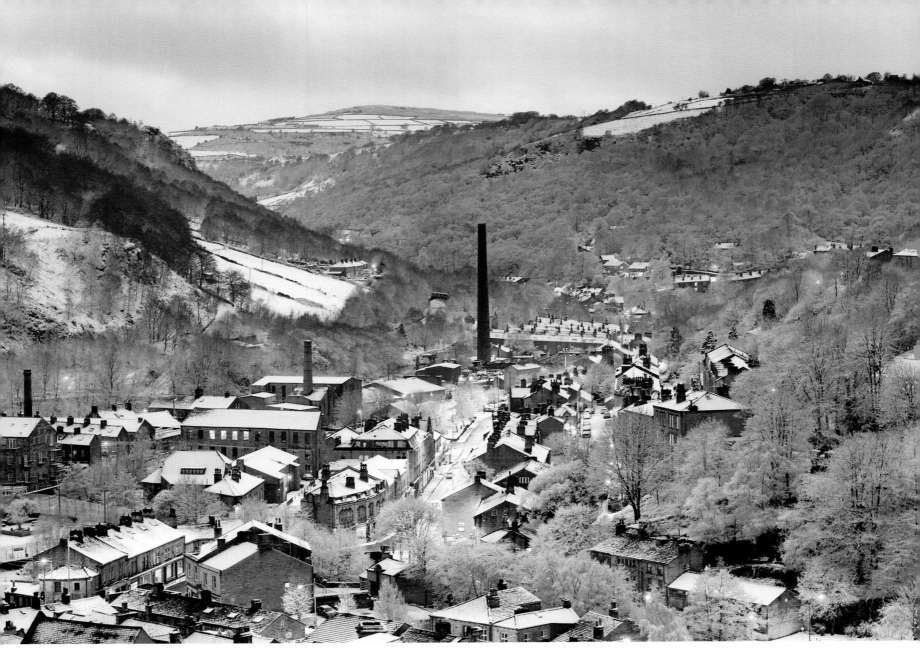

NIGEL HILLIER

Winter nightfall, Hebden Bridge, West Yorkshire, England

This shot was taken on a March evening, following a day of heavy snowfall. I had been out earlier in the day, walking for hours, shooting in the surrounding area. On my return, whilst editing the pictures I looked out of my window at Hebden Bridge town. I was struck by the stark contrast of the cold, grey, snow-covered buildings with the warm bright streetlights. It was only when the sun had gone down and the lights had come on that this scene came to life.

Natural England's 'Landscape on your Doorstep' Award

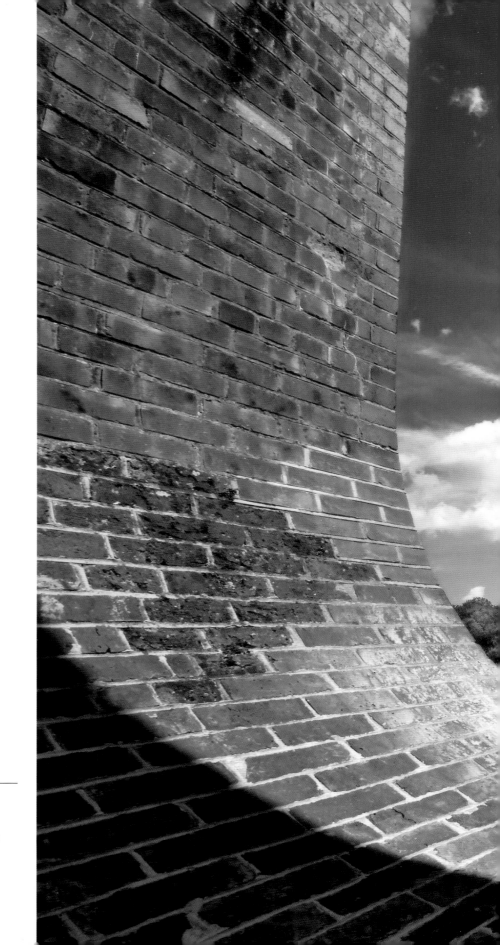

PAUL KNIGHT ⋯⋗

Balcombe Viaduct, West Sussex, England

The additive primary colours, the perspective and the ellipse of light and shadow governed the composition of this shot.

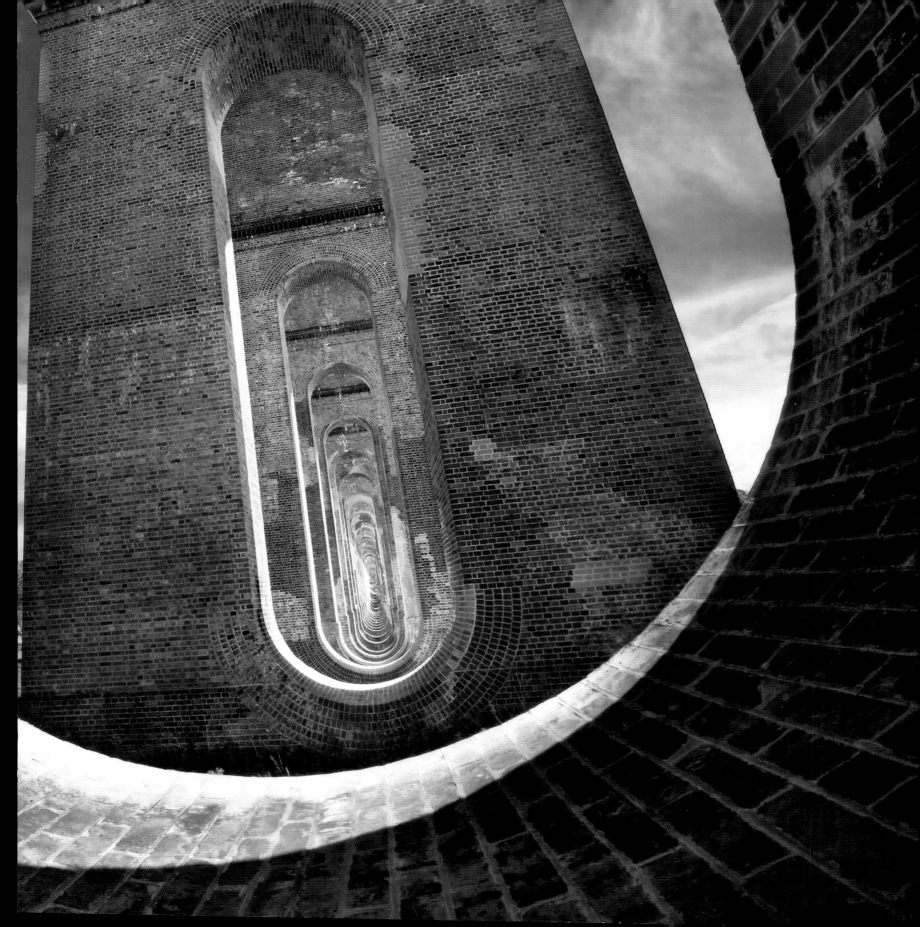

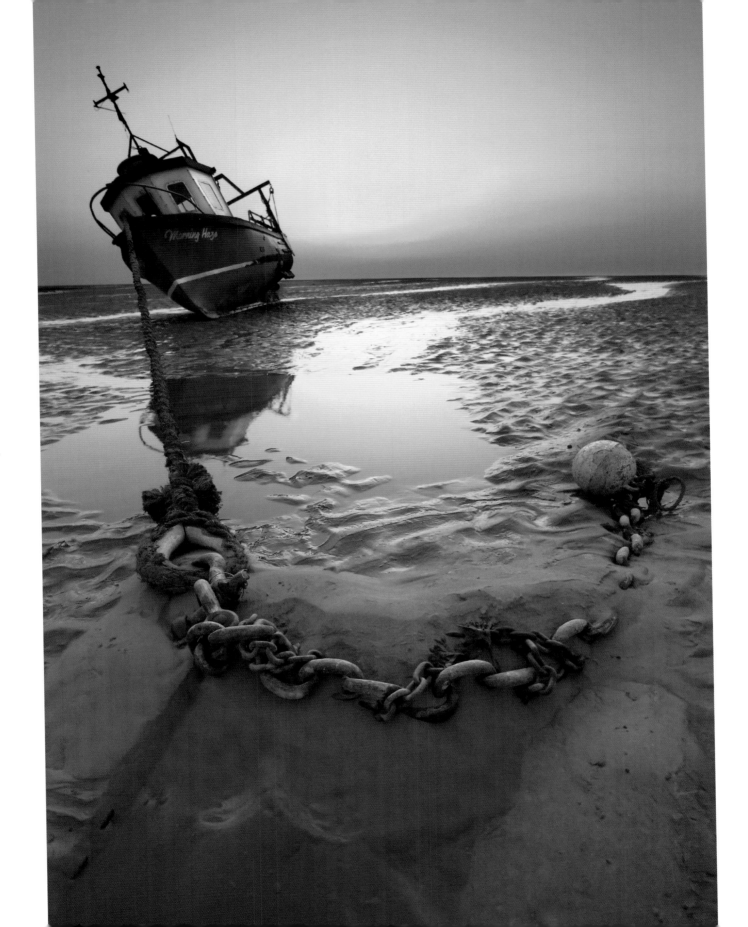

LEE RUDLAND

North Wirral Coastal Park, Wirral Peninsula, Merseyside, England

North Wirral Coastal Park was only created in 1986 and covers four miles of breathtaking scenery, from Dove Point at Meols to the Kings Parade at New Brighton. Whilst living in the North West, I spent a lot of time shooting around this location and it soon became one of my favourite hotspots. This photo was taken at Leasowe shortly before sunset. The rusty chain, which had caught my attention, provided a good lead-in line while the late evening light painted the textures in the sand where the tide had receded.

SIMON De GLANVILLE

Pigeon Pastoral, Burgess Park, Peckham, London, England

The pigeon is an often-overlooked character on our cities' streets. Much maligned as 'rats with wings', they are an under appreciated part of the scenery. Watching them in the local park, I find myself charmed by their dogged quest for bread and sex. I wanted to photograph them in their environment, but from a new perspective, so I used an old Belarusian fisheye lens and shot them from a worm's eye view. In the background you can see a Peckham housing estate. This, I suppose, is the Rock Doves' natural habitat nowadays.

IAN CAMERON

Post Sunset Depression, Findhorn, Moray, Scotland

At sunset on a chill and windy summer evening, the orb of the sun dropped into the sea and fizzled out, apparently signalling the end of play for the day. Despite my assertion that things would probably improve further, the group I was leading packed up all their equipment and scurried back to their vehicles leaving just two of us to continue. This was taken 45 minutes after sunset; the green mossy post embedded in an elliptical depression complemented the vivid red hue of the sky beautifully, even softly rim-lighting the edge of the scoop. It's never over 'til the fat lady sings.

CHRIS McILREAVY

Hadrian's Wall from Winshields, Northumberland, England

I regularly walk along the central section of Hadrian's Wall and February 2009 gave the most dramatic winter conditions I have seen there for nearly 20 years. Realising it could be many years before these scenes are repeated, I spent three days covering as much of the area as possible. This shot was taken from the slopes of Winshields as the sun set over the Northern Pennines. Freezing fog building over the distant Tyne Valley was glowing from the setting sun. The light was also sparkling on icy snowdrifts nearby. Although it was the end of the day, the only footprints in that place were mine. No one else had the privilege of seeing this view.

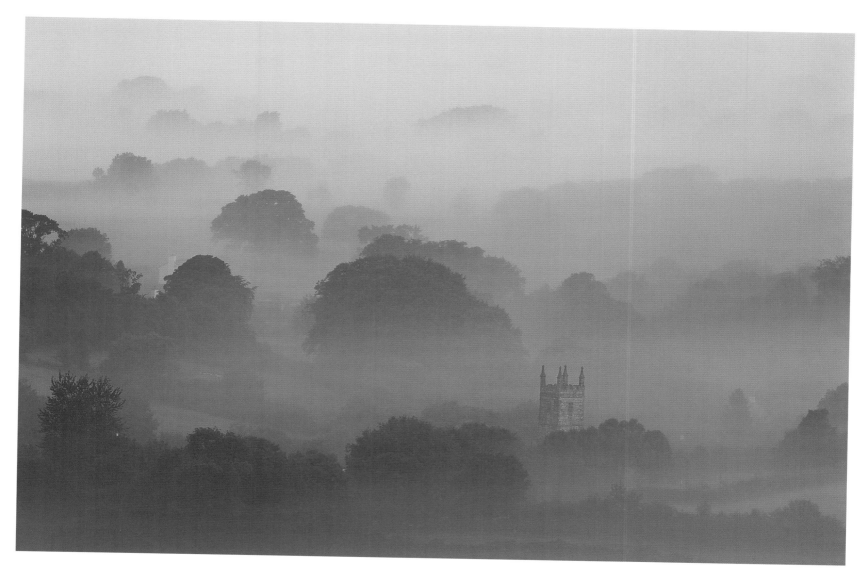

◀···· ROY MERRIFIELD

Sheep dipping at Gategarth Farm, near Buttermere Fell, Cumbria, England

Herdwick sheep are the native breed of central and western Lake District and the rightful heirs to the high fells. Much of the beauty and joy of walking in these fells is due to the hill farmers, who have skilfully managed the land for more than 1000 years. Eking out a living between the bleak and inspiring fells, where their sheep share grazing, they have used, and still use, a traditional type of farming as championed by the late Beatrix Potter 'for her beloved Herdwicks'. Dipping is a necessary procedure to support the health of the sheep, but no doubt is considered by them as a serious (but temporary) loss of freedom from the fells!

↑ ALEX NAIL

Mary Tavy Church in summer mist, Devon, England

I usually don't like colour casts in my images and this is particularly true in the case of blue casts, which can seem to suck the life out of my photos. On this early morning, before the sun had risen, the only thing lighting the mist was the clear, blue sky overhead. A strong blue cast was the result but this seemed to reflect the calm of the scene.

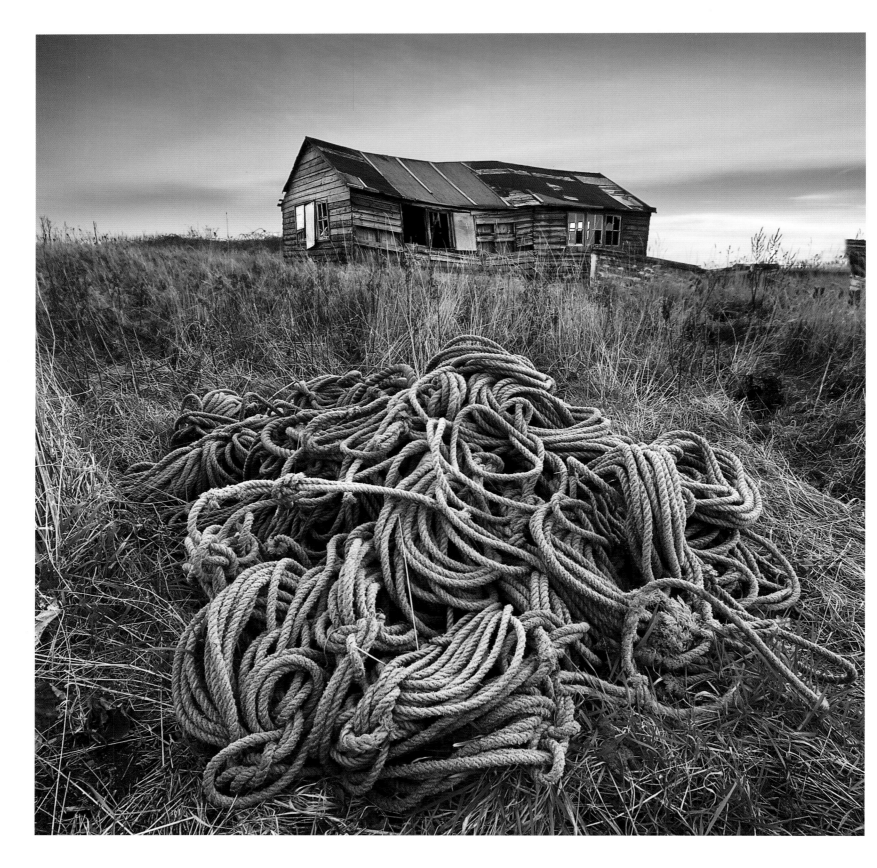

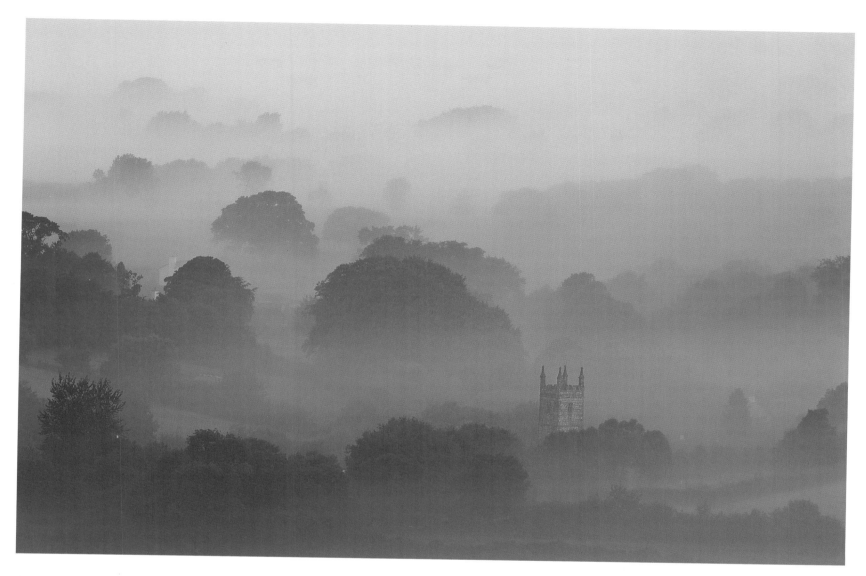

◄••• ROY MERRIFIELD

Sheep dipping at Gategarth Farm, near Buttermere Fell, Cumbria, England

Herdwick sheep are the native breed of central and western Lake District and the rightful heirs to the high fells. Much of the beauty and joy of walking in these fells is due to the hill farmers, who have skilfully managed the land for more than 1000 years. Eking out a living between the bleak and inspiring fells, where their sheep share grazing, they have used, and still use, a traditional type of farming as championed by the late Beatrix Potter 'for her beloved Herdwicks'. Dipping is a necessary procedure to support the health of the sheep, but no doubt is considered by them as a serious (but temporary) loss of freedom from the fells!

☗ ALEX NAIL

Mary Tavy Church in summer mist, Devon, England

I usually don't like colour casts in my images and this is particularly true in the case of blue casts, which can seem to suck the life out of my photos. On this early morning, before the sun had risen, the only thing lighting the mist was the clear, blue sky overhead. A strong blue cast was the result but this seemed to reflect the calm of the scene.

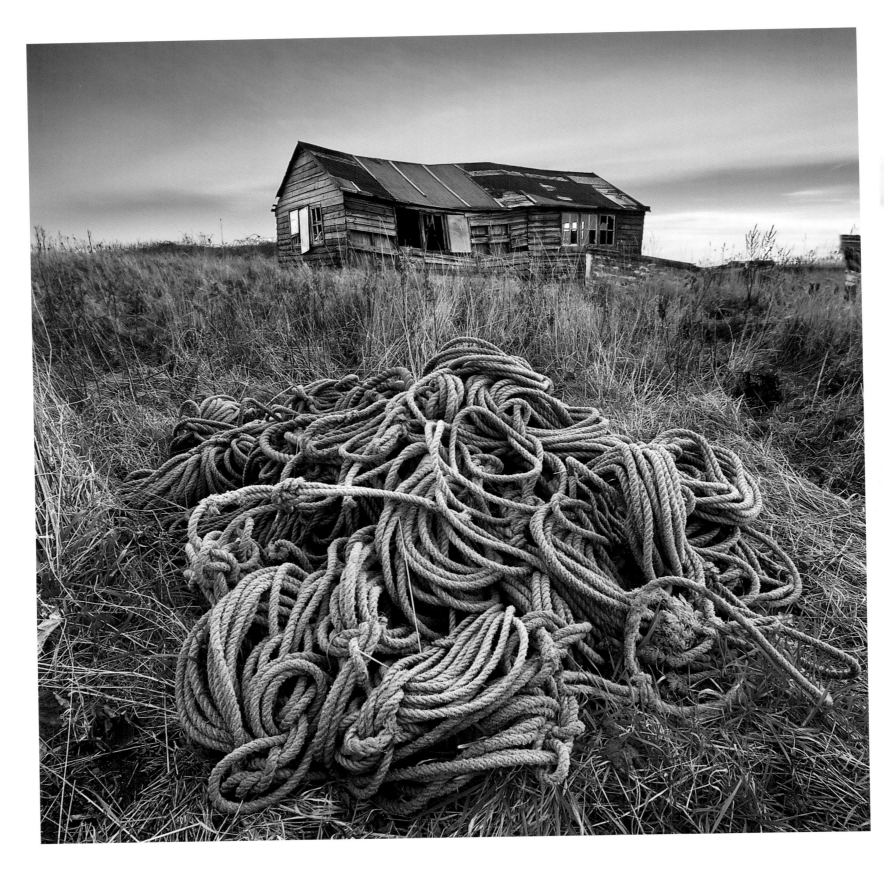

MARTIN CHAMBERLAIN

Abandoned fisherman's hut, Beadnell, Northumberland, England

The tiny village of Beadnell, on the rugged North Northumberland coastline, was once home to dozens of fishermen making a living from the sea, mainly through herring catches. Now, with fish stocks in decline, only a handful of fishermen remain in the village along with the occasional hint of a once thriving local industry.

MIKE STEPHENSON

Stonehenge, Wiltshire, England

I have always wanted to photograph Stonehenge as it's an iconic location — but have always been there with crowds of people or on a boring sunny sky. This was a very wet, cold day and the threat of constant rain had kept the crowds away. I found a good position so that I could position the camera over the ever-present ropes and waited for the light to develop. The feeling, as always around the stones, is one of respect for the ancients who built such huge sites with no modern technology. I also get an eerie feeling of being watched — or perhaps that's the American tourists!

LUCIE DEBELKOVA ⋯⟩

Magic morning light at Glen Etive, Scotland

This shot was captured during an early summer morning at Glen Etive. I was actually worried about revisiting this place, as we had been attacked by millions of midges here the year before. As there were reports of a vast number of midges across the whole of Scotland this year, I thought we would be eaten alive. To our surprise, there was not a single insect, just this wonderful light and sunrays coming through the clouds.

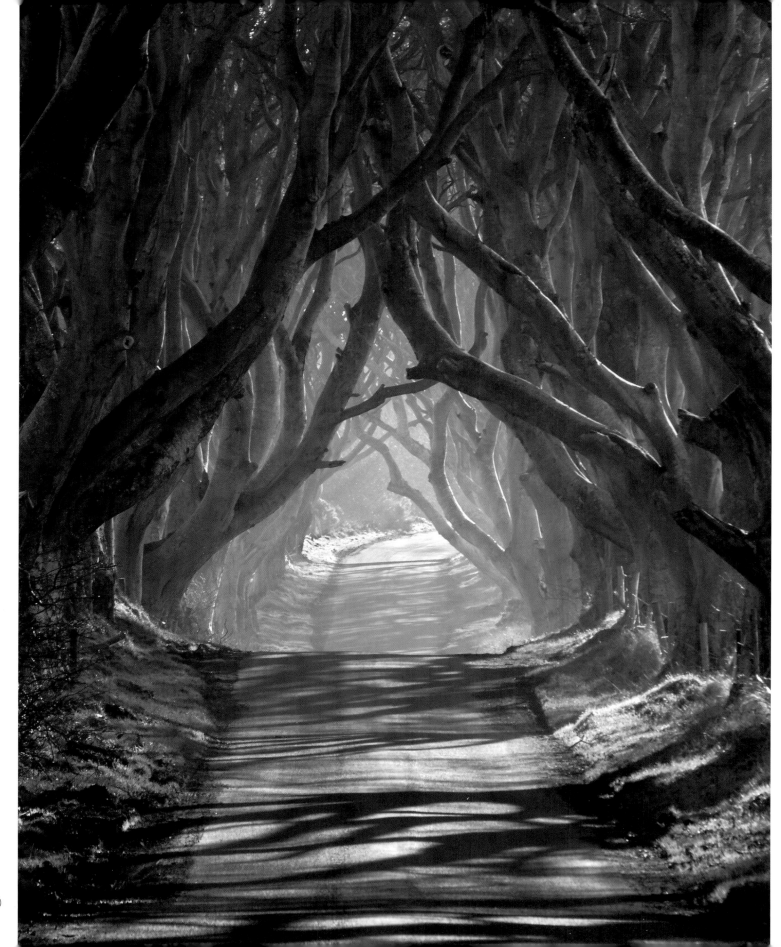

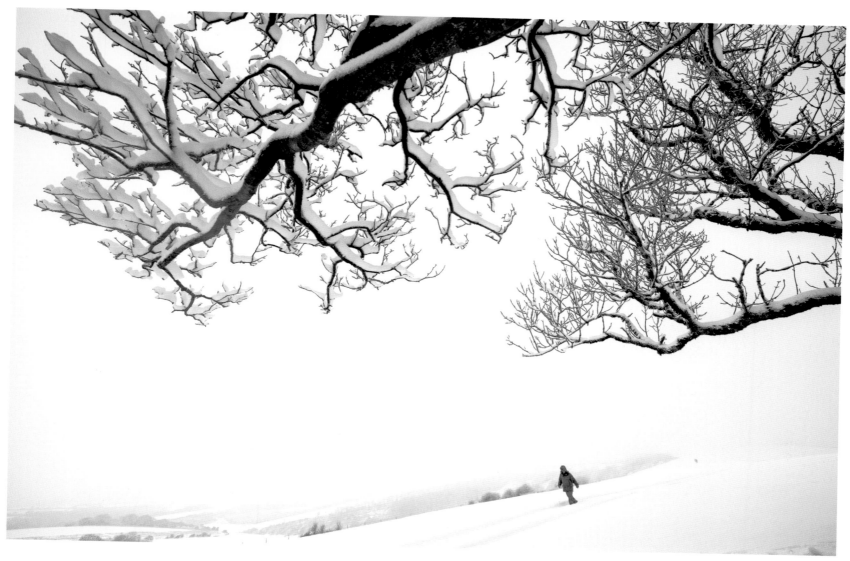

BOB McCALLION

The Dark Hedges, Co. Antrim, Northern Ireland

These 300-year-old beech trees look amazing in all seasons, but their stark, ethereal beauty is best seen in mid-winter. On this particular morning, just after dawn, conditions for photography were ideal, with sunlight filtering through a light mist, casting shadows of the branches on the road below. The resulting image, devoid of colour, comprising just light and shade, is one that I have been trying to capture for a long time to represent the local name of these trees – 'The Dark Hedges'.

CHRIS LEDGER

Heavy with snow, South Downs, West Sussex, England

It's funny how some places keep dragging you back. Following heavy overnight snow in early February, a pre-dawn start found me at Chanctonbury Ring, an Iron Age hill fort on the Sussex South Downs; a very familiar location – but transformed by the blanket snow cover. The snow-laden branches of the trees, together with the progressively mist-shrouded tones of the more distant landscape, made the composing of shapes and lines within the hand-held camera viewfinder a real delight.

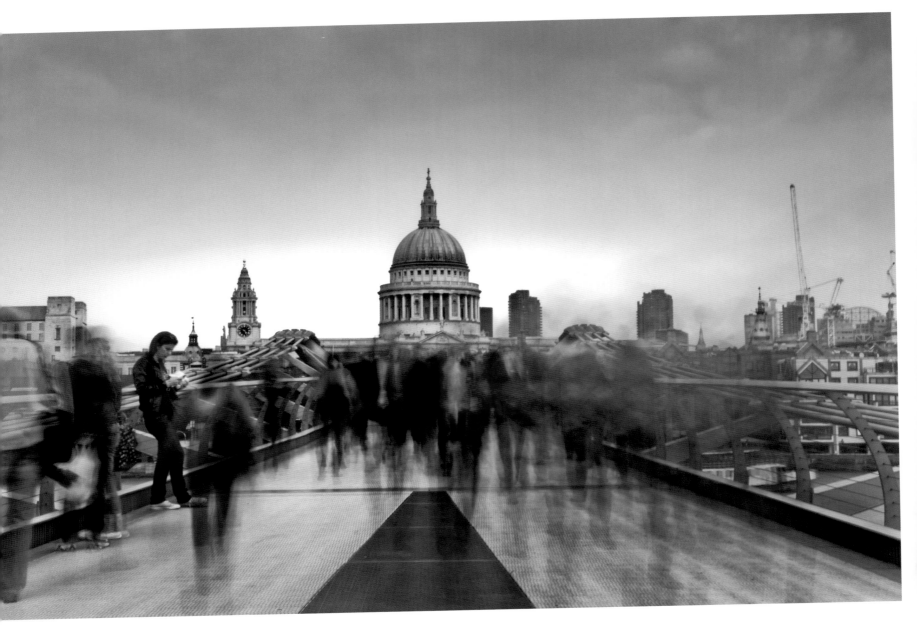

⟨ NATHANIEL GONZALES

Rushing souls of Millennium Bridge, London, England

I decided to travel to London from Oxford last May, hoping for good weather to take some photos of the vibrant city. Unfortunately, the weather was grey and wet but I wanted to make the most of it. I passed by Millennium Bridge which I have photographed many times before. There were plenty of passers-by that afternoon, so I decided to include them in the picture, as I wanted to convey their dynamic movement as an important element of the scene. I used a sturdy tripod so that I could use a long exposure.

MARK BAUER ⋯⟩

Dusk on Swanage Pier, Dorset, England

The trust, which maintains the Victorian pier in Swanage, raises money by selling commemorative plaques to the public, who often buy them as gifts for loved ones. I'd thought for some time that they would make an interesting foreground for a shot of the shelter on the end of the pier. I used an extreme wide-angle lens and set the camera very low and as close to one of the plaques as I could and timed the shot so that there was a balance of natural and artificial light, after the lights on the pier had come on.

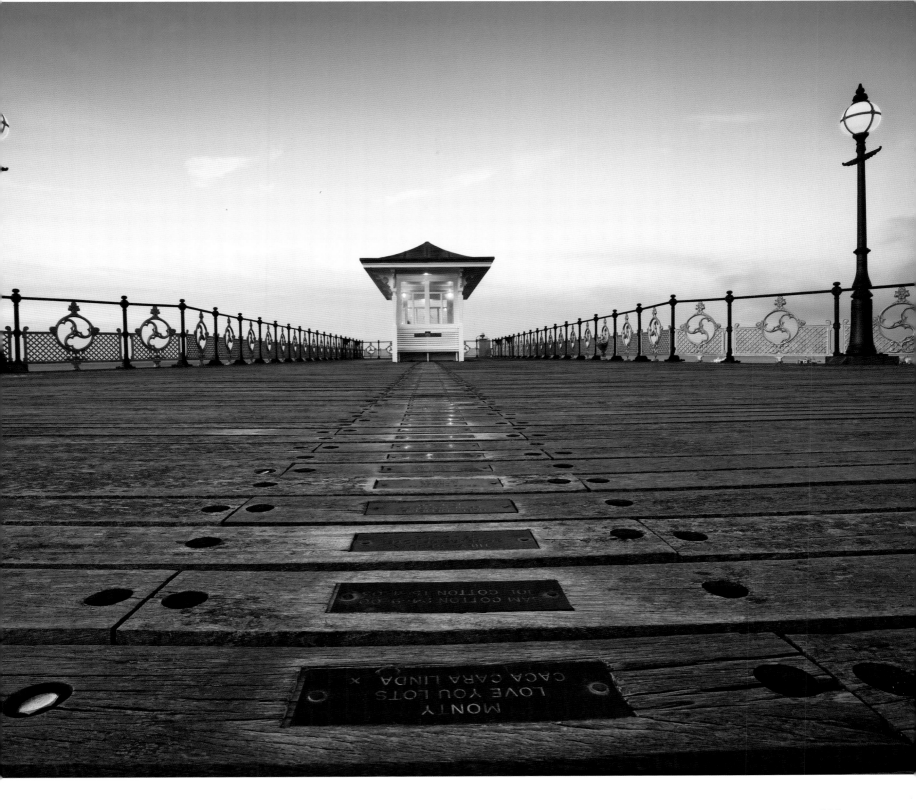

YOUR VIEW
youth class

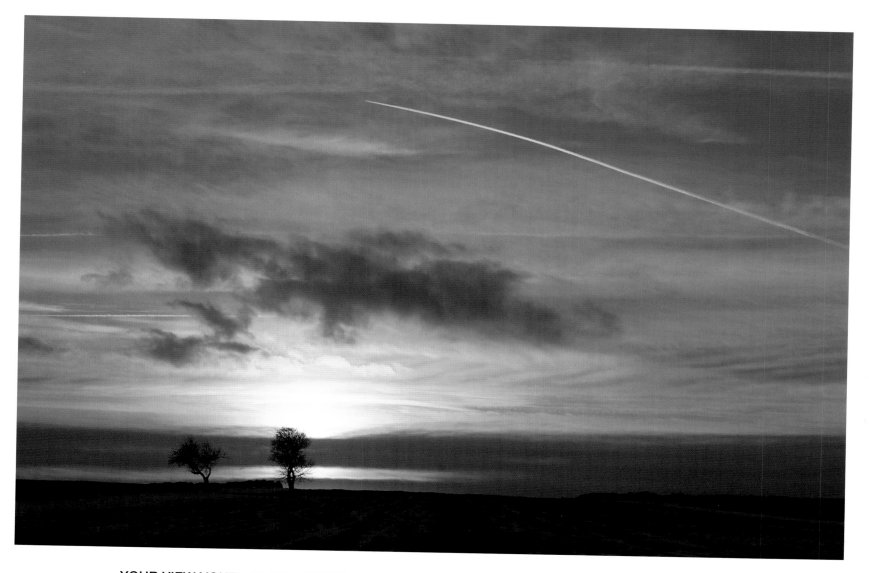

YOUR VIEW YOUTH CLASS WINNER

🕆 JAMES BAMBRIDGE

Winter light, Tideswell, Derbyshire, England

This image was taken in the fields around my home. It was early February and I was eager to try out a new camera that I had received a few days earlier. I liked the way that the snow revealed the tracks on the ground and the light illuminated the vapour trail.

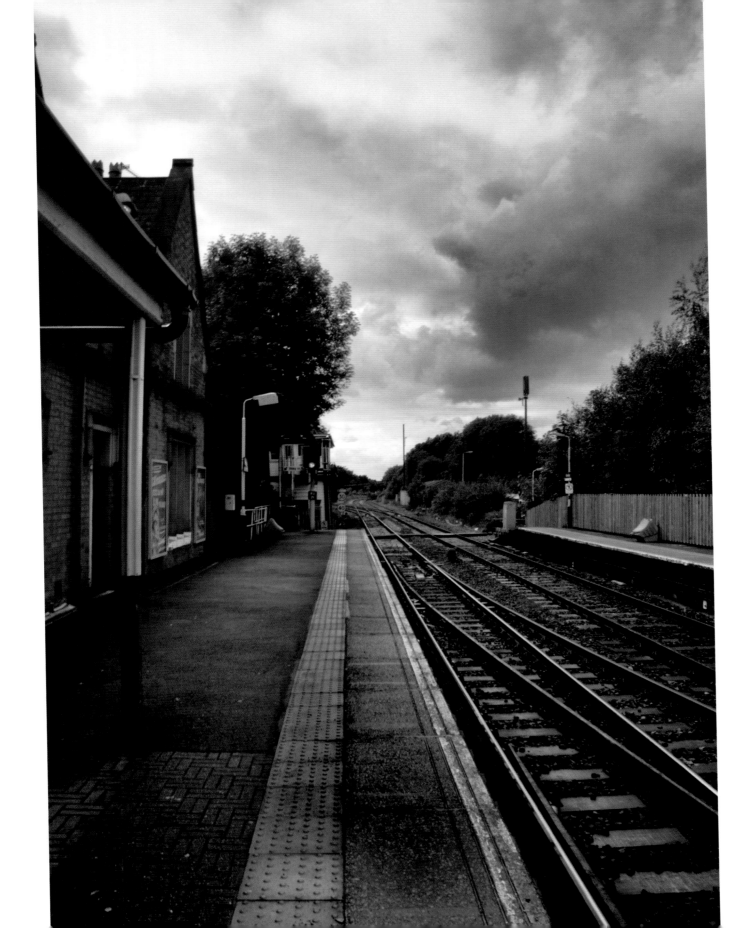

◂⋯ CHRISTOPHER MOSLEY HIGHLY COMMENDED **↑ JAMES McGOVERN**

Dark skies over Romiley Station, Cheshire, England

Autumn view, Markeaton Park, Derby, England

Summer never started over Romiley. Dark skies and clouds shrouded the village for many months, making this a rather morbid setting. The train station was such a lonely place, with no life around to see. Maybe, someday, the station will be booming with visitors coming to see the village's luxuries, however I believe that will have to wait until the warm weather flows in. The dark atmosphere and gloomy loneliness of the setting allowed me to capture a photograph that gives off a rather depressing feel. Of course, it is a general impression of the weather which British people go through on a daily basis, so, hopefully, many will connect with this and understand the nature of my target message behind the image.

I took this photo on a nice autumn day last year. The red and gold colours really appealed to me and the bench seemed an interesting element to include in a photo. I knelt down to get a lower angle. Also, I focused on the leaves and used a relatively wide aperture. This was to emphasize the autumnal theme of the photo. I decided on a central placement of the bench to add a feeling of symmetry and harmony.

JOSHUA CURNOW

Linseed field, Kent, England

This linseed field is by the side of the M25 and A2 in Darenth in Kent. For a short time each year, it becomes a sea of blue. I wanted to show the blue of the flowers close to the cloudy sky.

HAYDEN RAYNOR ⟶

Urbis, Manchester, England

I took this picture at Urbis — I loved the clouds going through the large glass panels.

PHONE VIEW
adult class

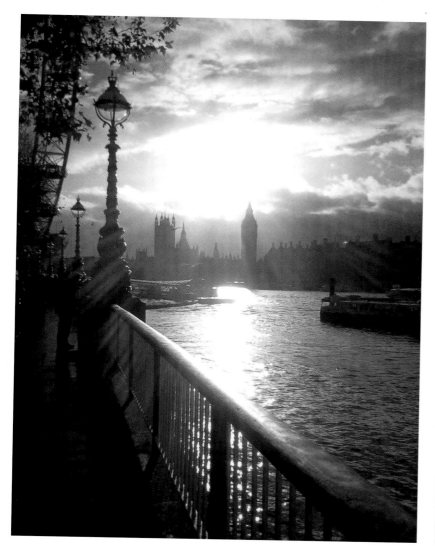

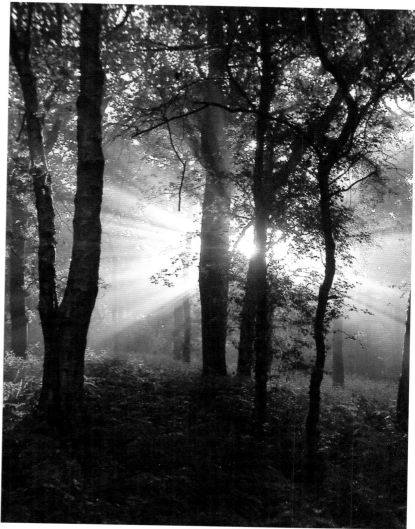

PHONE VIEW ADULT CLASS WINNER

🌳 **ALEX VAREY**

Storm clears over Westminster Palace, London, England

Taken on the South Bank just after leaving the 2008 'Take a view' Exhibition. My girlfriend had banned me from taking my SLR with me, so I was left with only my phone to capture this stunning scene (she agreed it needed photographing).

PHONE VIEW ADULT CLASS RUNNER-UP

🌳 **MAGGIE GUILLON**

Spring in Willey Woods, Nottinghamshire, England

Our house, an erstwhile farmhouse, is on a farming estate and I walk our dog there each morning and evening. It is the area described by D. H. Lawrence as 'the country of my heart' and, indeed, it has become the country of my heart over the years too. The image was taken on an early morning woodland walk where we often come across a small herd of fallow deer; if I call out to them they recognise my voice and don't run off but watch us warily from a distance. On this morning the sun was particularly strong and I only needed to wait for the right moment in order to catch it pouring through the branches in solid gold.

 TOM GOAD

Windy sheep, near Nantglyn, Denbighshire, Wales

I liked the relationship between the sheep and the wind turbine. The sheep seem to be nonchalant about the turbine that is just sitting there, sharing their landscape.

ED PAVELIN

Trees in a foggy car park, Merrivale, Dartmoor, Devon, England

I had just returned to the car park after a disappointing afternoon photographing the stone rows at Merrivale in fog and drizzle. After loading my soaking wet camera gear back into the car, I spotted this group of trees standing along the perimeter of the car park, almost silhouetted in the fog. Not wanting to get my gear out again, I quickly snapped this image with my camera phone. It turned out to be my most successful photograph of the day!

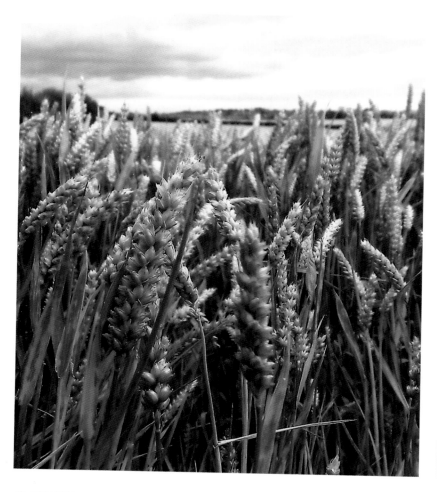

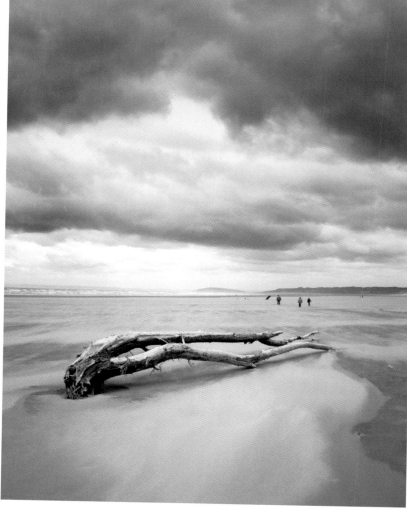

REBECCA BLOOR

Wheat field, Northamptonshire, England

Taken on the side of the road between Wellingborough and Olney on a cloudy, blustery August afternoon. We pulled over to look at the rolling countryside but the viewfinder couldn't capture the spirit of the scene. I was struck by the fluidity of the swaying wheat and I drew back and lined the camera up on the field just beyond the hedge and took three or four shots. This one, I think, encapsulated exactly the feeling of the day and the view.

GRAHAM SMITH

Stormy Llangennith, Gower Peninsula, South Wales

When my nieces visited us last February, we needed a location for their first kite-flying experience. A very windy Llangennith was perfect. The sand appeared to be dancing along the beach in the wind. Without my camera, I had to make do with my mobile phone.

PHONE VIEW
youth class

PHONE VIEW YOUTH CLASS WINNER

←··· KATIE COOK

Winter morning, Mendips, Somerset, England

It was a cold, frosty morning on New Year's Eve. My dad and I decided to go for a walk on the Mendips. There was a thick frost covering everything; it almost looked like snow. I saw this tree and thought it was very beautiful. I had my new phone with me, which was a Christmas present. This was one of the first images I took on my phone.

⬆ BETHAN JONES

Aberystwyth Harbour at sunset, Mid West Wales

I was out with my friends, sitting on a rock by the harbour, when I saw the boat coming in. The sun was setting and I thought it would make a good picture, so I took it.

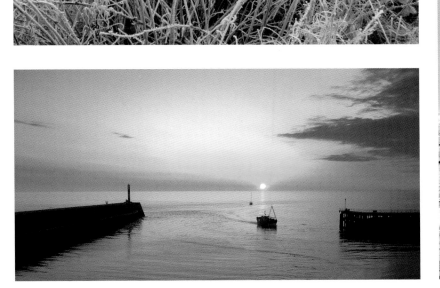

⬆ ALEXANDER LAWSON

Derwent Dam, Derbyshire, England

This is the view up the dam at Derwent reservoir on a nice sunny day. The water was streaming down the high walls. The bouncing bombs were tested here during the Second World War.

ALEX NAIL (p.3)
Canon 20D, Canon 70-200 f/4 L, 180mm, f8, 1/2 sec, ISO 100 Brightness and contrast adjustments in CS4, no colour adjustments.

STEEN DOESSING (p.5)
Canon 1Ds Mk III. Long exposure - 240+sec. Polarizing Filter + ND x13 Filter. Blue Filter by setting Colour Balance to Tungsten. Dodge and Burn + Levels and Curves in Photoshop.

GRAHAM McKENZIE-SMITH (p.13)
Nikon D200 with a Sigma 10-20mm. 1/80 sec @ f4.5, 100 ISO.

EMMANUEL COUPE (pp.18–19)
Canon 1Ds Mark III, 17-40L, Bracketed exposures, manually blended in Photoshop. Three frames stitched together to create panorama.

JON McGOVERN (p.20)
Nikon D60 @ 18mm. 1/80 sec, f/9, ISO 200. No filters were used. Combined exposures for the land and sky in Adobe Photoshop.

JOHN PARMINTER (p.25)
Nikon D300, Sigma 17-70mm@17mm, ISO 200, 1/15 sec, f/16. Lee 0.6 ND graduated filter. Minor levels tweaks.

TIM MORLAND (p.26)
Nikon D700, 180mm, ISO 400, f8, 1/60 sec Cropped & selectively sharpened, with some 'dodging and burning'.

ALEX NAIL (p.28)
Canon 20D, Canon 17-40 f/4 L, 40mm, f11, ISO100, 2 frames stitched to a panoramic, exposure blending of 2 frames 2 stops apart, 4 frames in total (2x2). Manual exposure blend in Photoshop CS3. Minor colour and contrast adjustments.

JACKIE WU (p.29)
Canon EOS 400D with Sigma 10-20mm f/4-5.6 @ 10mm, 3 AEB shots blended in Photomatix and Photoshop was used to enhance the colours.

ALEX NAIL (p.30)
Canon 20D, Canon 70-200 f/4 L, 122mm, f11, 1/45 sec, ISO 100 Brightness and contrast adjustments in CS4, no colour adjustments.

SIMON PLANT (p.31)
Canon 1Ds Mk II Tonal and colour adjustments.

MARTIN SHALLCROSS (p.32)
Wista 45, 150m lens, Ilford FP4. Yellow filter. No image manipulation.

ALUN DAVIES (p.33)
Canon EOS 40D with EF-S 10-22mm Canon lens at a focal length of 15mm, Bulb exposure of 89 sec, f/16, ISO 100. Tripod mounted. Shot in RAW. Converted to B&W in Photoshop CS3 following local contrast enhancement. Minor adjustments to brightness and contrast.

SŁAWEK STASZCZUK (p.34)
Canon EOS 350D + Sigma 100-300mm EX lens @ 150mm, tripod, captured RAW. 1/250s, F5.6, ISO 200. Contrast enhancement via curves adjustment.

DAVID TAYLOR (p.35)
Canon EOS 5D with a 50mm lens f11@1/25s with 2 stop ND grad.

DAVID TAYLOR (p.36)
Canon EOS 1DS Mk II with 50mm lens. ISO 100, F16@30 sec.

IAN CAMERON (p.37)
Pentax 67II, 55-100 zoom, polariser, 0.45ND hard grad, f/22 @ 6 sec, Velvia 50. Camera mounted on Gitzo 3530LS with RRS 50 ballhead.

JOHN PARMINTER (p.38)
Nikon D300, Sigma 10-20mm@11.5mm, ISO 200, 1/50 sec, f/11. Lee ND graduated filter. Minor levels tweaks.

CHRIS McILREAVY (p.39)
Nikon D700 with Nikkor AFS 14-24 @ 14mm, F11, 1/100 sec, ISO 400. RAW file converted in DxO Optics Pro. Levels and selective curves adjustments applied in Photoshop CS3.

ANDREW WHITAKER (p.40)
Canon EOS 50D with Sigma 10-20mm lens, f/11, 10 sec throughout. Shooting on a tripod, 3 shots were stitched together using panoramic program in Photoshop.

KEVIN SKINNER (p.41)
Canon EOS 300D, Canon EF 70-300mm IS USM, no filters used. 1/200 sec @ f/10. B&W conversion carried out in Photoshop.

JAMES PARREN (p.42)
Olympus E410, Zuiko 9-18mm @ 10mm, ISO 100, f8, 1 sec. 2 stop soft Lee ND grad over the sky. RAW file rendered in Capture One. Minor alterations to white balance contrast. Sharpening applied.

PIOTR PIASECKI (p.43)
Samsung 815 Pro, 10mm, 1/200 sec @ f/4.6, ISO 50.

DAVID CLAPP (p.44)
Canon 1Ds Mk III, Contax 35-70 f3.4 @ f11.

EMMANUEL COUPE (p.45)
Canon 1Ds Mark III, 17-40L, 2-stop soft-edge GND filter. Handheld.

KEITH NAYLOR (p.46)
Canon EOS 1D Mk III, EF 28mm f2.8 prime lens, 1/25 sec @ f20 -2/3EV.

ADRIAN HALL (p.47)
Canon EOS 50D, 10-22mm. 2 exposures blended to give the same effect as a reversed ND filter.

DAVID SPEIGHT (p.48)
Canon EOS 5D with Canon 17-40F4L USM lens. 1 sec @ F22. Image de-saturated in Rawshooter Essentials with final adjustments in Photoshop CS3.

ANDREW ROBERTS (p.49)
Canon EOS 20D with Sigma 10-20mm lens. ISO 100. Under exposed by a third. 3 stop ND grad.

MARK BAUER (p.50)
Canon EOS 1Ds Mk II, 24-105 f/4 L @ 45mm. 1/4 sec @ f/11. Lee 0.6 ND grad, tripod. No Photoshop work other than basic levels, curves and saturation adjustments.

KRIS DUTSON (p.51)
Canon EOS 5D, 17-40 f/4 L, 1/6@f22, ISO 100, Cokin 121F grad, tripod.

PETER COX (p.52)
Canon EOS 5D Mk II with EF 70-200 f/2.8L IS @ 200mm 1/2 sec @ f/16, ISO 100. Nominal post-processing including dodging/burning and curves.

CHRIS HOWE (p.53)
Canon 1Ds Mk III, Canon 16-35 @ 23mm, 1/60, f/13, ISO 200. Processed in Lightroom, with minor editing in Photoshop.

PAUL KNIGHT (p.54)
Canon EOS 5D, f22 @ 4 sec. Levels slightly adjusted in Photoshop.

ANTONY BURCH (p.55)
Canon EOS 40D, Sigma 10-20, ND4 Graduated Filter, Manfrotto 190 CL Tripod, Three RAW files shot in AEB mode -2 0 +2, HDR blended and tone-mapped in Photomatix Pro 3.

ADAM BURTON (p.56)
Canon EOS 1Ds Mk III with Canon 17-40L, Cropped into square format in Photoshop.

ADRIAN METZELAAR (p.57)
Canon 40D, 17-40L, 21mm, f16. Minor adjustments to levels, contrast and saturation. Use of two combined exposures to achieve maximum tonal range.

ROBERT GARRIGUS (p.58)
Canon EOS 5D, Canon EF 17-40mm L, Manual mode, 1/8 sec, f/18, 3-stop ND grad.

CRAIG JOINER (p.59)
Nikon D2X with 17mm lens, f/11, 1/4 sec, ND graduated filter, tripod with panoramic head and remote shutter release. Six overlapping vertical images were digitally stitched together to create this one panoramic image plus minor curves and saturation adjustments applied during RAW conversion.

JIM BARTER (p.60)
Canon EOS 350D, 50mm @ f6. Levels & saturation adjustments in Photoshop CS2.

DAVID KENDAL (p.61)
Canon 40D with EF-S 10-22 lens @ 14mm, 2 sec @ f/11, ISO 100. Lee 0.9 ND Filter to lengthen exposure and Lee 0.6 Hard ND Grad to control the sky. Cropped & levels adjusted in Photoshop.

STEWART MITCHELL (p.62)
Nikon D80 with Nikkor 70-300mm f/4.5-5.6G IF-ED AF-S VR Zoom @ 170mm. 1/250 sec, f/5.6, ISO 100. Shot in RAW and processed in Adobe Lightroom.

ANTHONY BRAWLEY (p.63)
Nikon D700 using an AF-S Nikkor 24-70mm 1:2.8G ED lens. The image was shot in RAW format with white balance adjusted in ACR and curves and mild 'lab' sharpening applied in Adobe Photoshop CS4.

BART HEIRWEG (pp.64–65)
Canon EOS 5D with Canon EF 70-200mm L 4.0, f14, 1/320 sec, ISO 200. Gitzo Tripod and RRS BH-55 ballhead. Mirror lockup and remote release. Lee 0.6 and 0.9 grad ND filter. A panoramic image merged from 6 vertical images using photomerge in Photoshop CS3. Cropped to 6 x 17 ratio.

GEOFF PERRY (p.66)
Canon EOS 5D, Canon 16-35mm L lens, 4 bracketed exposures @ 1/60, 1/20, 1/5 and 0.8 sec, f22, ISO 50, Focal Length-23mm. Merged on Photomatix with Levels and Curves adjustments on Photoshop.

MIKE HUGHES (p.67)
Nikon D100, Adobe Photoshop to enhance colour and exposure.

ALAN CAMERON (p.68)
Canon EOS 5D Mk II, Lens EF 24-105 F4 Is USM @60mm, 1/15 sec @ F16 ISO 800. Shot in RAW, Processed & adjusted in Lightroom 2.4

DAVID STANTON (p.69)
Canon EOS 1Ds Mk III, f16 @ 30 sec, ISO 100, RAW format.

NICKY STEWART (p.70)
Canon EOS 300D, 18-55mm. Adobe Photoshop for adjustments.

CLAIRE CARTER (p.71)
Canon 5D Mk II with Canon 24-105 f4L IS USM. f/10 @ 1/25, ISO 200. Tripod and Lee ND Grad. White balance in raw, curves, saturation, selective contrast.

SŁAWEK STASZCZUK (pp.72–73)
Canon EOS 350D + Sigma 100-300mm EX @ 137mm, tripod, captured RAW. 1/100s, F5.6, ISO 200. Contrast enhancement via curves adjustment.

DAVID SPEIGHT (p.74)
Canon EOS 5D combined with a Canon 17-40 F4L USM lens & Lee 0.9 ND Grad filter. 1/13 sec @ f11, IS0 50.

SŁAWEK STASZCZUK (p.75)
Canon EOS 350D + Canon EF-S 10-12mm lens @ 12mm. ND graduated filter and polarizer; tripod; captured as RAW file. 1/15s, F10, ISO 100. Cropped slightly, contrast/colour correction via curves adjustment.

DAVID STANTON (p.76)
Canon 1DS Mk 3, f16 @ 1/125, ISO 100, RAW format.

ALEX NAIL (p.77)
Canon EOD 5D with Canon 50mm lens. 1.4 @ f11. Two images stitched into a panorama; also exposure bracketed (3 stops) and blended manually using layer masks in Photoshop CS4. In total 6 frames. Basic colour and contrast adjustments were made.

ADAM BURTON (pp.78–79)
Canon 1Ds Mk III, Canon 24-70L, 1 sec @ F16, ISO 100, 0.9 ND Graduated filter.

VÁCLAV KRPELIK (p.80)
Canon EOS 450D + Canon EF-S 17-55mm f2.8 IS USM @ 44mm, tripod. f/11, 20/1 sec; ISO 100. Noise reduction & corrected horizon.

CHRIS LEWIS (p.81)
Nikon D200, 28-105 Nikkor @ 90mm, F13, 1/40s, ISO 100, Manfrotto 190B Tripod & remote release. Raw file processed in Capture NX2 and adjustments made using levels/curves. No filters. Orton Effect applied in NX2.

SŁAWEK STASZCZUK (p.82)
Canon EOS 350D with Canon EF-S 10-22mm @ 10mm. ND graduated filter, tripod, captured as RAW file. 1/250s, F8, ISO 100.

ROSS HODDINOTT (p.83)
Nikon D300, 10-24mm (@ 24mm), ISO 100, 3 minutes @ f/13, 0.9ND grad, polariser, 10-stop ND, cable release & tripod.

SAMUEL BAYLIS (p.86)
Nikon D90 @ 42mm. f14, ISO 200.

GARETH HUXTABLE (p.88)
Kodak EasyShare C340 pocket camera. Three exposures combined using Photomatix software.

JOSHUA CURNOW (p.89)
Canon Powershot SX110IS. Using Coral Paint Shop Pro X, I have trimmed the picture and used the fade correction facility.

STEPHEN GARNETT (pp.92–93)
Canon EOS 1D Mark II, 1/500 sec @ F8. Not digitally manipulated.

ALEX SABERI (p.94)
Canon EOS 5D, 100-400mm Canon lens @ 400mm. f/7.1, 1/500 sec, ISO 160.

GARY WAIDSON (p.95)
Canon EOS 5D. EF 17-40 f4L USM @ 40mm. Tripod with cable/timer switch. Bracketed exposures @ f8 manually blended.

PETE BRIDGWOOD (p.96)
Canon EOS 1Ds Mark III, Canon EF 17-40mm f/4L USM @ 31mm. 1/400 sec @ f/8.0, ISO 400. Reducing the amount of 'clarity' applied by Adobe Lightroom 2 has resulted in an intentionally 'softly' rendered result.

LES FORRESTER (p.97)
Canon 20D with 70-200 2.8 L. ISO 200, F6.3, 1/200 sec.

CRAIG EASTON (pp.98–99)
Leica M8, 21mm lens 1/180 sec, f8. 0.6ND Hard Grad. Adobe Camera RAW simple adjustments plus Photoshop Hue/Saturation and Curves.

CHRIS LEDGER (p.100)
Nikon D700. Nikkor 14-24mm @ 21mm. 1/500 sec @ f6.3. ISO 200. Hand-held.

JONATHAN LUCAS (p.101)
Canon 5D Mk II with Canon 15mm fisheye lens. JOBY Gorillapod. 1/2 sec, f4.5, ISO 100. Flash.

GORDON SCAMMELL (pp.102–103)
Nikon D200 with 14-24mm lens. 1/640 sec, f4.5, ISO 200. Curves and levels tweaked.

JAMES SWAN (p.104)
Canon EOS 1D Mk II with Canon Zoom Lens EF 24-70mm 1:2.8 L USM @ 48mm. 1/800 sec, f/13, ISO 400.

GORDON FRASER (p.105)
Canon EOS 5D, 70-200F4L, 1/8000 sec @ f5.

GRAHAM HOBBS (p.106)
Pentax K10D with DA 50-200mm lens @ 138mm focal length (207mm equiv). 130/s @ f/16, ISO 200. No manipulation other than slight enhancement in Photoshop.

ROGER CLEGG (p.107)
Bronica SQAi with 50mm lens, Seckonic 508 light meter, Ektachrome 100VS, Nikon medium format scanner. Photoshop Elements used to tweak contrast, highlight detail and saturation.

MATT KING (p.108)
Pentax K10 with 50 - 200mm Pentax zoom @ 50mm. The image has been cropped and levels/saturation tweaked but no other digital manipulation has been done.

BRIAN GRIFFITHS (p.109)
Pentax K10D with Tamron 18-200. 1/80 sec @ f22. ISO 400. Selective levels, curves and saturation.

STEVE REW (p.110)
Canon EOS 5D with 24-70mm 2.8L lens. 1/400 sec, f/10, ISO 100. Curve adjustments and sharpening applied in post-processing.

IAN SNOWDON (p.111)
Nikon D200 with Nikkor 18-70 f3.5-4.5G ED-IF AF-S DX Lens @ 65mm 1/180 sec, f8, ISO 100.

MAGDALENA STRAKOVA (p.112)
Canon EOS D60 with Sigma 70-210mm @ 70mm, converted to black and white, increased contrast, darkened edges.

PETER SMITH (p.113)
Hasselblad 553ELX with 80mm lens. Fuji film, ISO 400. Scanned from negative.

ANNA WALLS (pp.114–115)
Nikon D300 with 18-200mm lens @ 200mm. 1/40 sec, f/13, handheld. Processed in RAW and levels and curves then adjusted in Photoshop CS3.

LAURENCE CARTWRIGHT (p.116)
Nikon D90 with 16-85 lens @ 16mm. 1/200 sec, f22. Shutter speed priority. Fill-in flash to highlight subject. Shot in RAW with minor tweaks in post processing for contrast, levels and sharpness

JONATHAN LUCAS (p.117)
Canon 5D Mk II with Canon 28-300mm f3.5-5.6L IS USM. 1/750 sec, f11, ISO 800.

ALEX SABERI (p.118)
Canon 5D Mk II with Canon 24-70mm lens. 1/60 sec, f7.1, ISO 500.

217

CHRIS BRYANT (p.119)
Pentax LX, 28mm f2.8 lens. Red Filter. Kodak Tri-X @ EI200 developed in Kodak T-Max developer.

RICHARD HARRIS (p.120)
Canon EOS 350D with Canon EF28-80mm USM. 1/2000 sec, f/18, ISO 1600. Auto level and auto colour adjust plus about 10% added contrast in Photoshop CS3.

MARK BARTON (p.121)
Nikon D300 with Nikon 80-200mm 2.8D ED. 1/800 sec, f/8, ISO 200. Giottos 3260B monopod.

TOM ROBERTS (p.122)
Samsung GX10 with Sigma 10-20mm @ 11mm. Aperture Priority, 1/50s @ f22, -0.3 EV. Pattern metering, AWB, ISO 100. Levels & Curves adjustments + cropping.

JONATHAN LUCAS (p.123)
Canon 5D Mk II with Canon 15mm fisheye. 1/2000 sec, f8, Fill flash, ISO 400.

MARCUS McADAM (pp.124–125)
Canon EOS 5D Mark II. 17-40mm lens. 1/100 sec, f14, ISO 100. RAW format.

ROSIE ALDRIDGE (p.126)
Canon 350D with W/A Canon 10-22 lens @ 22mm, 1/180 sec @ f/9.5, ISO 200.

DAN LAW (p.127)
Nikon D80 with 18-135mm (kit lens) @ 44mm. 3 sec, f4.8, ISO 200.

CRAIG WELDON (p.128)
Nikon EM and Velvia slide film.

CHRIS FRIEL (p.129)
Canon EOS 40D 50mm F1.4. In camera B&W Jpeg.

DAVID HUTT (pp.130–131)
Canon EOS 5D with 24-105mm lens set @ 24mm. 1/100 sec @ f7.1, ISO 100. Shot in RAW, uncropped, processed in Photoshop CS3.

TREVOR WRIGHT (p.132)
Sony DSLR A350 28mm f6.3 @ 1/60 sec.

STEPHEN EMERSON (p.133)
Canon EOS 5D with Canon EF 24-105mm f/4L. 2 sec, f5.6, ISO 100.

JEFF ASCOUGH (pp.134–135)
Leica M8 with 21mm lens. The image has been darkened and lightened, and converted to black and white digitally.

ANDREW DUNN (p.136)
Canon 350D with a 70-200mm F4L lens. 1.6 sec, f/32, ISO 100.

MARTIN ERHARD (p.137)
Olympus C8080. 1/60 sec, f3.5, ISO 200. Some adjustments in Photoshop.

GERRY WILSON (pp.140–141)
Nikon D200 with 17-35mm Nikkor lens. ISO 1600.

JAMES McGOVERN (p.142)
Canon EOS 450D. 1/50 sec, f/5.6. Converted to B&W in Adobe Photoshop.

LIZZIE DRAVNIEKS (p.143)
Fujifilm FinePix S100FS @ 28mm. 1/550 sec, f5.6, ISO 100. Image cropped and slight adjustments to brightness and contrast.

JOHN PARMINTER (pp.146–147)
Nikon D300, Sigma 10-20mm@16mm. 45 sec, f/29, ISO 100. Lee ND graduated filter. Minor levels tweaks.

BRIAN GRIFFITHS (p.148)
Pentax K10D with Tamron 18-200mm. Two multi-exposure and focus length images blended manually. Selective levels and curves. Some saturation adjustment in Photoshop CS2.

PAUL KNIGHT (p.150)
Canon EOS 5D 1/2 sec @ f22. Levels adjusted in Photoshop.

PETER STEVENS (p.151)
Nikon D700 with 70- 200 f2.8G Nikkor @ 135mm. 1/200 @ f7, ISO 200.

MATTHEW HALSTEAD (p.152)
Nikon D300 with 12-24mm lens @ 12mm. 1/200 sec, f9, ISO 200.

BRIAN GRIFFITHS (p.153)
Pentax K10D with Tamron 18-200mm. 1/160 @ F8. ISO 100. Tripod. Desaturation, selective levels and curves. Dodge and burn tool in Photoshop CS2.

IAN CAMERON (p.154)
Pentax 67II with 90-180mm zoom, unfiltered, f/16 @ 4 sec, Velvia 50. Camera mounted on a Gitzo 4530LS with RRS 50 Ballhead. Image subsequently converted to monochrome in Photoshop using channels.

PETER STEVENS (p.155)
Nikon D700 with 85mm f1.8 Nikkor lens. 1/320 sec @ f9. ISO 200. Minor digital adjustments made to the levels and histogram. Some digital ND filtering added to top and bottom of image.

DUNG HUYNH (pp.156–157)
Canon 50D, Sigma 24-70mm @ 64mm. 1/1000 sec, f5.6, ISO 100.

DUNCAN SOAR (p.158)
Nikon D3 with Nikkor 24-70mm AFS @ 31mm. 6 sec, f14, ISO 200. Cropped & balanced Adobe Lightroom & flare removed in Photoshop.

ERIC WYLLIE (p.159)
Canon 350D with 18-55 kit lens. Adjustments in Aperture to help the exposure and to bring the colour of the foreground grass out of the shadows.

DON BISHOP (p.160)
Canon EOS 5D with Sigma 17-35mm lens @ 35mm. 0.3 sec @ f16. RAW format. Minor levels adjustments in Photoshop. Application of Velvia Vision to retain the warmth of the late afternoon light.

RICHARD BURDON (p.161)
Nikon D700 with 24-120 lens @ 26mm. 1/8 sec @ f22, ISO 200 Levels and Curves adjustment layers in Photoshop.

MARK LAKEMAN (p.162)
Canon EOS 400D, Sigma DC EX 18-50mm. Manfrotto 190 pro tripod, Manfrotto 329 head. Single shot exposure, cropped slightly.

ADRIAN LYON (p.163)
Canon EOS 5D @ ISO 1600. I used Photoshop to adjust curves and levels to enhance the mood of the image so it was more like the eye saw it rather than how the camera saw it.

NIGEL HILLIER (p.164)
Nikon D300, 17-55 2.8 lens @22mm. 1/100 sec, f7.1, ISO 400. Lit by on-camera and SB-800 flashes.

ANDREW TUCKER (p.165)
Canon 40D with a Sigma 10-20mm wide-angle lens. I took the photo in RAW format and played with levels only a little in Photoshop Elements 6. One of my first attempts with using Photoshop.

DAVID LANGAN (p.166)
Canon EOS 5D, Canon 17-40L, Tripod, Remote Release, Mirror Lock Up, Lee 0.6 ND Hard Grad. Basic manipulation using Adobe Camera Raw and CS3 - levels, contrast, hue and saturation.

ADRIAN BICKER (p.167)
Olympus E-510 with Olympus 300mm f/2.8 lens. 1/160 sec @ f/4, ISO 200. Adjustments in Camera RAW.

DAVID STREETER (p.168)
Panasonic DMC-FZ8 @ 10.4mm. f3.2, ISO 100. Minor adjustments to contrast, brightness and hue.

LEE RUDLAND (p.169)
Canon EOS 5D with Canon EF 17-40mm lens @ 17mm, 4 minutes @ f8, ISO 100, 2 stop Lee ND grad filter, tripod and cable release. Raw file converted to mono and adjusted using levels, curves, dodging and burning.

ED PAVELIN (p.170)
Bronica SQAi, 50mm lens, Fuji Velvia 50, 1.5 minutes @ f/22, tripod.

ANITA STOKES (p.171)
Canon 1Ds Mk III with Canon EF 24-105mm @ 105mm. 1/400 sec, f10, ISO 200. Tripod.

STEEN DOESSING (p.172)
Canon EOS 1Ds MkIII.

MELANIE MUKHERJI (p.173)
Canon EOS 5D, EF28-70mm f/2.8L USM @70mm. 0.4 sec @ f/16, ISO 100. Adjustments to levels, contrast and saturation.

KEVIN BEECH (p.174)
Nikon D2Xs, 17-55mm f/2.8 Nikkor lens @ 38mm, tripod. 10 sec @ f/18, ISO 100. Shot in RAW, edited in Photoshop - levels and curves, dust removal and slight sharpening.

GARY WAIDSON (p.175)
Canon EOS 5D with EF 70-200 f2.8L IS USM @ 195mm. 6 sec, f11. Tripod, ND filter. Spotting and contrast management.